Card Photographs,

A Guide To Their History And Value

by

Lou W. McCulloch

Photographs: Thomas R. McCulloch

Schiffer Publishing Ltd

Box E, Exton, Pennsylvania 19341

Dedication

*To Tom, my favorite
photographer.*

Design and Paste-Up: Steve Carothers

Library of Congress catalog card number: 81-51444

ISBN: 0-916838-56-0

This book may be ordered directly from Schiffer
Publishing, Box E, Exton, PA 19341. Please include
$1.50 postage in U.S.A. Please try your local book
store first.

Printed in the United States of America.

Acknowledgments

William Darrah, Gettysbury, Pa., contributed information on cartes de visite and stereographs.

Mike Goldstein, Los Angeles, Calif., photographed collection of cartes de visite, cabinets, and postcards.

Frank D. Guarino, DeBary, Fla., quoted prices from photograph lists--*Picturesque America.*

Mr. Kauffman, New Haven, Conn., quoted prices from photographic list--*S. & L. Heritage.*

Bob Malley, Ferndale, Mich., quoted prices of cabinets and miscellaneous photographs from *The Keeping Room.*

J. Simon, Eggertsville, N. Y., quoted prices of photographs.

TABLE OF CONTENTS

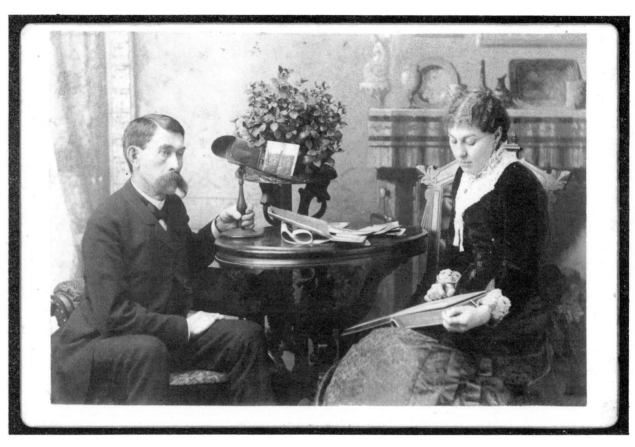

The family album and stereoscope were focal points in any Victorian parlor.

Introduction

If you happen to have any periodical literature dating from the late nineteenth century, check the advertisement headings for photographic items. Although the title *Miscellaneous* usually was adapted for the subject, some publications felt that cartes de visite, stereographs, and photographic studios belonged under the heading of *Sporting Goods,* or *Proprietary Articles.* Actually the periodicals of the 1860s, such as *Harper's Weekly* and *Leslie's,* contained numerous advertisements of reputable photograph dealers. By the 1880s, however, there was some confusion as to what this new form of art constituted. Was photography indeed an art, and of scientific interest? And into what category should it be placed?

When photography was in its infancy there was no doubt about the subject's appeal to the scientifically minded. Sir William Hershel, the noted British astronomer, dabbled in photography; and certainly M. Daguerre and M. Niepce would not have discovered the photographic process without having attained the quality of scientific curiosity. When images were transferred from the lens of a "camera obscura" to various metallic plates, a new age began—an era that could record exact replicas of occurences or personages, and thus could no longer hide imperfections.

Unfortunately the likes of Anthony, Brady, and Nadar were the exceptions rather than the rule. During the 1860s a myriad of amateur photographers arrived on the scene, and emerged from every small town and large city. The carte de visite, invented by Andre Adolphe Disderi in 1854, brought the photograph into every family album with the likes of President Lincoln rubbing shoulders with distant relatives.

Disderi's multiple-lens camera could record several poses on one plate, thus reducing printing costs and opening the door to mass production. Yet few realized that photography could be an acceptable art form; the majority of photographers shied away from outdoor views or still-life compositions.

The sensitive portrayal of soldiers in battle and the aftermath of the Civil War, as depicted by Mathew Brady's staff, was another matter. All the studio props, the painted scenery and fake rocks, could not replace the reality of a body-strewn battlefield.

Perhaps it is the term "reality" that best describes photography whether it is in the eye of the photographer, or in the eye of the beholder. The somewhat staring, and frequently faded images of the daguerreotype and ambrotype were replaced with the posed reality of the nonsmiling Victorians reproduced on a slip of paper mounted on cardboard.

The camera obscura, which inverted and reversed an image in a horizontal direction, was applied to photography. (1860, Natural Philosophy.)

The portable camera obscura consisted of a tent of black cloth, a table to receive the image, and a tube with prismatic lens. (1860.)

The carte de visite photographers often attempted to enliven the prints of their stoned-faced customers with a touch of color, and the artist's palette was frequently used in combination with a camera as a trademark on the reverse of a card. Sometimes the artist overtook the cameraman, and the carte became a miniature painting with little semblance to the original photograph.

More than likely, the pained expressions were a result of long sittings and the uncomfortable head rests that were a part of every photographer's paraphernalia. Often the apparatus was hidden beneath a piece of draped fabric or among the props in a setting. The age of instantaneous photography had hardly raised its head, and much of the cameraman's art was still, literally, in the dark.

Illumination was mainly from the sun shining through glass walls or ceiling, aided by a few carefully placed reflectors. The inefficiency of the sun for illumination was described in an 1884 article in the *Scientific American,* in comparison to sun lamps which "...possess very great advantages over solar light, as the latter depends upon the state of the atmosphere and is often insufficient in our latitude

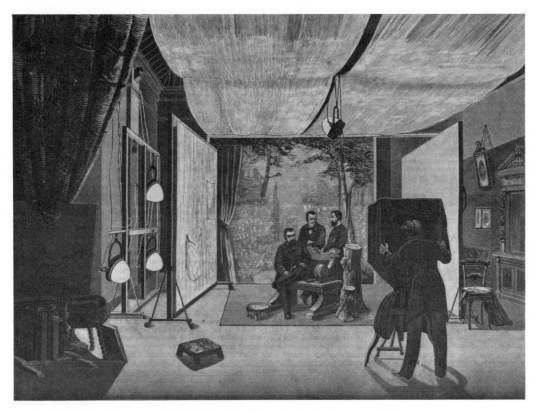

A photographic gallery lighted by sun lamps.

for a full third of the year." Thus the photographer of the late nineteenth century had to be not only an amateur artist and machinist, but also a meteorologist.

Although the stereograph cards were developing simultaneously with the carte de visite, it was the cabinet photograph that caused its demise. The cabinet was nothing more than an overgrown version of the carte, which easily lent itself to to elaborate costuming and backdrops. Even the backs of the cards displayed a growing change from unadornment to superfluous decoration.

But with improvements appearing daily in the field of photography it was the cabinet that reflected the new experiments, and drove photographers out of their studios to capture buildings and outdoor scenes. They found that a picture of a shop front, or a baby in his buggy, sold just as well as a portrait—although the portrait could not be discounted as a mainstay. Photography "just for the fun of it" was still a pastime of a select few.

Correspondingly, it was no accident that many of the better known photographers of the day turned to the stereographic process as an expression of their art. After all, any forerunner is an explorer of sorts, and this medium gave the adventuresome an excuse to tour the world on the pretense of providing stereographs for the public.

Obviously, C. R. Savage and William H. Jackson did not always have business on their minds when photographing the unspoiled West, for there was personal satisfaction in recording scenes never before seen by the masses. The "proof of the pudding" lies in the fact that many of these drifting travelers were involved in geodetic and governmental surveys. Probably their names deserve to be listed in a book of early Western explorers as much as in any book dealing with the origins of photography.

Photographic postcards, tobacco cards, playing cards, and other miscellaneous cards have just recently gained the attention of collectors. Just as the carte de visite and stereograph recorded the last half of the nineteenth century, the postcard displayed the trains, ships, disasters, actors, politicians, and daily life of the first half of the twentieth century.

The tobacco and cigarette cards were novelties that were frequently discarded rather than being pasted into colorful scrap albums. Today complete sets are relatively scarce. Souvenir playing-card decks, with different views on each card face, often contained images by noted photographers; photo-visiting cards and trade cards, novelties that have long been neglected, also give an insight into the past. Thus, photography is not only a lesson in realities but also in insights: an instance of apprehending the true nature of a thing.

CHAPTER I
The Collection,
Learn to Limit

When one is first enamored with the card photograph, it is difficult to practice restraint. Portraits with austere expressions, children in quaint outfits, engravings of famous paintings, are purchased indiscriminately, perhaps because they resemble a relative or are interesting conversation pieces. Price, of course, is always a factor. The beginning collector may wonder why he should pay an enormous sum for a single photograph, when a whole album full of photographs can be bought at half the cost.

Once a modest collection is accumulated, there is the question of what to do with it. Although personally the photographs are regarded as treasures, disappointment has to be faced as to reactions by others. Unless a friend or family member shares your new interest, there may be comments such as, "What are you going to do with those?" Or, "Why do you want pictures of people who aren't even relatives?"

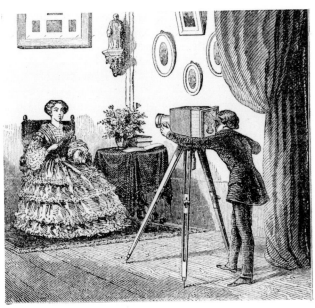

A daguerreotype studio of the 1860s.

Determinedly, the photographs are placed in folders or sleeve, open at least on one end so that moisture cannot form. This fact was culled from observing that many fine photographs were being ruined by ignorant dealers who had sealed photos, which causes moisture beads to form in the airtight space. Because many plastic or cellophane sleeves are made from acidic materials, some collectors prefer to store card photographs loosely in boxes. Besides humidity, sunlight is a comparable enemy that can fade grandpa's smile as easily as Rose Rand's stage costume.

Cleaning card photographs is a delicate undertaking not to be considered by amateurs. "Foxing" is a common problem that appears on vintage photographs as small brown stains. Actually it is a fungus that invades the paper fiber and thus is practically impossible to remove. If photographing such an item, some of the stains may be minimized by using colored filters. Surface dust can be eliminated with a soft brush, lens paper, or a kneaded fresh-bread ball. Since many photographs are albumen prints, care has to be taken not to remove the emulsion or glossiness.

Occasionally cards have telltale grooves around their centers, which indicates that a rubber band has left notches of wear. Others have clipped corners from being forced into albums, portions of the photograph torn away, or oily deposits from fingerprints. There is little that can be done for such conditions; but lessons can be learned by observing what causes the damage.

Haphazard collecting soon becomes unrewarding. Once the type of card or theme of the collection is decided on, the search begins. Purchases are now limited, but condition and rarity surely outweigh quantity. There are some cases where quantity might be an asset over quality, such as when a comprehensive listing is desired for dating specimens, or when an entire series is being compiled.

A general knowledge as to dating and printing techniques is eventually gained from accumulating a collection, but at some point further references should be consulted. The local library may be of assistance in acquiring editions dealing with early photographica or postcard collecting, and possibly this can be used as an aid in purchasing a personal library.

Sometimes references are not available in the field you have selected, or certain needed details are lacking. Instead of abandoning the search, try to realize that others have been in the same situation and would enjoy the challenge of investigating your particular problem. Photographic and postcard societies are often listed in publications on antiques, and dealers who advertise are usually aware of several organizations that can be of assistance to you.

At any rate, the publications and sale catalogues put out by such clubs are well worth any subscription cost or annual dues. Membership lists offer a means to meet others who share the same interests, and most societies have exchange programs and advertising columns. Organizations which might be of help include:

Deltiologists of America (postcard collectors), 3709 Gradyville Road, Newtown Square, Pennsylvania, 19073. Publishes *Deltiology* six times a year.

International Center of Photography, 1130 Fifth Avenue, New York, New York, 10028. Various publications are available.

International Museum of Photography, George Eastman House, Rochester, New York, 14607. Publishes *Image* four times a year.

National Stereoscopic Association, P. O. Box 14801, Columbus, Ohio, 43214. Publishes *Stereo World* bimonthly.

Photographic Historical Society of New York, Box 1839, Radio City Station, New York, New York, 10019. Publishes *Photographica* ten times a year.

Auction catalogs can be used as aids in determining values on items in your collection and recent trends. Even out-of-date catalogs can become valuable references which can help in recognizing a photographer's work or the image of a famous personage. Items of interest can be kept on a list that is updated to show increases in value. The name of the gallery or auction house, sale date, description, estimated price, and realized price should be recorded. The descriptive text should include:

Type of card (stereograph, etc.)
Title, if any.
Subject matter or locality.
Photographer.
Publisher.
Period.
Technique (instantaneous, etc.)
Type of print (albumen, etc.)
Theme (theatrical, etc.)

File cards recording each acquisition should also be kept and are an important part of a collector's library. Handling these cards is much preferred over constantly touching the original photographs or mounts. The information listed above can be noted as well as a xerox cross-filed in another location. Care has to be taken in xeroxing some photographs because the rays may damage the positives.

At this stage the collector has to determine a budget for purchases and plan for the future. A certain amount of funds could be set aside each month for photographic purchases, or a bid limit for a particular auction house could be established. It may be advantageous to save the "fund" for a few months and make a major acquisition rather than settle for whatever comes along. Dealers appreciate having a "list of wants" from their customers, and, if advised, only catalogs containing these "wants" will be sent. This alleviates the pressure of buying just to stay on a mailing list, and saves the dealer unnecessary postage.

A plan for the future might include deciding on the ultimate goal of a collection—whether it is obtaining the works of a particular photographer, completing a set, finding views of a hometown, or concentrating on cards from an exposition. After recent reference materials in the chosen field are exhausted, a collection can be augmented by consulting contemporary journals and advertisements for information. If various types of photographs and journals related to a single subject are accumulated, the collection is termed "topical."

Further limitation may be achieved by choosing a singular size of photographic mount. There was a wide assortment of mounts and images produced, but the standard sizes were as follows:

Popular Sizes of Images and Mounts

	Size	Introduced in the United States
Carte de visite	2¼ x 3½ image, 2½ x 4 inch mount	c. 1859
Cabinet	4 x 5½ image, 4½ x 6½ inch mount	1866
Victoria	3¼ x 5 inch mount	1870
Promenade	3¾ x 7½ inch mount	c. 1874
Boudoir	5 x 8¼ inch mount	c. 1890
Imperial	7 x 10 inch mount	c. 1890
Panel	4 x 8½ image, 8 x 13 inch mount	c. 1900
Stereograph	3 x 7 inch mount (Europe, 1854) 4½ x 7 inch mount (Cabinet, Artiste, or Deluxe)	1859 c. 1870
Kodak	2½ inch diameter, No. 1 image 3½ inch diameter, No. 2 image	1888 1889

Finally the beginner and connoisseur alike should seek out museum collections to become familiar with photographers, subject matter, processes, and periods. Fine photographic collections reside in the following institutions:

Floyd and Marion Rinhart Collection, Ohio State University, Columbus, Ohio 43210.

The Gernsheim Collection, Humanities Research Center, University of Texas, Austin, Texas 78712.

International Museum of Photography, George Eastman House, Rochester, New York 14607.

Metropolitan Museum of Art, New York, New York 10028.

Museum of the City of New York, New York 10029.

Library of Congress, Washington, D. C. 20540.

Smithsonian Institution, Washington, D. C. 20560.

CHAPTER II
The Carte de Visite,
Remembrance of a Visit

The ornate, gold-embossed leather album was hidden behind a box filled with old mementos and newspapers. My clumsy childish fingers easily pried open the brass clasp and revealed a photograph of a bearded gentleman with unblinking light-colored eyes. What a handsome man he was, surely he must be a great-grandfather or a notable distant uncle. Glancing through the pages, a myriad of curious faces stared out at me, from glamorous satin-bedecked women to sad-faced children in crumpled clothing.

At ten years of age, I felt that in my grandmother's cupboard I had discovered a treasure book filled with long-lost relatives that could be searched for family resemblances. But the last photograph in the album drove me to ask another person's opinion, for the image was shockingly that of a bearded lady in Victorian finery.

The distinguished gentleman with the unblinking light-eyes turned out to be none other than Ulysses S. Grant, and the shocking bearded lady was thought to be a local circus attraction. Unfortunately these interesting individuals could not be claimed as my ancestors.

This carte de visite (pronounced *kart de vee-zeet*) album was typical of the 1860s era, for interspersed among the distant cousins and forgotten relatives were famous personalities of the day. Such photographs, "of notable persons, choice pictures, and works of art," were advertised in magazines such as *Godey's Lady's Book* for the sum of fifteen cents each or eight for a dollar. Ladies were advised that, at this low price, they could furnish their albums at comparatively small cost and feature a great variety.

It seems that the collecting of cartes de visite had usurped the accumulating of visiting cards, tokens of affection, and linen labels that were popularly pasted into scrapbooks during that period. The term *cartomania* was coined to describe the international hobby, and even Queen Victoria had 110 photo albums containing portraits of society and royalty.

It all started in 1854, when the French portrait photographer Andre Adolphe-Eugene Disderi experimented with several exposures on a single plate. By one printing process several prints were produced, and thus reduced the cost and amount of time involved. The most attractive pose or scene could be easily picked from the single sheet, then trimmed and mounted on card stock. The mounted card was approximately 2½ by 4 inches, slightly larger than a calling card and, correspondingly, received the French equivalent for visiting card as its *nom de plume*. Disderi

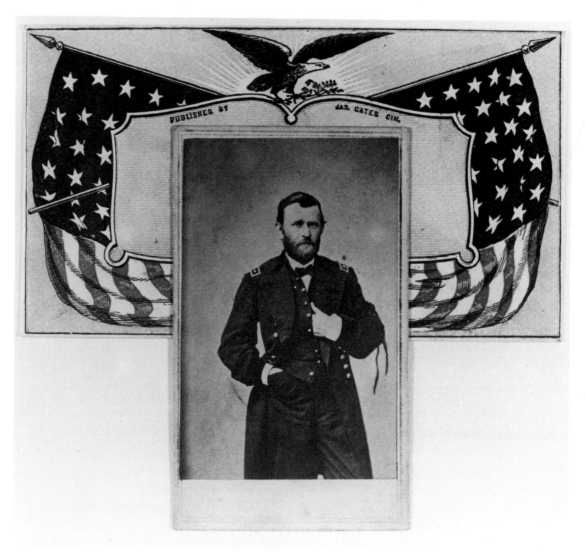

General Grant within the frame of a patriotic envelope, dating from the Civil War.

patented the process for the carte de visite, but the four-lens camera was not perfected until 1860 by the London photographer C. Jabey Hughes. For different poses or clients the lenses were uncapped separately.

Although Disderi is recorded as the inventor of the carte, historical data indicates that the procedure was simultaneously discovered by other photographers. As early as 1851, Louis Dodero of Marseilles had suggested various uses for carte-sized portraits, and *The Practical Mechanic's Journal* of 1855 indicated that the fashion of handing out photographs while visiting had originated as an American custom.

It is doubtful that Disderi foresaw the extreme popularity of his cartes de visite in the 1860s, or, for that matter, thought that the cartes would ever lose favor once the public discovered them. But he did have his time of glory, for the likes of Napoleon III were among his famous patrons.

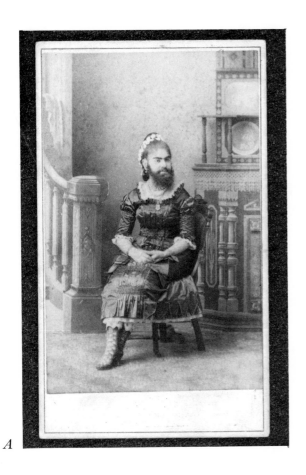

A

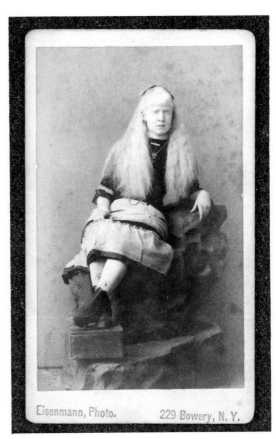

Eisenmann, Photo. 229 Bowery, N. Y.

B

*A.B. Two distinguished attractions of Phineas
T. Barnum's Museum were the bearded lady
Annie Jones, and the Albino Lady, both
photographed by Charles Eisenmann of New
York City.*

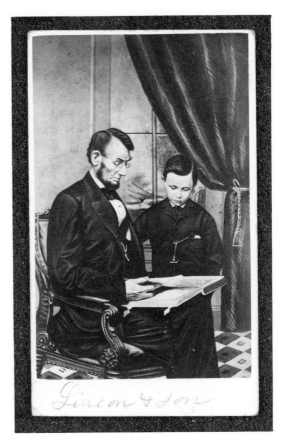

*C. President Lincoln with his son, Tad.
(Retouched from pirated Brady negative.)*

C

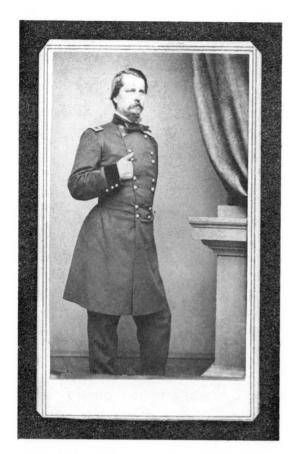

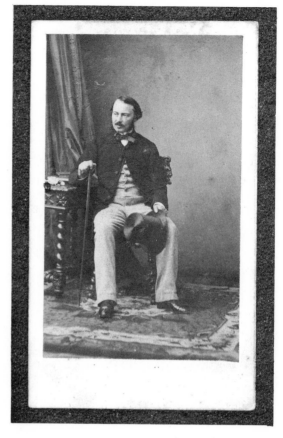

General Hancock, from a M. Brady negative.

Disderi & Cie of Paris, Count de Persigny, c. late 1850s.

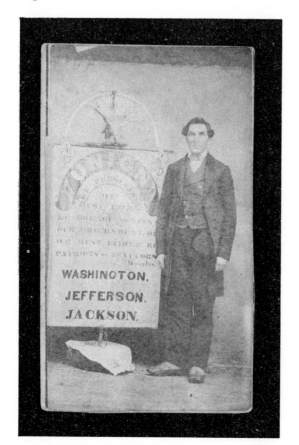

Unidentified Union sympathizer, c. 1862.

Beginning in the early 1860s, his studios were located on Hanover Square in London, the Boulevard des Italiens in Paris, with other shops in Toulon and Madrid. By February of 1866 he was advertising 65,000 portraits of celebrities. His photographs are still admired today for their simplicity of pose and contrasts of dark and light. Unfortunately the cabinet photograph eventually caused the demise of its predecessor, and Disderi was also affected for he died in near poverty.

Within a decade, a multitude of amateur photographers were producing thousands of cards in every major city and hamlet. Quantity rather than quality became commonplace, for, after all, there was a market for almost any famous personality in milady's album. A printed catalog from an 1865 Philadelphia agency offered several hundred selections that could be ordered through the mail.

A photo that was considered a best-seller was called a "sure" carte. Subjects included officers of the army and navy, civil officers, President Lincoln, authors, artists, distinguished personages, and copies of pictures. This last category consisted of reprints of Currier and Ives, seasonal pictures by Thorwaldsen, allegorical interpretations, and other genre subjects.

If the term "copies of pictures" invokes the feeling of unimportance, remember that even photographic reprints are bringing high prices at auctions today. John P. Soule of Boston produced a prize series of carte de visite genre reprints of paintings in the 1860s, with titles such as *The Belle of the Season, Homeless,* and *Peace.* Some of the most spectacular of these cartes are hand-colored in blues, reds, greens, yellows, browns, oranges, and flesh tones. Besides adding color to a Victorian lady's album, they also were sold to benefit soldiers during the Civil War. Appropriate themes included an allegorical interpretation of *Emancipation,* and *Hopes and Fears* that depicted a mother and her children anxiously reading a war-newspaper extra. The majority of Soule's delightful photographs are from paintings by G. G. Fish.

Of course common family photographs could also be copied. A photographer of the 1880s with a sense of humor stated on the reverse of his carte de visite, "Do not trust your pictures out of town to be copied by traveling photograph bummers, who make great promises and generally deliver very poor work."

There were other notable exceptions to the mass-produced reprint photographers and the studios cranking out portraits for ten cents a piece. Fortunately some photographers retained an artistic sense in regard to the posing of subjects, lighting, and backgrounds. Understandably these proponents usually had dabbled in earlier forms of photography, and boasted of a higher clientele than the average small-town commercialist.

J. J. E. Mayall and Camille Silvy produced some of the finest cartes de visite in England, with American counterparts such as Mathew Brady and Edward Anthony. The cursive letter "N" beneath a portrait or a typographical study identifies it as a Nadar, the pseudonym of Gaspard Felix Tournachon, a colorful French photographer whose interests ranged from ballooning to drawing caricatures. An example of any of these photographers will be outstanding in a collection, not only because their names are well-known, but also because the camera's lens produces an art form when placed in the proper hands.

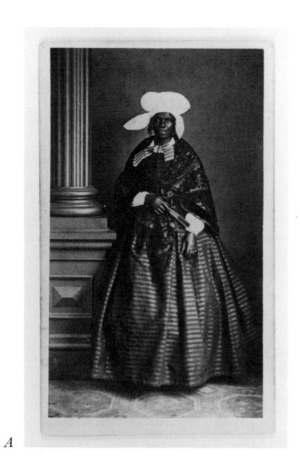

A

B

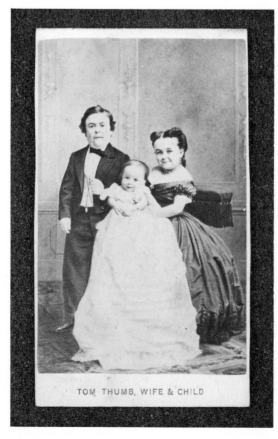

TOM THUMB, WIFE & CHILD

C

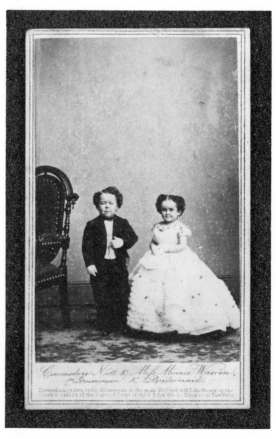

Commodore Nutt & Miss Minnie Warren,
as Groomsman & Bridesmaid.

D

20

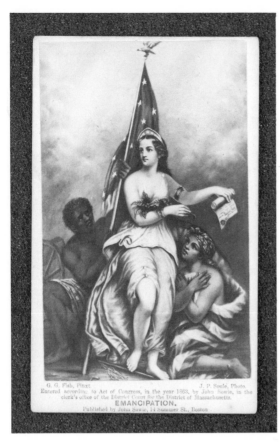

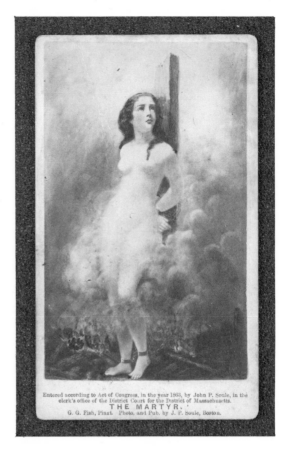

Emancipation. 1863, by J. P. Soule. *The Martyr. 1863, by J. P. Soule.*

A. Lydia Joyce, photographed in 1862 by E. H. Clark of Great Barrington, Massachusetts.

B. Props were sometimes used to promote other photo-services, as this carte de visite of a man posed beside a Brewster stereoscope.

C. A photographic fabrication of Tom Thumb, wife, and child.

D. The bestman and maid of honor at Tom Thumb's wedding were Commodore Nutt and Miss Minnie Warren, from a M. Brady negative, 1863.

Photomontage - His excellency Governor Eyre and staff.

E. & H. T. Anthony advertising carte de visite picturing female personalities.

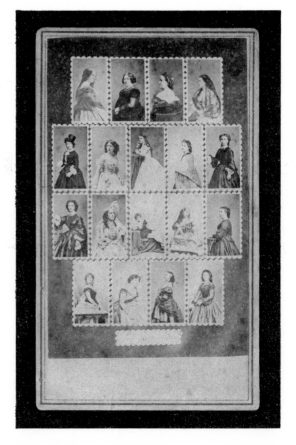

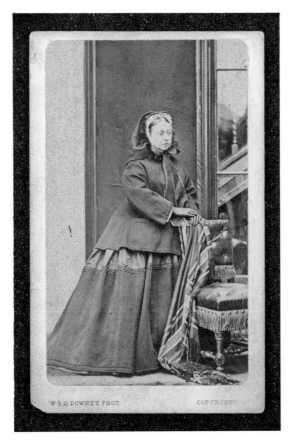 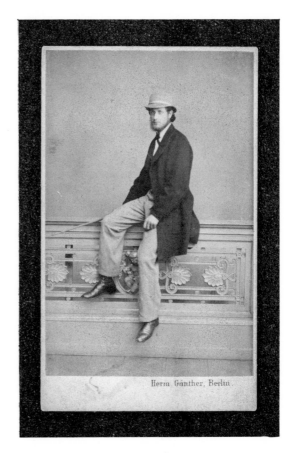

The Queen, W. & D. Downey. *Gentleman, Hermann Gunther.*

It is generally easy to identify the photographer of a carte de visite, for, thanks to the lure of advertising, the majority placed the name or emblem of their studio on the carte's reverse. Dating a carte de visite is another matter. As with the stereograph, an approximate date can be established by the card's stock color, corners, fiber, and decoration. Of course if a tax stamp is in evidence on the reverse, the card will date from the period 1864 to 1866 when the law required their usage.

Other clues to dating include fine lines of color such as black or gold that framed the photograph and were used in the early 1860s. Also during the same period many gem tintypes (ferrotypes) were mounted on oval card designs, and these medallions were later used with trimmed cartes.

The 1870s and 1880s brought more experiments with backgrounds, lighting, and subject matter. Instead of the overposing and stiffness seen in early examples, the subjects became more relaxed and natural as carte photography developed. Thus an occasional smiling face dating from the late nineteenth century can be found.

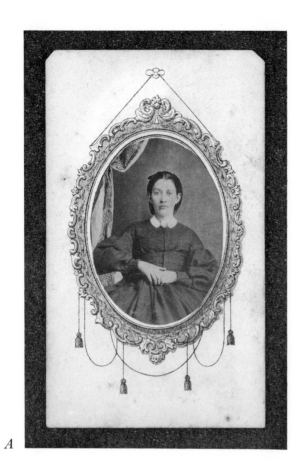

A

B

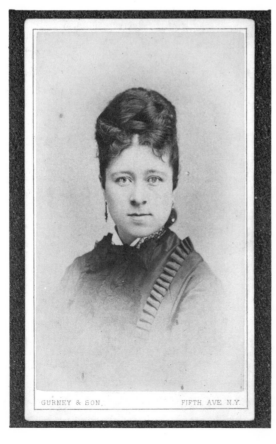

C

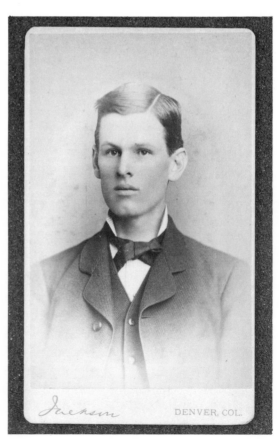

D

24

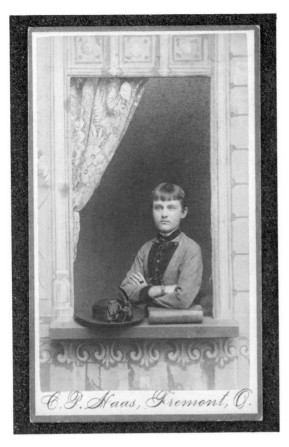

An elaborate studio backdrop complete with curtain.

Foster advertisement for "The Great Baby Photographer" of Cawker City, Kansas.

← *A., B. Oval framed carte de visite, oval matted ferrotype.*

C., D. Gurney & Son of New York was a famous portrait gallery of the East; whereas William H. Jackson's portrait studio in Denver, Colorado was soon to become noted in the West.

Exceptions to the rule arise in any dating guide, but a general outline may be of assistance. One must keep in mind that some photographers insisted on ignoring the current styles, and retained mounts predominantly used in the 1860s for a decade or two longer. As previously mentioned, old family portraits were also copied and placed on contemporary mounts of the period. Experiments in retouching, enameling, and other techniques can be found dating from each ten-year span following the carte de visite's inception circa 1854. Cartes dating previously to 1860 are relatively rare, and consequently are deleted from the following scale:

25

DATING THE CARTE DE VISITE

Period: 1860–1868

Thin stock, square corners.

White, ivory mount.

Double border lines; outer line thick, inner line thin. (Lines commonly seen in gold, black, red, light purple, etc.)

Single border line of color, square corners.

Oval framed vignette, sometimes draped with fringe.

Tax stamps on reverse: September 1, 1864–August 1, 1866.

Austere props such as columns, curtains, chairs, balustrades.

Hand-coloring added.

Period: 1869–1879

Medium stock, rounded corners.

White, cream, beige mounts.

White front, colored reverse (pink, dark-green, pattern: light gray on lemon, etc.)

Single border lines (gold, red, black, purple, blue, etc.)

Props as a bridge, fence, fake rock, etc.

Period: 1880–1905

Thick stock, rounded corners.

White, cream, light green, pink, etc. mounts.

Single border lines, or absent.

Gold beveled edge on mount.

Photomontage, such as oval portrait surrounded by actual photo of a forest.

Elaborate backdrops, outdoor views, etc.

Incidentally, the trip to a photography studio in the 1870s was generally an elaborate undertaking. There was so much concern about the proper dress, makeup, pose, and expression to be taken, that the appointment was likened to a trip to the dentist.

In the 1872 edition of *Twenty-three Years Under a Skylight,* H. J. Rodgers describes a photographer's view of his studio and clients. Women were advised against wearing excessive trappings, and gentlemen were told not to wear too closely fitting garments. The total artistic effect could be spoiled by the wrong selection of shade, color, or pattern that might not be harmonious to the complexion.

Fear and nervousness caused awkwardness in expression as well as in pose. The photographer said that "if the features are unnaturally inanimate, heavy and dull while sitting, the picture must necessarily depict some degree of mental imbecility." Ladies also had a habit of tightly compressing the lips to make the mouth appear "small, dainty, and pretty."

It was up to the photographer to achieve a pleasant final product, although his opinion did not always coincide with his client's. It was suggested that photographing hands and feet should be avoided because "the whole power or optical capacity of the camera is brought to bear chiefly upon the head, producing a more natural likeness and a more meritorious specimen of art."

Photographer: "I should suggest that you have a profile picture taken, your features are peculiarly and consistently adapted to that style." Harper's Weekly, 1869.

The parting of the hair, projection of the face, reflection from a shirt, and broadness of the shoulders had to be taken into consideration in a gentleman's portrait. The less than desirable client who wished to have his "mug" taken was one who left a trail of mud and broken props throughout the studio.

Women, groups, and children were even more of a problem. Blue-eyed blonds were best taken on a cloudy day, and hair styles had to harmonize with the form of the face. A dark-complexioned gentleman could not be placed in the center when accompanied by two ladies of light complexion. The ladies did not require one half as much time in the light as his dark-hued features. Babies and small children had to be made complacent with an entire toy shop ranging from a jumping-jack to a base drum.

All in all, the nineteenth century photographer is portrayed as a soul-tried individual who had little chance to experiment with his trade as an artistic medium.

A man's handkerchief or Dinkelspiel box of the 1860s featured a slot in which to place a carte de visite.

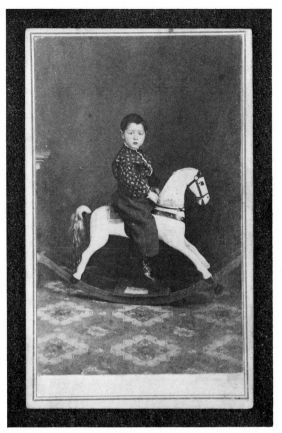

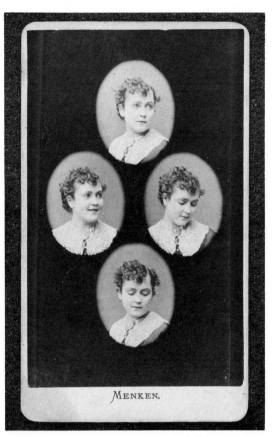

Boy on toy-horse, c. 1860.

Matted-medallion portraits of the actress, Menken.

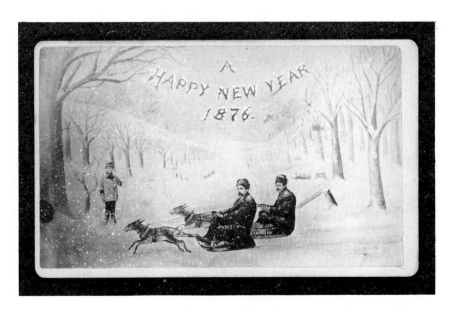

A carte de visite used as a New Year's greeting in 1876, was an early attempt at photomontage.

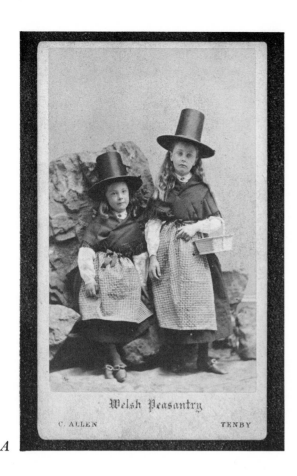

A. Welsh Peasantry, *photographed by C. Allen of Tenby.*

B. C. The Lame Boy, *a carte de visite used for charity purposes was accompanied with a sympathetic plea for contributions.*

THE LAME BOY.

I am a poor, lame helpless boy,
 Without good legs or feet ;
It was God's will to make me so,
 Therefore I will not fret,

My photograph I now do sell,
 A living for to make ;
It's education I do want,
 As much as I can take.

My parents now are very poor,
 They cannot help me much ;
So I must get along myself,
 I never will be rich.

God will reward and prosper all,
 That unto me doth give ;
He will return it all to you,
 With blessings from above.

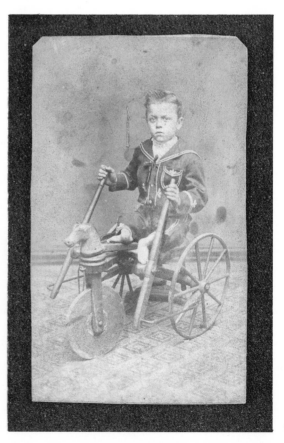

A

B

C

A study in butter of The Dreaming Iolanthe, 1876.

French genre novelty.

An elaborate Spencerian design entitled "King of the Forest" drawn with a pen by William Warren and then photographed.

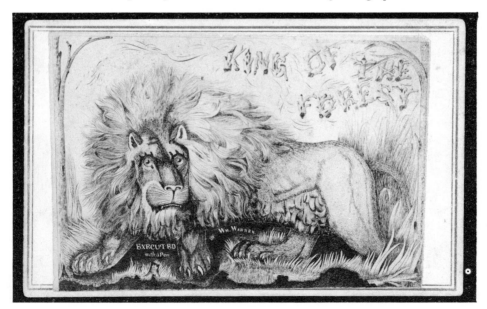

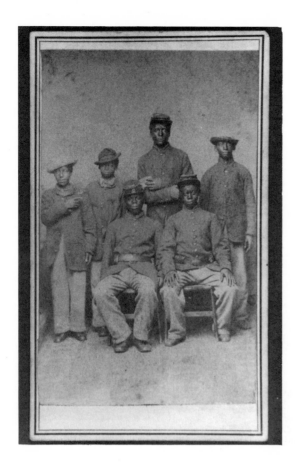

Civil War black regiment, photographed by Robertson of Providence, Rhode Island.

An Italian masterpiece photographed by C. Naya.

Page of sculpture cartes de visite by D'Alessandri of Italy.

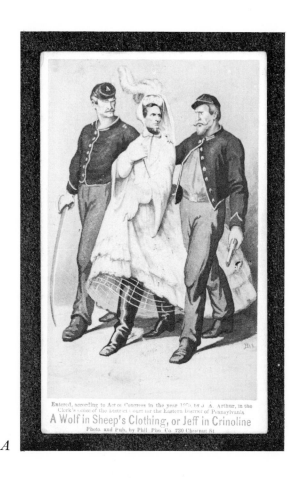

A

Entered, according to Act of Congress in the year 1865, by J. A. Arthur, in the Clerk's office of the District Court for the Eastern District of Pennsylvania

A Wolf in Sheep's Clothing, or Jeff in Crinoline

Photo. and Pub. by Phil. Pho. Co. 730 Chestnut St

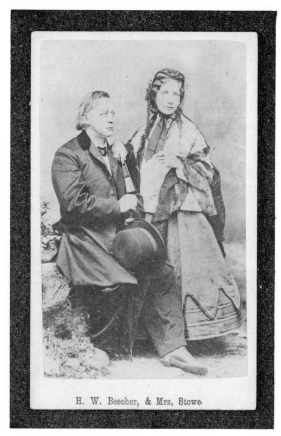

H. W. Beecher, & Mrs. Stowe.

B

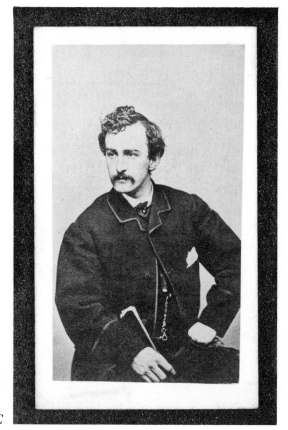

C

A. "*A Wolf in Sheep's Clothing, or Jeff in Crinoline.*" depicted Union sentiments in 1865.

B. Henry Ward Beecher with his daughter, Harriet B. Stowe.

C. The assassin and actor John Wilkes Booth.

34

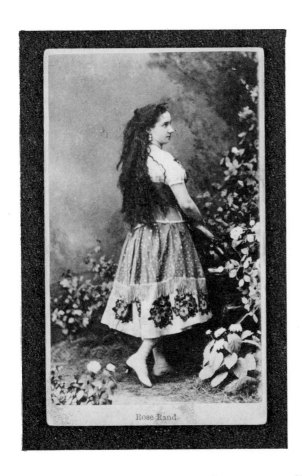

Stage personalities Rose Rand and Grace Rawlinson.

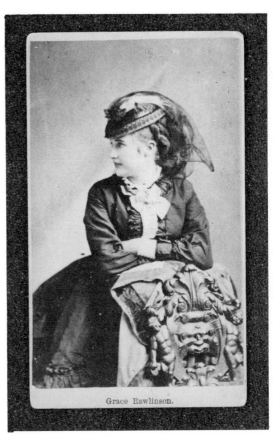

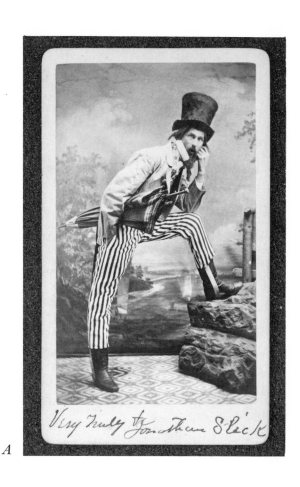

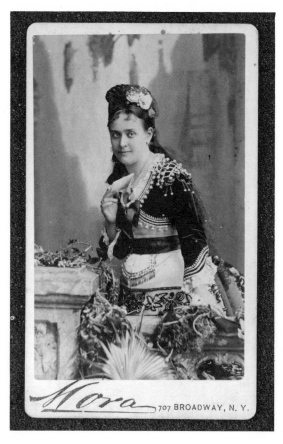

A

B

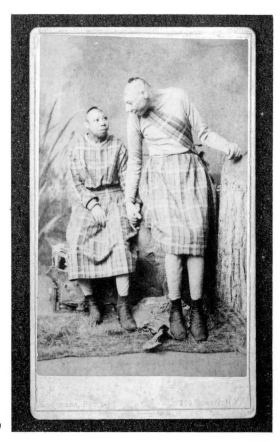

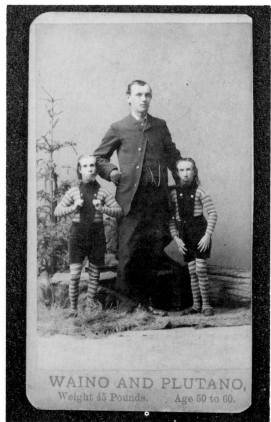

WAINO AND PLUTANO,
Weight 45 Pounds. Age 50 to 60.

D

E

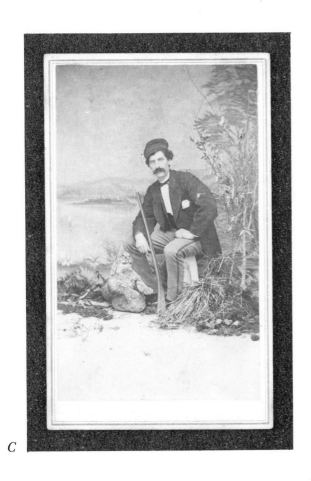

C

A. *Theatrical pose of Jonathan Slick, c. 1870.*

B. *Mora, J. M., Portrait of a stage personality.*

C. *A hunter with his bobcat. Notice the fake gun-stock.*

F

D. *Charles Eisemnamm specialized in photographing human oddities like Pinhead the Monkey Man and friend.*

E. *Waino and Plutano, The Wild Men of Borneo.*

F. *Eli Bowen, The Legless Wonder.*

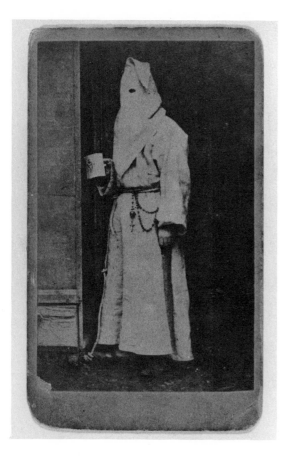

A

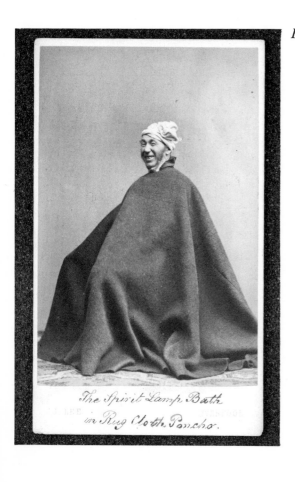

B

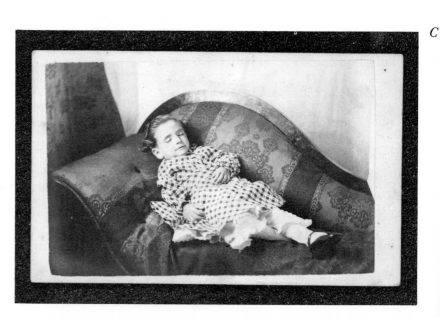

C

A. *Ku Klux Klan member or Hooded Penitent, c. 1870.*

B. *A visitor to the "Spirit Lamp Baths, in Rug Cloth Poncho," c. 1870s by J. Lee of Liverpool.*

C. *Postmortem photography gained popularity with the carte de visite format.*

D. *Bedford, F. Gloucester Cathedral, from the South-East.*

E. *Smithsonian Institution, c. 1870.*

F. *Whitney, J., Views of Minnehaha and Castle Rock published by Whitney's Gallery of St. Paul, Minnesota.*

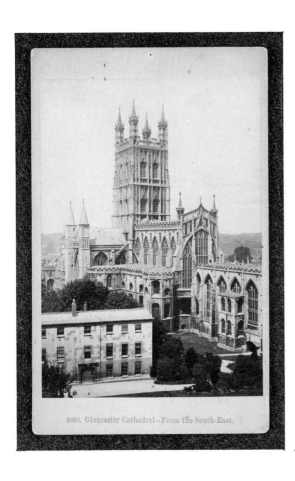

2860. Gloucester Cathedral—From the South-East.

D

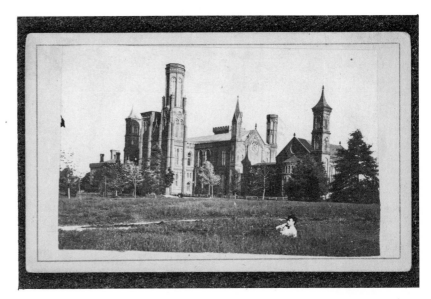

E

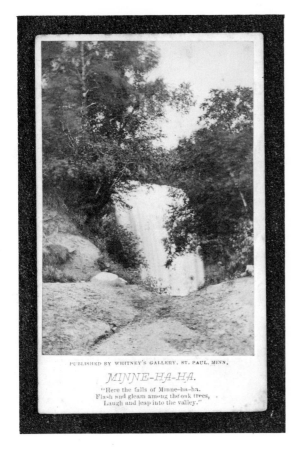

PUBLISHED BY WHITNEY'S GALLERY, ST. PAUL, MINN,

MINNE-HA-HA.

"Here the falls of Minne-ha-ha,
Flash and gleam among the oak trees,
Laugh and leap into the valley."

F

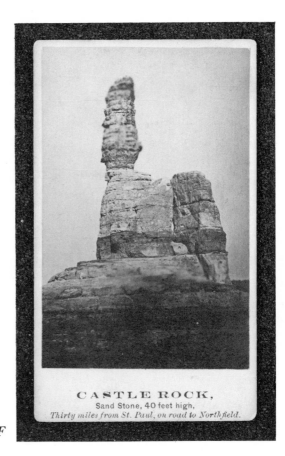

CASTLE ROCK,

Sand Stone, 40 feet high,
Thirty miles from St. Paul, on road to Northfield.

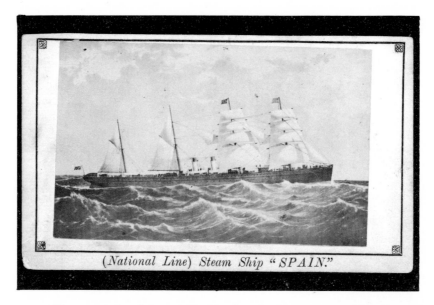

The carte de visite of the National Line Steam Ship "Spain"; pictured cabin plans on its reverse.

A "Gruss Aus" carte de visite that was a predecessor to the greeting postcard.

CHAPTER III
The Cabinet,
Container of Life

As in the world of art, photography evolved according to the various styles of the photographers and tastes of the public. The carte de visite was a novelty that brought photographs of the noteworthy as well as common family portraits into the realm of collectibility; they were combined in elaborate albums made specifically for their display. The cabinet photograph was a continuation of this pastime, and at its introduction was thought to compliment the carte de visite.

HISTORY

As early as 1862, photographers began searching for a new portrait novelty. In *The Photographic News* of May 18th, 1866, a London portrait photographer by the name of F. R. Window suggested the cabinet-sized mount, and eventually opticians developed the needed camera lenses.

Correspondingly, photographers in America and on the continent were attracted to the greater size of an approximately 4 by 5¼ inch image on a 4¼ by 6½ inch mount. Not only could the photographer's name and place of business be more prominently displayed below the portrait, or on the reverse, but a higher price could be charged for the larger size.

Once the cabinet was recognized as a fashionable format, noted photographers began to advertise. Napoleon Sarony (1821–1896) was originally from Canada, and a partner with S. Laroche in a Birmingham, England, studio from 1864 through 1866. Late in 1866 he opened his first New York studio, and for the next three decades he photographed nearly every contemporary celebrity.

Sarony achieved his greatest recognition in cabinet photography, and his flowing signature beneath the portraits of theatrical and other famous personalities of the day became a sure sign of quality. Although often the camera was not triggered by Sarony but by an assistant, he focused his attention on directing his clients. If an individual was seeking a publicity or a theatrical pose, he might imitate an actual stage setting in his studio.

He introduced elaborate painted backdrops, and encouraged clients to bring interesting accessories. Actually the clients could not help but be somewhat dramatic and expressive on viewing such objects as a crocodile hanging from the studio's ceiling. Sarony also displayed a flamboyant personality, and often dressed in outlandish clothes to attract attention. He was short in stature, and rightly gained the nickname of "The Napoleon of Photography."

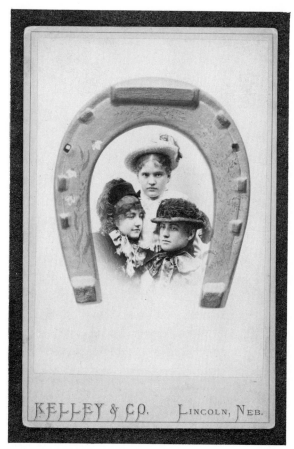

A

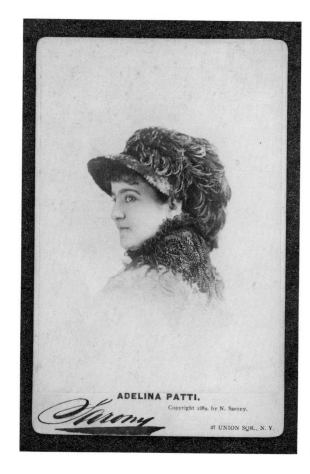

ADELINA PATTI.

Copyright 1882, by N. Sarony.

Sarony

37 UNION SQR., N. Y.

B

C

A. *Trompe l'oeil, or a "fool-the-eye" photograph of a group of women within a horseshoe.*

B. *Sarony, Napoleon. Adelina Patti, 1882.*

C. *Cabinet-size sample card of female personalities.*

D. E. *Newsboy stage personalities Sylvia Gerrish and Marie Tempest.*

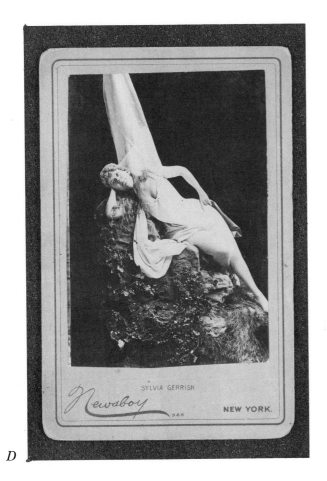

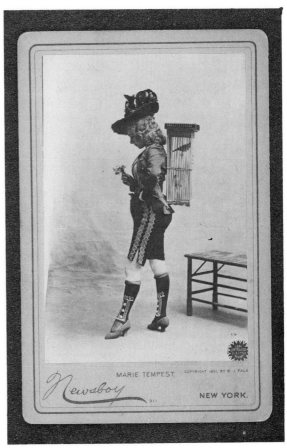

D E

Sarony retained the copyrights on his photographs, but frequently had to pay royalties to the noteworthy. Charles Dickens received a royalty, as did Lillie Langtry, who was considered the most beautiful woman of the day. For the sum of $5,000 Sarony produced some 90 poses of Lillie. Sarah Bernhardt received $1,500 for her time in the studio; and the soprano Adelina Patti walked out with $1,000 in her purse.

Jose Maria Mora (born 1849) also prominently featured a cursive signature on his portraits, and had a studio on Broadway dating from 1870. After the Civil War, Mathew Brady's gallery adapted the cabinet mount for it was considered a "higher type" of photograph. Other noted cabinet studios included the London Stereoscopic and Photographic Company of London; Lafayette of Paris; K. Tamoto of Japan; and G. Brogi of Florence, Italy.

ALBUMS

Albums displaying typically Victorian ornateness offered slots to fit both cartes de visite and cabinets. Because of the larger format of a cabinet, the albums could now be larger and more elaborate. Some were cumbersome, with attractions such as silver horseshoe latches, music boxes, brass trappings, velvet paintings, embossed celluloid, tooled leather, and chromo-lithographed pages. The albums naturally attracted attention as a parlor table display and became the center of discussion at teatime.

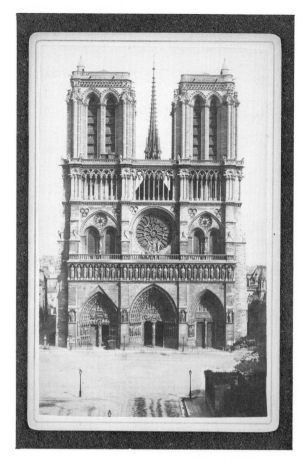 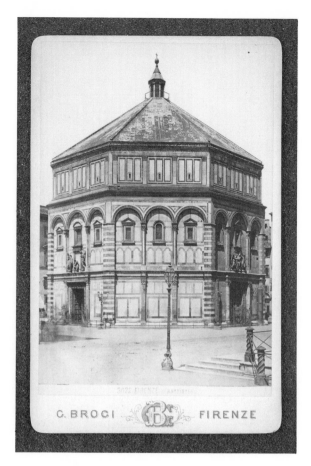

Notre Dame Cathedral, France. *G. Brogi view of Florence, Italy.*

It is interesting that a mail-order catalog of 1894 introduced the section on photographic albums with the warning, "Complaints are often made that openings are too small for pictures." Buyers were reminded that the slots were of standard size, and that mounts should be trimmed to fit into any opening. Unfortunately many desirable photographs were destroyed in this manner, and the task of removing photographs from albums without tearing the slots also damaged many fine albums. There were scissor-like utensils that were supposed to simplify picture removal, but a common flat knife was most suited to open a slot.

Albums with slots for both sizes of photographs came in the common 8½ by 10½ inch size, or the tall and thin 7 by 16 inch "Longfellow" size, and in various upright designs. Pocket photograph cases of seal-grained calf leather were also available. A typical top-of-the-line album featured full celluloid covers with calf-leather back, cupids on the cover, silvered extension clasp, floral decorated interior, and openings for 28 cabinets and 16 cartes. Some of the upright styles had drawers for nonstandard photographs, trefoil mirrors, and linings of puffed satin.

STUDIOS

The studio of the cabinet photographer was not unlike that of the carte de visite photographer, and, of course, most studios were producing both formats. There was a gradual change to a relaxed atmosphere, mainly because of the reduced sitting times and casual poses that became popular.

44

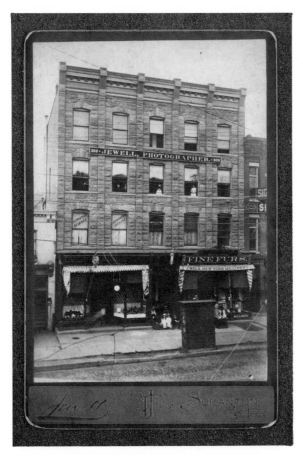

*The Jewel Photography Studio in
Scranton, Pennsylvania.*

*Shell photo studio prop and painted
backdrop.*

Dapper gentlemen leaned on fences made from branches, ladies resplendent in coats and hats stood on rustic bridges with real flowers and grasses visible in the foreground. Children brought their toys or pets to be recorded, and the sports-minded displayed their favorite bicycle, roller skates, or fighting stance. Painted canvas backdrops simulated outside scenes or parlor settings, and often incongruous objects were added as novelties.

Special attention was given to copying and enlarging, with duplicates furnished at reduced rates. Thus it is not unusual to find daguerreotypes or tintypes reproduced on cabinet cards, and such photographs are dated by the mounts. The artist's palette or paint brush was commonly seen entwined in the advertisements on the reverse of the cabinets, although the image was placed there to convince clients that this was an "artistic" photographer rather than a painter.

Few cabinets are found intensely colored, but many were delicately tinted as to hair coloring or blushing of cheeks. By the 1890s, photographers were concerned with making portraits appear like paintings. Optical tricks were used to achieve softened features, cloud effects, and toning. Those who preferred a definite painting could have their cabinets enlarged to any size and finished in pastel, crayon, india ink, or watercolors. The real and the artificial were mixed mainly because of the widely held belief that photography was a mechanical process, and original artwork was not.

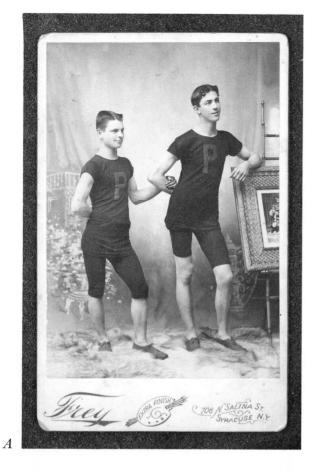

A

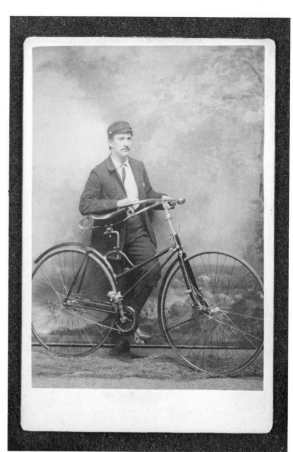

B

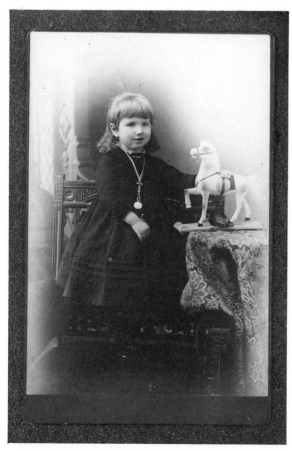

C

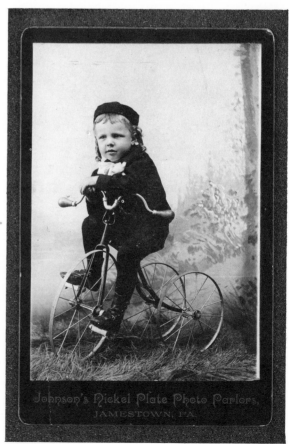

D

A. B. Occupational: Oarsmen and bicyclist.

C. D. Children's toys were popular props in any studio.

E. The photographer offered a stable of toy animals to amuse children. c. 1890.

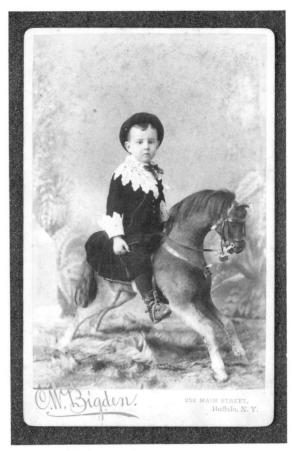

E

PROCESSES

The cabinet photograph shared the new term "instantaneous" with the contemporary developing stereograph; whereas the instantaneous stereograph referred to the skillful capture of action by a photographer, in cabinet work the term was used to describe short durations of exposure. This term was particularly used in advertising children's portraits.

George Eastman popularized the dry plate in 1881, and by 1885 the wet-plate method was outmoded. The exposures for wet plates had ranged from fifteen seconds to a minute, but the gelatin dry plate took only three seconds. Another time-saver was that the glass plates could now be conveniently delivered from the factory already coated with the sensitized emulsion. Expressions and attitudes could now be captured in the flash of a shutter.

By the end of the 1870s, cabinet cards were being produced by various photomechanical processes. The woodburytype, patented in 1864, used the original negative to make a relief of bichromated gelatin. The purplish tinge brought a new brilliance and sharpness to the positive. They are also identifiable by their absence of any graining. A similar process was the artotype which, when glazed, can easily be mistaken for an albumen print.

Albumen paper was readily available to the first cabinet photographers. It could be purchased for printing collodin negatives till around 1895, and was a rival to the new gelatin-bromide paper. The paper was already coated with a solution from the white of an egg and salt, then sensitized with silver nitrate.

Early albumen prints are sepia-toned because of being washed with chloride of gold, and later examples had a decided gray cast. Other photo processes included the heliotype, a lithographic procedure, and a platinotype which was printed on uncoated paper sensitized with salts of platinum. The latter produced some of the highest quality prints and could not fade.

Actual nude studies on cabinet mounts are relatively scarce; c. 1880.

CHILDREN

Now that portraits could be taken "instantaneously," children could be recorded in more relaxed poses. In fact it was common practice to give a child a photographic prop to occupy his time—a book, mirror or toy—so that a natural attitude could be obtained. It is obvious that a child's best finery was worn; occasionally even the boys sported lace-collared dresses. In part this was attributable to the popularity of Mrs. Frances Hodgson Burnett's portrayal of the well-mannered Little Cedric in *Little Lord Fauntleroy* and the subsequent play based on the book.

Seasonal studio poses were effective, such as when a child was dressed in winter attire and stood beside a sled. Babies were most often photographed in their own wicker carriages or propped up with pillows on Victorian chairs. Collectors prize children's portraits that display toys of the era—a "police" brand wagon, an iron fire engine, toy horse on wheels, or large bisque doll. Others prefer photographs with children posed with their favorite pets such as a dog or a rabbit.

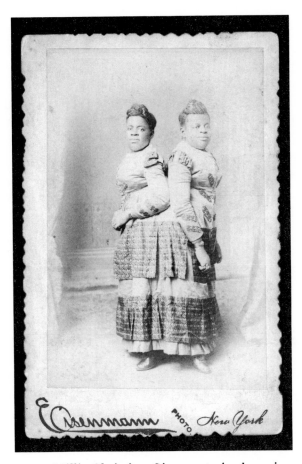

Millie-Christine, Siamese twins born in 1851. By Charles Eisenmann of New York.

STAGE PERSONALITIES

The most popular subject for cabinet photography—next to the common portrait—was a portrayal of stage personalities of the day. One must remember that placing pictures in an album was a pastime in many Victorian parlors, and appealing subjects were the glamorous and those mentioned in contemporary publications. Of course New York City was the center for the release of major plays, homes of elite society, and the location of noted photographic galleries.

By 1870 there were over 300 galleries in the city, and among the respected were the studios of Mathew Brady, Napoleon Sarony, Jose Maria Mora, and William Kurtz. Thousands of portraits of actors and actresses, often in the costumes of roles that gave them notoriety, were taken and the copies offered for resale to theaters, hotels, tobacco companies, mail order firms, and other enterprises.

Sometimes a small royalty (or large, as previously mentioned in regard to "big" sellers) was paid to the photographed subject, but the advertising and fame that resulted from the proliferation was priceless. Lotta Crabtree (1847–1924) was immortalized as "Little Nell" in Charles Dickens' *The Old Curiosity Shop;* Joe Jefferson (1829–1905) was portrayed both before and after his nap in *Rip Van Winkle;* Adah Isaacs Menken (1835–1868) was depicted in a death scene from *Mazeppa* (1866); and Elsie Leslie, complete with long golden locks, was forever recognized as the original *Little Lord Fauntleroy* (1888).

The degree of involvement on the part of the photographers in capturing an actress or actor in their performance was sometimes carried to extremes. Napoleon Sarony was apparently an imposing figure—despite being only a little over five feet tall—especially when he dressed in a hussar's uniform and yelled instructions to his clients as if directing his namesake's army. Jose Maria Mora's studio was known for its hundreds of painted canvas backgrounds that were available, from snow-covered mountain tops to desolate desert scenes. Every accessory imaginable was used as a prop, including family treasures that were brought in to be immortalized.

Other "actress" full portraits bordered on the burlesque, with daring exposure of legs and suggestive leers. Today such poses seem almost comical; but during the 1880s and 1890s these cabinets were considered quite naughty, and found a popular market as free giveaways by tobacco companies. Even the mail-order catalogs of 1894 offered "cabinet-size photographs, taken from life, of prominent actresses of the vaudeville stage, in full costume" for 15 cents each or $1.50 per dozen.

OTHER NOTED PERSONALITIES

Presidents were portrayed on cabinets, as well as Queen Victoria, generals, authors, and poets. Although it is fairly easy to discover an image of President Rutherford Hayes, General U. S. Grant, or James Garfield, President Abraham Lincoln depicted on a cabinet mount is relatively scarce.

The great publicist P. T. Barnum, of circus and museum fame, was photographed by Charles Eisenmann of New York City, and many mounts were personally autographed. Wild West stars like the Bartlett family holding rifles, or Annie Oakley, Pawnee Bill, and May Lillie in deerskin outfits, were added to family albums as novelties. Samuel Clemens (Mark Twain) was shown shaking hands with John T. Raymond after his portrayal in the *Gilded Age,* and a handsome Thomas Edison was photographed in the Brady Galleries with his invention, the phonograph.

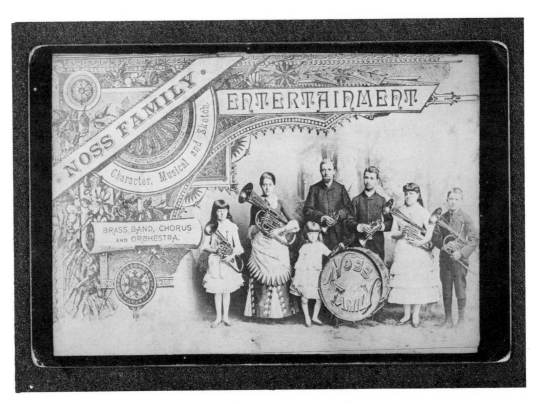

The Noss Family of New Brighton, Pennsylvania, featured a brass band, chorus, and orchestra.

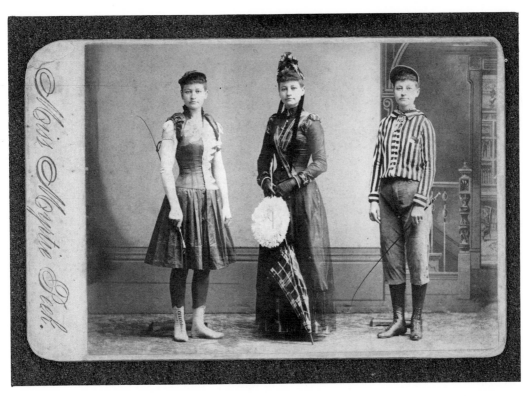

Timed exposure: Miss Myrtle Peek, an equestrienne; note center ghost image.

The Sutherland Sisters had a total hair-length of 37 feet and were concert artists.

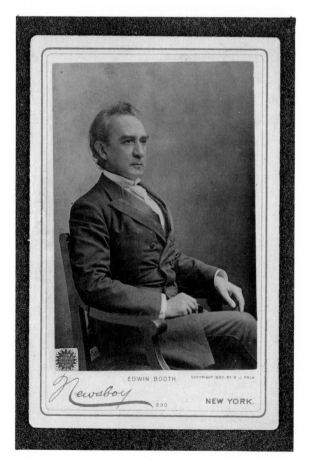

Edwin Booth, 1889, published by Newsboy, photographed by B. J. Falk.

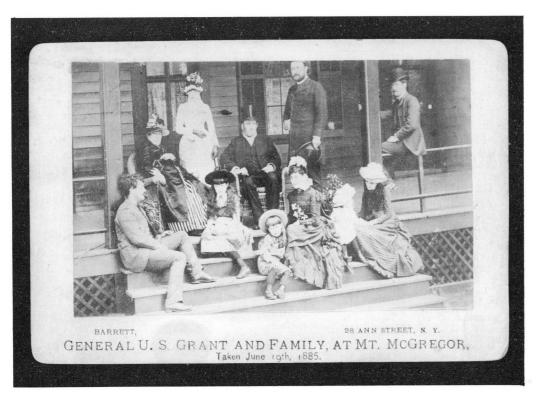

General U. S. Grant and family at Mt. McGregor taken on June 19, 1885.

Mementos from the 26th Ohio V. V. I. army corps of the Civil War were recorded in front of an ornate painted backdrop.

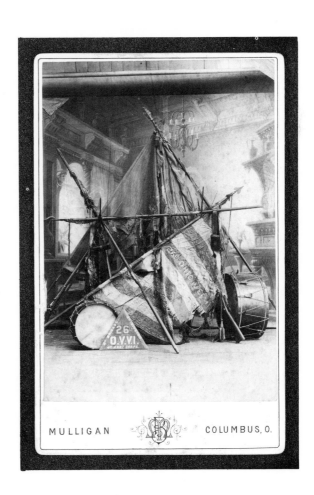

Photographs that reflect social customs or record vanished styles are of particular interest to collectors. Occupational cabinets fit into this category, such as those depicting people with the tools of their trade and clothing suitable only in their particular field.

Sports fans could buy pictures of well-known ball players, acrobats, wire artists, and pugilists. Common photos of oarsmen, bicyclists with their large-wheeled vehicles, or women on roller skates are other sports-related cabinets.

Photographs of adults or children with their favorite instruments are frequently discovered; musical groups are more difficult to find. An unusual example is that of "The Rock Band Concert Party" consisting of members of the Till family, with xylophones, drinking glasses, sweet potatoes, and other unusual instruments in evidence in the background.

Job-affiliated costumes or uniforms are intriguing historical documentation of past occupations, and range from firemen and policemen to railroad workers and miners. Perhaps a leather-aproned cobbler is seated at his bench ready to hammer a shoe, or a vested pharmacist is holding a bottle all set to dispense medicine.

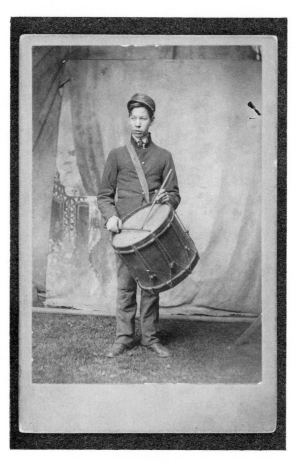

Drummer in Civil War uniform taken
in tent, painted backdrop.

Occupationals: Violinist and pharmacist.

ODDITIES

During the first decades of the nineteenth century life was a struggle, and death an everyday occurence in a community. Memorials were sewn on silk to honor George Washington, and family deaths might be preserved with a tinted print "In Memory" of the deceased. And because most deaths were untimely, particularly in infancy, there was a natural desire to preserve the image of the departed.

Once the dawn of photography appeared, the daguerreotype, ambrotype, and ferrotype were relegated for post-mortem use. Cartes de visite were the first paper-print photographs used in this manner, and cabinets followed soon after. Most of the examples of post-mortem images were of children, tastefully arranged by family members on a favorite chair or couch. Sometimes a flower was placed in the child's hand, or a bouquet arranged beside the body. Today many people are appalled by such photographs, but one must remember that the practice was based on an accepted social custom.

Memorial cards on white or black cabinet mounts noted the birth and death of some individuals, and occasionally featured a vignette photograph. These gold-edged mounts were handed out at funeral services in the 1880s and through the 1910s. Many cabinets recorded floral memorials, and usually a photograph of the deceased was tucked in among the roses.

In a 1903 catalog for ordering memorial cabinets, a specific photograph design could be chosen. A picture was sent (any size or kind) and duplicates were made. The directions further stated that "any head in group pictures can be copied by our expert without allowing other heads to show." One card with a mounted photo was 50 cents, and a dozen could be ordered for $2.00. Over 100 verses, in several languages, were available to be printed below the photograph, but the most popular sentiment was: "Gone but not forgotten."

The great showman Phineas T. Barnum indirectly influenced the carte de visite and the cabinet photographic market. Besides displaying his own autographed image in great quantities, he encouraged his museum attractions to be photographed. After all, P. T. Barnum never could pass up an advertising opportunity.

One of his earliest schemes was to erroneously announce that Mr. and Mrs. Tom Thumb were to become parents—and later hire a baby for Lavinia to hold during her appearances, while the real mother of the child stood nearby and posed as a nurse. The temporary parents were photographed with the baby, and hundreds of the cartes de visite were sold for twenty-five cents each.

The national appeal of the marriage in 1863, and the activities of Tom Thumb, was just the beginning of a curious desire by the public for bizarre photographs. Noted studios, such as Morrison of Chicago, Sword Brothers of York, Pennsylvania, and Newsboy of New York, specialized in celebrity photography. But Charles Eisenmann of New York was the master of preserving human-oddity images.

Beginning in the 1860s, Eisenmann cataloged through the carte de visite format every midget, dwarf, and abnormal sideshow attraction that frequented New York City. His studio was located in the Bowery area, as was the Wendt Studio that carried on the public exploit of freaks into the cabinet stage of photography.

Eli Bowen, "the legless acrobat," was photographed with his family; and Eng and Chang, the original Siamese twins, were also immortalized. Fat men, women, and children, could be amply displayed on cabinets, as well as the Seven Sutherland Sisters and their 37-foot total hair growth. Although some amateur photographers tried to jump on the bandwagon by falsely representing small children as midgets, the noted studios had no cause to try such tricks.

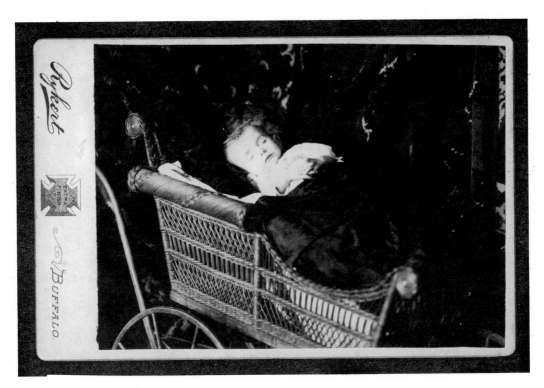

Postmortems of infants was a service offered by many photographers.

An unusual way to write a letter, c. 1880s.

Albino snake-lady, by Charles Eisenmann of New York City.

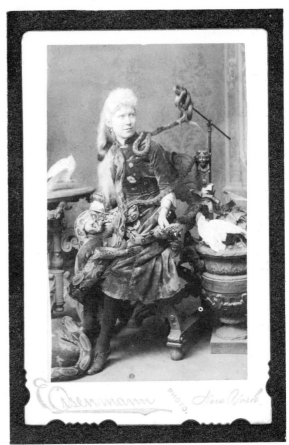

EXTERIOR AND INTERIOR VIEWS

When cataloging photographs it readily becomes apparent that there was a great change in subject matter—from the wallet-sized carte de visite to the cabinet—namely, the outside view.

European photographers were the first to accept this challenge, for there was a proliferation of carte de visite views available to tourists. Cabinet views of Notre Dame, famous fountains, hotels, and other landmarks were offered to the public. Some photographers, like Francis Bedford of England and C. Naya of Italy, preferred the stereograph to the cabinet, although both produced cartes de visite.

In the United States the cities of the Far West were chronicled: mining districts, territorial buildings, historical landmarks, railroad scenes, and expedition sites. William H. Jackson's views of Colorado are among the most difficult to find. These date from 1880, after he had settled in Denver. Rather than consciously recording unusual sights, Jackson seemed more concerned about achieving a photographic memory of the gradual development of the West. His cabinets of the Leadville, Colorado, mines and overviews of towns such as those located in Clear Creek Canyon, are unmistakable historical documents. Charles Savage of Utah, and F. Jay Haynes of Minnesota, also produced quality cabinets of the early West.

There were a few cabinet copies of photographs dating from the Civil War, like those produced by Theodore Wiseman of Lawrence, Kansas, in 1885. Taken from 1864 original negatives, the seven views showed various angles of Andersonville Prison when 33,000 Union prisoners were housed in the stockade. Civil War battle paintings and engravings were also reproduced as cabinets.

Famous events, such as the Centennial Exhibition of 1876 (28 views) and the Columbian Exhibition of 1893, were preserved in cabinet series, although the majority of outside views were of common occurrences. Train wrecks, oil wells, steam engines, and other industrial marvels became novel photographs, as were town parades, panoramas, ports, factories, and corner stores. As advertisements, studios often photographed their own buildings and these are of particular interest to collectors of vintage photographs. Interiors of studios are rarer yet; but inside views of Victorian homes, grocery stores, or historic landmarks, can occasionally be found.

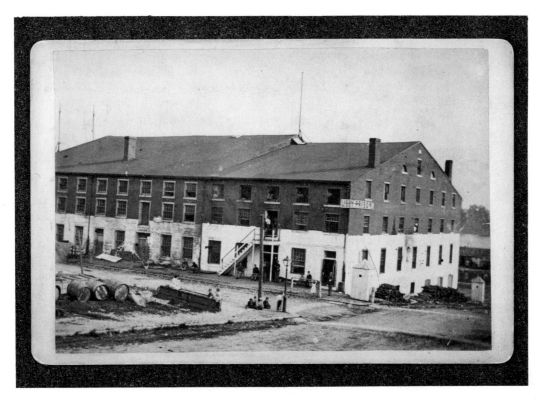

Libby Prison, by unidentified photographer.

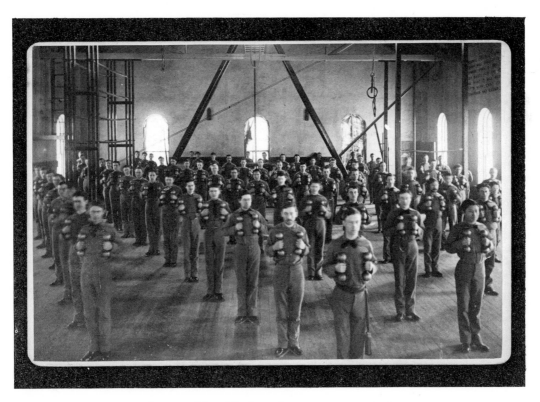

Gymnasium exercises, unidentified academy.

*The Toll Gate on Pike's
Peak Trail, by William H. Jackson*

Crew with steam engine to power saw mill.

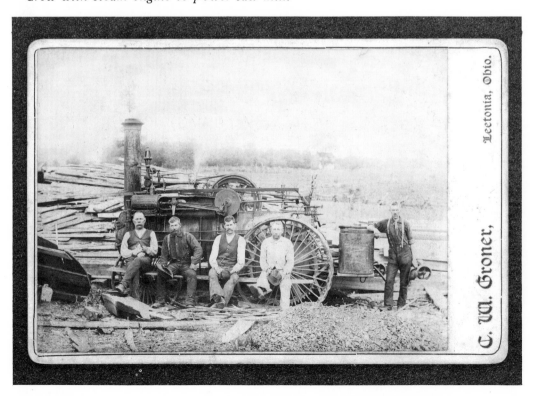

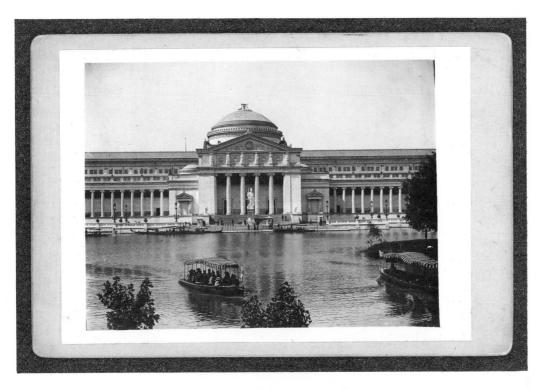

Columbian Exposition, 1893, Administration building.

*Watkins, C. E. Interior view
of the Palace Hotel, San Francisco.*

Palace Hotel, cor. New Montgomery and Market Streets, S. F.
WATKINS' NEW CABINET SERIES
Yosemite and Pacific Coast, 427 Montgomery Street, San Francisco.

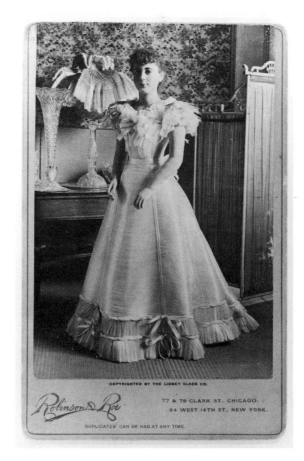

*The Glass Dress, royal robe
of Princess Eulalia of Spain, supplied
by The Libbey Glass Co. and exhibited
at the World's Fair in 1893. The dress
cost $12,500.*

CABINET PREMIUMS

As the carte de visite, the cabinet photograph was offered as a tobacco premium. An *Old Judge* cigarette trade card dated 1888 stated: "If you want full photographic collections of your favorite baseball players, you can easily get them. You will find a printed slip in every box of *Old Judge* or *Gypsy Queen* cigarettes you buy. On return to us of twenty-five of these slips, we will mail you (prepaid) an elegant cabinet photograph, handsomely mounted, of any baseball player, in club uniform, you may select from our printed editions. In this way you can get the photograph of every player of prominence in any club in the country."

Photographs of celebrities were also given away in this manner, as well as semi-nude photographs of women.

DATING GUIDE

Thick, white stock with rounded corners predominated throughout the cabinet period. For decades photographers continued to use favored mounts, so it is very difficult to date cabinets. General trends that have been noted were:

1869–1979:

> White or cream stock.
> Thin mount with square corners.
> Single line of color on front.
> Plain or small amount of advertising on reverse.
> Deep-brown or maroon mounts with gold printing.

1880–1889:

> Tints such as gray with double green line border, tan with single brown line, cream with brown printing, black with gold edge, gray design on pale yellow reverse, colored printing on front with single line of design.
> Thicker mount with rounded corners.

1890–1899:

> Tints such as rose, primrose, maroon, bottle-green, pale green, beige stock.
> Gold beveled edge, gold serrated edge.
> Elaborate advertising on reverse.

1900–1920:

> Tints such as gray mounts with colored printing.
> Pebbled surface with embossed edge design.
> Scalloped framing of image.

COLLECTIONS

A representative collection of cabinets resides in most of the major photographic repositories, notably the Library of Congress in Washington, D. C., and the International Museum of Photography in Rochester, New York. Of course the cabinet cards located in the Library of Congress are more of a political nature, such as senators, cabinet members, and executive members taken mainly at the Brady studio.

The Eastman Museum houses cabinets such as theatrical portrayals by Charles Eisenmann; portraits by the firm of Elliot and Fry (London, active 1863–1905); 45 portraits of celebrities by Benjamin J. Falk (1853–1925); photomontage experiments by E. B. Fay (active New York City, 1865–1875); portraits by S. B. Fell (active Morrisburg, Ontario, 1870s); and numerous others.

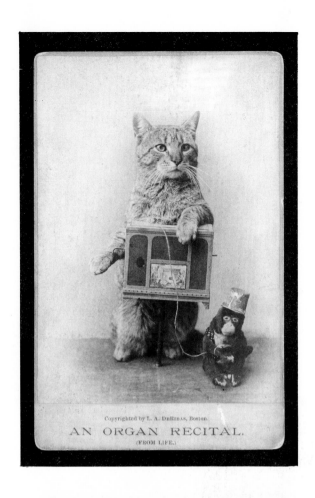

An Organ Recital by L. A. De-Ribas of Boston.

The trompe d'oeil effect was used in the framing of images.

A

B

A. This flag portrait was probably obtained in honor of a school play or event.

B. A fine portrait of an inhabitant of Chanute, Kansas.

C. Portrait of President McKinley by G. Edmondson.

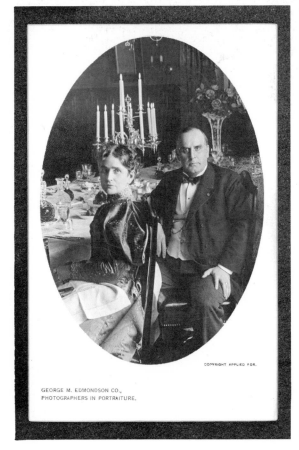

C

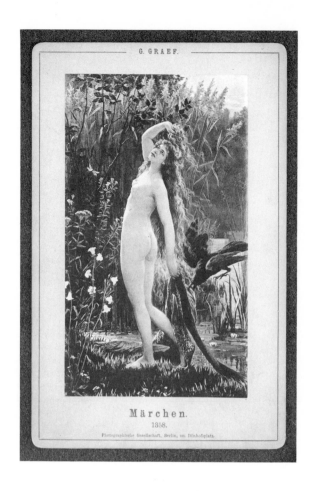

Genre subjects originating from painting Marchen.

"Qui vent des Pommes," a risque cabinet from France.

66

Cabinets were sometimes distributed to promote causes, as for a missionary or ragged shoe shine boy.

A unique Christmas and New Year greeting portrays an aborigine tribe.

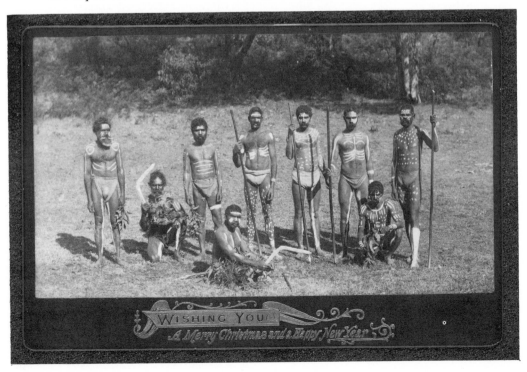

WISHING YOU
A Merry Christmas and a Happy New Year

An incredible hunter with no arms, peg-leg, and special sling for his shotgun.

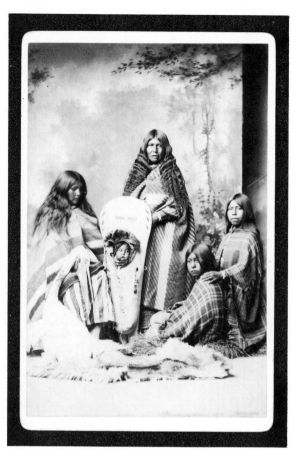

Savage, Charles R. Studio portrait, group of Indians.

Crow Indian with papoose and "Horse Thief," a Mescalero Indian.

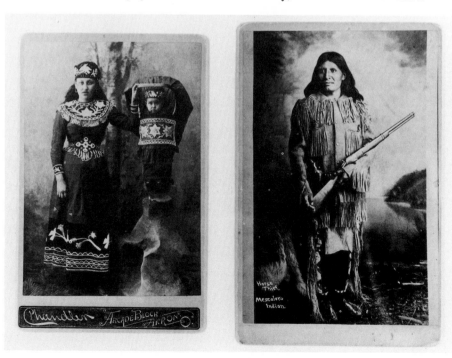

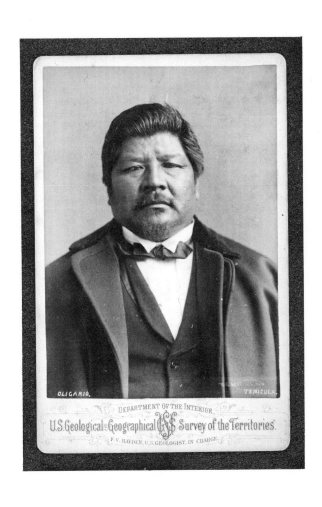

*Indian portraits taken on the
U. S. Geological Survey of the
Territories: Oligario of the Temi-
cula tribe and Buffalo Goad of
the Caddo tribe (attributed to
W. H. Jackson).*

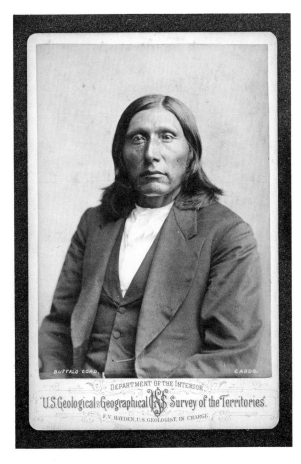

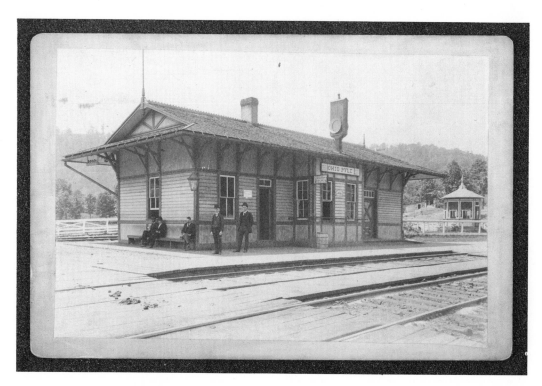

Outside view: Railroad station.

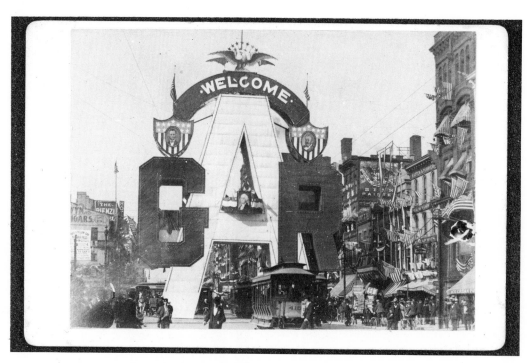

Buffalo, New York welcomes the Grand Army of the Republic.

CHAPTER IV
The Stereograph,
Double Vision for Thousands

The stereograph developed contemporarily with the carte de visite and the cabinet; in fact the "twin pictures" predated both techniques. But the interest in the three-dimensional illusion was more lasting and still reigns supreme with most collectors.

Fig. 236.

The Dubsque stereoscope featured large lenses which touched each other so that they adapted to anyone's eyes.

HISTORY

As early as 1838, Charles Wheatstone had devised an instrument to view images in three dimensions. This was before photography had been perfected. Two exact drawings were placed the width and depth of field of correct eye projection. As with the procedures connected with the camera obscura, it was only natural to substitute the perfected photograph for the drawing. Wheatstone coined the word "stereoscope" to designate the property of a representation of solid figures. In 1859, Oliver Wendell Holmes called the double-eyed or twin pictures "stereographs." The terms stereogram and stereoview have also been used interchangeably to describe the double image, but the name "stereopticon" refers to a completely different photographic process.

By 1871, a single-lens lantern-slide projector was known as a stereopticon, whereby two projectors were placed one on top of another. The views disolved into one and were produced from single-image glass slides.

In the early 1840s, Antoine Francois Claudet of London and others experimented with Wheatstone's stereoscope. Since light had to be admitted from all sides to reflect the daguerreotype image, results were limited. Finally Sir David Brewster invented a closed stereoscope in 1849, and Jules Dubsque-Soleil displayed his version at the London Great Exhibition of 1850. And because Queen Victoria and Prince Albert were intrigued with the novelty, the stereograph received enormous publicity. Within two years the daguerreotype's silvered image and the glass stereographs were replaced with paper prints from glass negatives.

The calotype, which W. H. Fox Talbot termed his salt-paper negatives, had been introduced in England in 1835. His images were printed directly on paper rather than on glass or metal. In 1849 the Langenheim Brothers of Philadelphia tried to popularize the calotype for stereoscopic use; but the wet-collodion print, perfected by Frederick Scott Archer in 1851, usurped the process. The wet-collodion photographer coated a glass plate with collodion (a solution of alcohol, ether, and pyroxyl), sensitized it with silver nitrate, and placed it in a camera.

Development was a tricky undertaking that commanded dexterity in the juggling of dampened plates and placement of bulky equipment in the usual portable darkroom. The prints were most often made on albumen paper prepared with a solution consisting of the whites of eggs. Invented by the Frenchman Louis D. Blanquart-Evrard in 1850, this printing paper was the favorite among photographers for cartes de visite, cabinets, and stereographs until gelatin-bromide paper was introduced in 1873 by Mawdsley.

EYE PERCEPTION

Generally the stereoscopic camera had double lenses, mounted approximately 2½ inches apart to simulate human sight. The negatives of two images reproduced on a single plate were then processed and prints made. The prints were then cut apart, reversed from left to right, and mounted on card stock. This corrected the lateral inversion of the pictures. Sometimes the photographers cut the negatives and switched them before printing so that the prints were on one piece of photographic paper.

In the beginnings of stereoscopy, the photographer had to make two exposures with his camera. He would move a short distance for the second exposure, or position two cameras to accomplish the feat; thus stereographs made from two negatives showed the evidence of a moving object or person in one image, but not in the other. Stereoscopic cameras that were perfected in 1860 eliminated this procedure.

It is interesting that during the 1910s some stereograph companies produced views designed to strengthen eye development. For instance, a patented series by Keystone was used "for the development of comfortable vision and a high degree of depth perception." Such exercises supposedly heightened the three-dimensional effect, with practice, and various numbers on the images indicated the changes in fixation. The fascination with depth illusions recalled the earlier experiments of pioneer photographers with angles and distances.

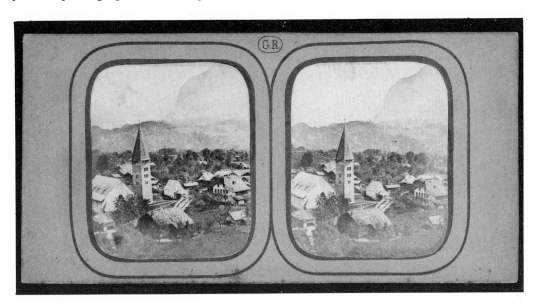

Early salt-print sterograph of scenery in Switzerland, by Gebhardt & Rottman, c. 1855.

Tissue mount made from two negatives, Bourne, Switzerland, c. 1857.
A figure stands on the bridge in the right image.

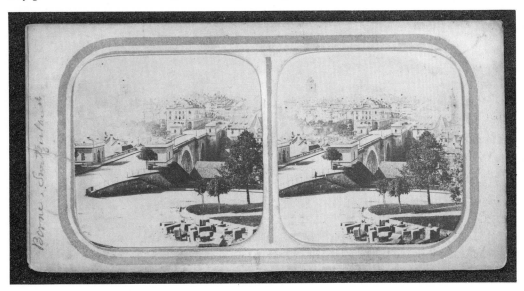

Langenheim Brothers

Besides the calotype and albumen print, the stereograph was produced as a daguerreotype, ambryotype, tintype (ferrotype), and glass transparency. The Langenheim Brothers of Philadelphia at first produced daguerreotypes, and then bought the United States patent for Talbot's calotype process in 1849.

William (1807–1874) and Frederick (1809–1879) Langenheim combined to become one of the leading photographic houses in the world by the 1860s, producing stereographs on glass during the 1850s, and concentrating on paper prints by the end of the decade. The Langenheim glass positives were viewed by transmitted light, and the first series in 1855 was titled *"American Stereoscopic Views."*

Perhaps the most common photographic view of all time was recorded in this series—the beautiful Falls of Niagara. It was up to Carleton Watkins of San Francisco to issue in 1861 a glass series noting the rival view of the West, the first National Park of Yosemite.

The earliest card views of the Langenheims were produced in 1854 and featured small prints edged with gold. These calotypes or salt prints were generally lacking in detail, and for several years carried only a small identifying label on the reverse. In 1859 and 1860 a blind-stamp of "Langenheim" was added to the front. By the sixties the Langenheims decided to concentrate on magic-lantern slides (termed Hyalotypes by Frederick) and The American Stereoscopic Company succeeded the firm, with financial interest being retained by William Langenheim.

Anthony

An equally propitious and prolific producer of stereographs was Edward Anthony (1818–1888) with galleries in Washington, D. C. and New York City. His portrait studio was established in Washington in 1842, where he recorded the members of Congress by the daguerreotype process. The majority of these treasures were later destroyed by fire. His first stereoscopic "emporium" was opened in 1859, at 308 Broadway in New York City.

Early series dating from this period have cream mounts with negative numbers below 600 (check right corner of left image for etched number); labels with "Anthony's Instantaneous Views," or the E. Anthony imprint. A few labels were printed with only the numbers and title description. The labels dating from that address were approximately 2½ by 6 inches, and reduced to 1½ inches in width after a move to 501 Broadway.

It was early in 1860 that Edward added the name of his older brother Henry T. Anthony (1814–1884) as a partner. Since 1853, Henry had been involved mainly in photographic manufacturing and perfecting a wet-plate instantaneous process. Some dark-cream colored mounts were used in 1860, and these were gradually replaced with yellow mounts.

In the late 1860s, a few series were published with an orange front and pink reverse, to be followed by the popular orange front and white reverse in the early 1870s. By 1873 their views numbered over 11,000 titles, and the company was recognized as the largest photographic supplier. The imprint was dropped the following year, but they continued to manufacture stereographs until 1892.

Some of the favorite series of collectors are instantaneous views of the public buildings of New York City (1859); Yosemite Valley; A Visit to Central Park in 1863; Southern Scenes; Glimpses of the Great West; and views of New York City by the new Gelatine-Bromide Process. Late cards also bear a 591 Broadway address.

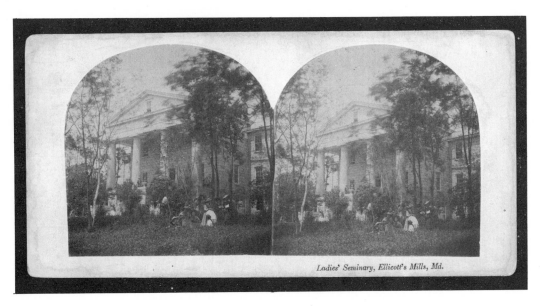

Langenheim: Ladies' Seminary in Ellicott's Mills, Maryland, 1858.

Langenheim: Label for The American Stereoscopic Company, 1858.

E. & H. T. Anthony & Co. No. 5278, *vignetted view of Sylvan Water,
from Sylvan Avenue, Greenwood Cemetery.*

*Alloway, Kirk. Views of the Land of Burns, London Stereoscopic Company,
c. 1857.*

AMERICAN STEREOSCOPIC COMPANY

As previously noted, the American Stereoscopic Company succeeded the Langenheims after 1861. Many photographers contributed negatives to the firm, but were not given credit on the stereograph. By the end of the 1860s over 2,000 titles were listed, and the company changed ownership. An innovative technique of the American Stereoscopic Company was to list all the numbers and titles in a particular series on a label on the reverse. Accordingly one could mark the view pictured, or keep track of what was needed to complete a series.

NEW YORK STEREOSCOPIC COMPANY

The New York Stereoscopic Company began issuing stereographs in 1859, changing from ivory to gray mounts within a year. Among the hundreds of views were many foreign scenes ranging from Turkey to Russia. The D. Appleton Company of New York was associated with this company in 1860, when the New York Stereoscopic Company was listed as a copublisher. Four years later, the company ceased issuing cards.

LONDON STEREOSCOPIC COMPANY

Founded in 1854, The London Stereoscopic Company was one of the largest producers of stereographs in the 1860s, rivaled only by Anthony in New York and Ferrier in Paris. The noted photographer William England produced a striking record of the International Exhibition in 1862 for the firm, as well as views of Switzerland, Ireland, America, and Paris. The head of the firm, George Swan Nottage, also sold stereoscopes numbering over half a million by 1856, and two years later boasted of a listing of 100,000 stereograph titles. This company truly tried to put a stereoscope in every home.

ON THE BACK

In a few cases a stereograph may be judged of more value for the back than the view on the front. Obviously a collector should check both sides for any indication of photographer's or publisher's imprint. Sometimes a magnifying glass helps to read negative etchings, blind-embossing, titles of series, or miniscule initials.

Before the mid-1850s, stereographs rarely bore any identifications other than a title or number in manuscript. Many amateur collectors pass over these views as insignificant; but most are one of a kind examples, frequently signed in the hand of the photographer. Printed labels were commonly used by the end of the decade, ranging from quarter-inch strips to full back labels.

G. W. Wilson, of Aberdeen, Scotland, preferred wide tinted labels with a title such as "Glen Almond—The Small Glen" and identifying No. 503 centered in small print on the label. In the 1860s Charles Gerard of Paris, used small strips with the

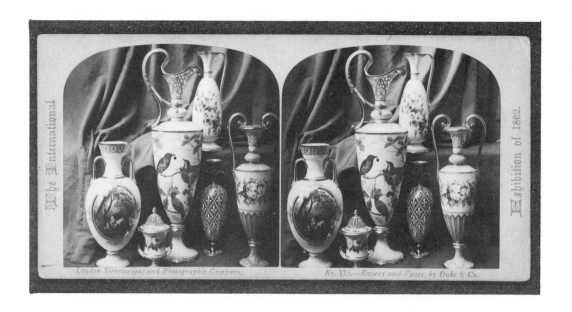

England, William. Displays of vases and glass at the International Exhibition of 1862, published by the London Stereoscopic and Photographic Company.

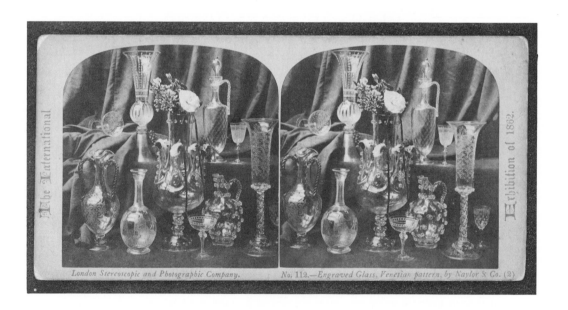

country, his initials, "Paris", and manuscript titles. Others intertwined initials in moresque designs during the early 1870s. The Langenheim label is perhaps one of the most desirable, as are the early Anthony imprints.

Beginning with the International Exhibition of 1851, photographers thrived on public recognition. On the back of his Pacific Coast Series, Carleton E. Watkins of San Francisco proudly displayed the front and reverse of the medal presented to him at the Paris International Exposition of 1868. He received the first prize awarded to the United States by the committee on photographic landscapes, and the only medal for California views.

Others, like F. Charnaux of Switzerland, displayed an array of medals dating from 1870 through 1879. Charles Weitfle of Central City, Colorado, exhibited an 1878 medal, presented by the Colorado Industrial Association, on some of the backs of his cards. A general date of publishing can be arrived at by noting such rewards.

Backs may also feature a supplier's or photographer's rubber stamp, stencil, descriptive text, view list, or advertisement. The publisher Underwood and Underwood frequently printed back descriptions in six different languages. A unique stereograph photographed and published by George W. Butler in 1874, described on its reverse a $30,000 colossal statue of a Civil War soldier erected at Antietam Cemetery. The view could be ordered through the mail for twenty-five cents, or one dollar for a 10 by 12 inch view.

Collectors' favorites include back engravings of the Palace Railroad Photograph Car, or any product advertisements. During the 1870s, the United States Stereoscopic View Advertising Company of Philadelphia solicited business houses to feature their ads on the reverse of stereographs. Most carried six billboard advertisements, ranging from ice cream ads to a "cash" clothing house located in cities like Allentown and Philadelphia, Pennsylvania.

Of interest to the philatelist, some stereographs bought between September 1, 1864, and August 1, 1866, bore revenue stamps. Generally these two-cent stamps are of little value. Deltiologists or postcard collectors should note that a few late series of lithoprint stereographs were printed with postcard divided backs. Stereographs were also printed in postcard size.

DATING STEREOGRAPHS

Any reference work regarding card photographs has to be indebted to the studies conducted by William Culp Darrah. His books *Stereo Views* (1964) and *The World of Stereographs* (1977) are indispensable to the stereograph collector, particularly for dating guidelines. The dating guide which follows is an adaptation from information culled from these works, with modifications gained from personal observation. Exceptions to the rule can occur in each period.

Card Mounts:
> 1851—1867, square corners, flat, thin stock.
> After 1868, round corners.
> After 1879, curved or warped mount.

Mount Colors:
> 1851—1862 White, gray, ivory, cream, brown, pale-blue, green, lavender.
> 1862—1876 Light to dark yellow.
> 1865—1876 Cream, ivory, blue, green, purple, orange, pink.
> After 1877 Beige, tan, cream, dark-gray, black, orange, yellow (curved mount).

American Views reprint. The Great Stone Face.

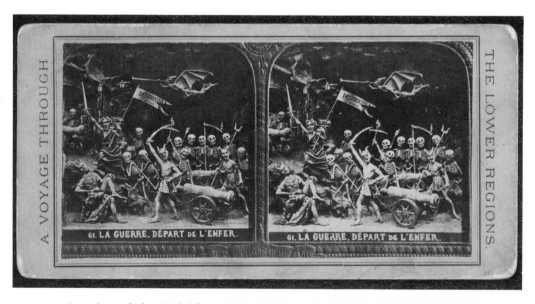

Reprint of the "Diables or Journey to the Lower Regions." Note the remains of the former tissue mounts.

REPRINT SERIES

By the mid-1870s, manufacturers openly pirated views from unknowing photographers. Some publishers bought negatives to settle debts, but most were stolen without compensation or notification. Eadweard Muybridge added the pseudonym "Helios" to his negatives in 1867, apparently to prevent this practice. Correspondingly, the firm of Thomas Houseworth in San Francisco received the highest award for landscapes at the 1867 Paris International Exhibition. Actually the views were by Watkins, Weed, possibly Muybridge, and others.

The practice was applied in mass proportions, with copy series such as American Scenery, Best Series, America Illustrated, Centennial Views, and European Series. The glories of the Yosemite were frequently copied, and deserve to be cross-referenced in case an unsigned Watkins, Muybridge, or other noted photographer is discovered. A flagrant reprint were the copies of the early French tissues of "Diables" or "The Lower Regions." The tissue mounts are easily visible in the new prints. Of course the heavier mount was sturdier, even though the image was generally less distinct.

These cheaply produced views usually carried no identification other than a printed series title. They are not to be discounted, for even copies of scarce views, as of the Great Eastern, Colorado mining towns, and early California settlements, have retained value.

TINTING AND LITHOPRINTS

Unknowledgeable flea market and antique dealers are sometimes confused about the value of "colored" stereographs. For instance, a common lithoprint, produced after 1898, may bear a high price tag because color is visible. Actually the multi-colored stereographs that usually are of more value are the early hand-tinted views. The tinting was applied onto the paper print by hired artists who were paid a small amount for each card.

Although the coloring was primitive during the 1855 to 1865 period, the cards are striking in contrast to monochrome examples. Tissue views that showed touches of hand-coloring when exposed to light, are also of interest. Keystone, Kilburn, Underwood, and others tried to revive tinting in the 1890s, but the paints would not adhere properly to the albumen surface.

Lithoprints were produced by the half-tone lithographic process. These prints flooded the market in the early 1900s, particularly the multi-colored examples. Sharp impressions are preferred over blurred color-overprints, and complete series are relatively difficult to obtain. The genre or humorous series, depicting courtship, a soldier's farewell or return, weddings, and flirtations, are popular with collectors.

A

B

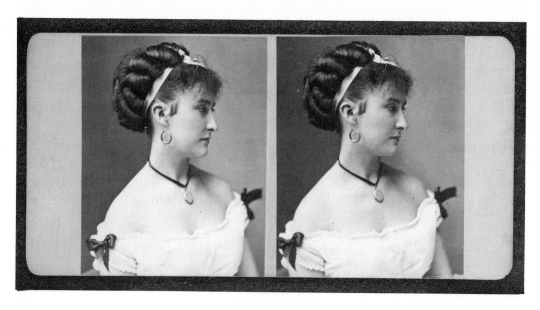

C

Naturally the famous wanted to be recorded in stereograph, just as they had been in other photographic mediums. Anthony published a series entitled *American & Foreign Portrait Gallery* which included portraits of Abraham Lincoln and noted generals. Later the presidents Lincoln and Grant were first represented in copied photographs or engravings, perhaps surrounded by a bouquet of mourning flowers or skeleton leaves. Presidents as McKinley or Roosevelt could be captured making a noteworthy speech or even in an intimate moment with their families.

Photographic pioneers like Samuel F. B. Morse and Sir David Brewster appeared on stereographs, as did their inventions of the telegraph and the lenticular stereoscope. The noted photographer C. W. Carter, of Salt Lake City, Utah, added a stern-faced portrait of Brigham Young to his Mormon Celebrities series.

Other series recorded theatrical personalities, sports feats, scientific explorers, military figures, world leaders, short-lived heroes, and human oddities. J. Gurney & Son of New York was perhaps the most noteworthy producer of portrait stereographs, although other fine series were offered by Fritz Luckhardt of Austria, the London Stereoscopic Company, Sarony of New York, and Stolze & Company of Berlin.

Portraits of common, unidentified personalities are also of interest. Early examples are relatively rare and range from hand-tinted stereographs of newborn babies to pale post-mortem photographs.

A. Bierstadt, Charles. *Maria Spelerini crossing the Niagara Rapids.*

B. *A stereo-photographer perched eighteen stories above the pavement of Fifth Avenue, 1905, Underwood & Underwood.*

C. *J. Gurney & Son, 1867, female study of Miss Ada Harland.*

D. *J. Gurney & Son, a ballerina.*

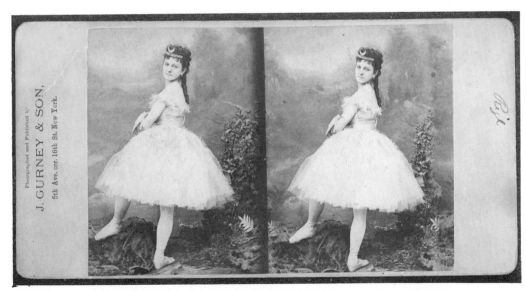

D

83

DISASTERS

Just as newspapers and television of today give grisly accounts of fires, floods, storms, and earthquakes, the stereo photographers were on the scene of major disasters. One can imagine the awe struck expressions on the faces of those viewing the destruction safely in their parlors, and the equally dawning expression by publishers who suddenly realized that "morbid shots" sold sterographs.

Nevertheless, disaster cards documented the San Francisco earthquake of 1906, the Johnstown Flood of 1889, and the Chicago Fire of 1871 for all time. Of course sometimes a posed victim was added to the foreground to produce more apathy, or a camera angle made a stack of twisted wreckage appear larger. Common train derailments, ship groundings, and similar scenes are also classified as disasters—at least in the eyes of the beholder.

Barker, George. The Johnstown, Pennsylvania, calamity, " A slightly damaged house," 1889.

The San Francisco Earthquake, April 18, 1906, ruins of the magnificent City Hall, photographer in forefront.

OUT WEST

There is something exciting about viewing unexplored territory or the unspoiled wilderness. Stereographs depicting the early west still invoke some of this excitement and have retained a sense of adventure. Photographers went to the area to explore and capture images of scenery and life that was foreign to those back East. They soon discovered there was a ready market for such views—from sets depicting the First National Park of Yosemite, to street scenes in the bustling city of San Francisco.

The Western photographer was a determined individual, for there were hardships at every turn or mountaintop. For instance, in a souvenir album entitled *Among the Rockies* a grouping of four horses and three donkeys is pictured as "photographer's assistants." The photograph was taken in the San Juan County, Colorado, near Silverton, at an altitude of over 14,000 feet. Further description included: "Cameras, plates, and other photographic material, besides camp outfits, must be transported on pack animals into almost inaccessible spots in order to obtain the best views of mountain scenery, at great expense of time and money. The hardships endured and the obstacles to be overcome by a mountain photographing party are not appreciated by the public who only see and admire the beautiful results."

Stereographs of the West are being appreciated by collectors today—one has only to note the high prices achieved at photographic auctions and dealers. In a recent article in *American Arts & Antiques* the five key nineteenth century landscape photographers were listed as Carleton E. Watkins, Eadweard J. Muybridge, Andrew Joseph Russell, Timothy H. O'Sullivan, and William Henry Jackson. All these camera artists produced stereographs, and will be briefly discussed along with others of note.

Photographer's assistants were often trustworthy mules like W. H. Jackson's mule, Hypo.

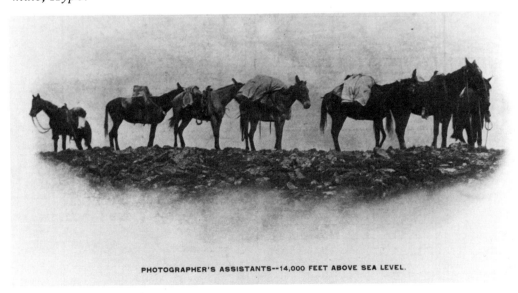

PHOTOGRAPHER'S ASSISTANTS--14,000 FEET ABOVE SEA LEVEL.

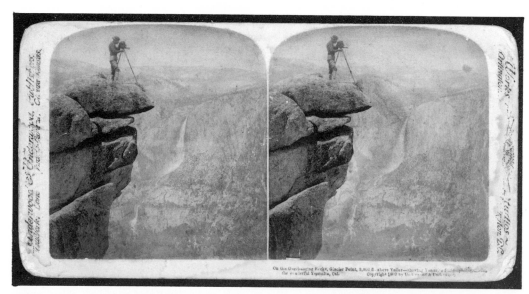

A

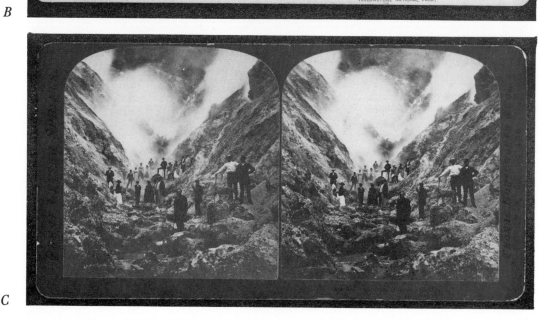

B

C

Hart, Alfred A. (1816-1869)—Of Sacramento, California. Hart photographed the expansion of the Central Pacific Railroad during the late 1860s in an official capacity. His earliest views of California and the Sierra Nevada Mountains bear the address of 135 J. Street, and later views list 65 J. Street. On Hart's death in 1869, Carleton E. Watkins purchased Hart's negatives, and later I. W. Taber acquired the Central Pacific Railroad views from Watkins.

Haynes, F. Jay (1853-1921)—In 1879 in Fargo, Dakota Territory, Haynes began a series of over 1,000 subjects titled *Catalogues of Stereoscopic Views.* Two years earlier he had experimented with photography in Moorhead, Minnesota. His series recorded views between Lake Superior and the Missouri River on the line of the Northern Pacific Railroad. Because this railroad had concessions in Yellowstone National Park, Haynes was designated as official photographer, and opened a studio there in 1884.

The next year Haynes had a special "Palace Studio Car" built from a Pullman, and operated it on the railroad for twenty years. He was a friend of William H. Jackson, and both were part-time artists who admired each other's work. The famous travelogue lecturer, John L. Stoddard, used Haynes' "Winter in Yellowstone" pictures in 1887. Photographers Laton Alton Huffman (Indians, Bad Land subjects) and E. W. Hunter (stagecoach parties, animal subjects) were trained by him.

Haynes' post in Yellowstone was taken over by his son, Jack Ellis Haynes, in 1916. F. Jay Haynes photographed Canada (1881); Indian portraits (1881); Montana (1880s); the Giant Geyser (1885); Old Faithful (1899); and Alaska (1890) among other subjects. Many of his pictures were made into engravings for *Harper's Weekly* and *Frank Leslie's Weekly.*

Houseworth, Thomas—The San Francisco firm of Lawrence and Houseworth (views dating to 1862) was succeeded by Thomas Houseworth & Company in 1867. Copyright numbers began to appear in 1864, and two years later the negatives reached over 1,000. In 1867 he won the highest award for landscape photography at the Paris International Exposition. As previously mentioned, many of these views may have been by Watkins, Weed, Hart, Muybridge, and others.

A. Photographing the wonderful Yosemite was sometimes a hazardous business.

B. Haynes, F. Jay. Camping on Yellowstone Lake, Yellowstone National Park.

C. T. Houseworth & Co. Witches' Cauldron, Sonoma County, California.

D. F. Jay Haynes, 1887 winter expedition of Yellowstone, from John L. Stoddard's Lectures, 1898.

D

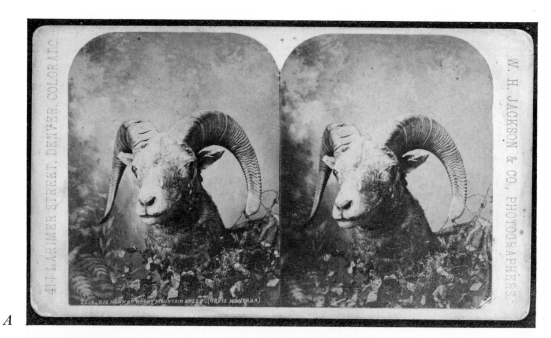

A

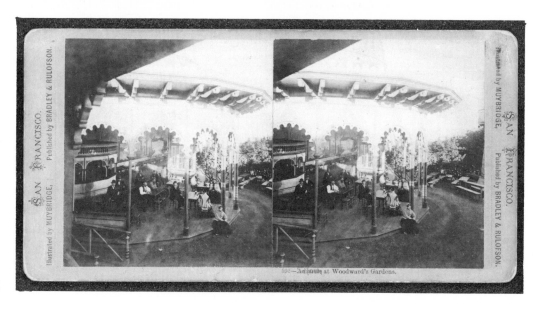

B

C

Huffman, Laton Alton (1854-1931)—A post photographer at Fort Keogh, Montana Territory, beginning in 1878, Huffmann later had a studio in Miles City, Montana. During the 1880s he photographed the praire, Bad Lands, soldiers, buffalo, Indians, and Yellowstone National Park (1883).

Jackson, William Henry (1843-1942)—Late in 1867, Jackson opened a portrait studio in Omaha with his brother Edward. The Jackson Brothers toured the territories in 1868 and recorded Indian tribes, then Edward returned to farming. The following year William produced a series of Union Pacific Railroad views, and late in 1869 he joined Dr. Ferdinand V. Hayden's survey of the territories. He packed 200 pounds of equipment on his mule "Hypo," and toured the Yellowstone area in 1871. On his return he closed his gallery in Omaha.

Because of his photographs, and the publishing of an album entitled *Yellowstone's Scenic Wonders,* in 1872 Yellowstone was declared the first national park. Soon he was photographing the Great Teton Range (1872); Mount of the Holy Cross in the Red Table Mountains of Colorado (1873); cliff dwellings of the Mesa Verde; and other views of the Rocky Mountain region for the Hayden Survey until 1878. One of his assistants was T. J. Hine of Chicago, whose majority of negatives were later destroyed in the Great Chicago Fire.

At the Centennial of 1876, Jackson constructed a model of Indian cliff dwellings, and in 1879 he opened a studio in Denver. J. F. Jarvis manufactured some of his stereograph negatives under a Washington, D. C. imprint, and Anthony published over 2,000 views with a Hayden Survey imprint. He also produced cabinet mounts, cartes de visite, postcards (beginning with his association with the Detroit Publishing Company in 1897), mammoth prints, and albums of views from Venezula, West Indies, and the Bahama Islands (1900–1905). His photographic career spanned over eighty-five years and he utilized every format imaginable to display his multiple talents.

Muybridge, Eadweard (1830-1904)—Born Edward Muggeridge in London, England, he migrated to America in 1851 and was a merchant until 1855. For the next decade he was an established California bookseller, and then in 1867 he opened his "Flying Studio." Signing his negatives *Helios* (referring to a sun god) the pseudonym was used on his stereographs to prevent plagiarism. He produced the first series of mammoth prints of Yosemite (1867) and the first guidebook for that park (20 photographs.)

Independent sales outlets for his work were eventually opened at San Francisco's Woodward's Gardens (1869–1872); Selleck's Cosmopolitan Gallery of Art (1867–1868); Nahl's Studio (1869–1873); and Bradley and Rulofson's (after 1873). A resume of his photographs of over 2,000 views was published in 1873 and titled, *A Catalogue of Photographic Views, Illustrating the Yosemite, Mammoth Trees, Geyser Springs, and Other Remarkable and Interesting Scenery of the Far West.*

A. *Jackson, W. H. Big Horn or Rocky Mountain Sheep, Oryis, Montana.*

B. *Jackson, W. H. Granite Rocks near Laramie Peak, Views of Rocky Mountain Scenery.*

C. *Muybridge, E. No. 595, Saloon at Woodward's Gardens, published by Bradley & Rulofson.*

A

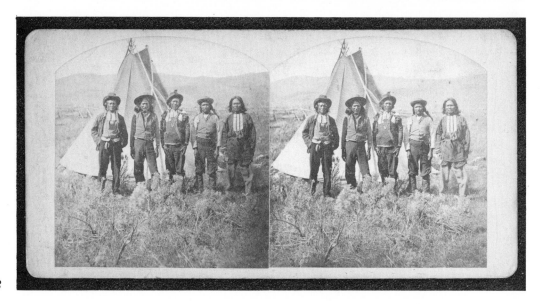

B

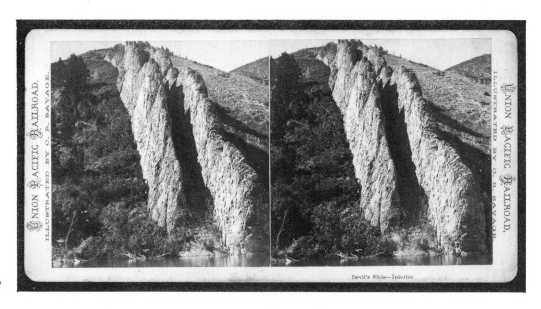

C

The numbering of this edition is not continuous because some negatives were bought by other publishers. For instance, the stereograph numbered 1377, "Tisayack, from Glacier Point," published by Bradley and Rulofson, was also produced by E. and H. T. Anthony as "Glories of Yosemite Valley."

Subjects included Yosemite Valley and Calaveras Grove of Mammoth Trees (25 views, 1867); Scenery of the Yosemite Valley (160 stereographs, 100 cabinets, 1868); Vancouver Island, and Alaska (1868); Lighthouse Board (70 views for Pacific Coast Series); Farallon Islands; Railroads (Central Pacific, Union Pacific, California Pacific); Geyser Springs; Woodward's Gardens (amusement park in San Francisco, outlet, 1869–1872); the Modoc War (50 views, Indian War in lava beds along Oregon Border, 1873); and Central America (1875). Perhaps Muybridge is best known as a pioneer in the field of motion pictures and for his experiments in locomotion photography.

O'Sullivan, Timothy (c. 1840-1882)—During the Civil War he was associated with Mathew Brady and Alexander Gardner as a photographer, and joined the Geological Exploration of the 40th Parallel in 1867. In 1870 he went to Panama with Commander Selfridge's Darien Expedition, and on his return joined the Wheeler Survey of the Arizona and New Mexico Territories (1873). He also photographed mine interiors, and many Indian tribes of the West.

Reilly, J. J.—Reilly started his photographic career at Niagara Falls, and moved to California about 1870. He is known mainly for his views of Yosemite and railroad scenes. His stereographs were offered in wholesale lots throughout the United States during the 1870s and 1880s. Reilly was associated with Hazeltine, Ormsby, and Spooner at various times in his career.

Russell, Andrew Joseph (1830-1902)—Russell was a photographer during the Civil War for General A. Haupt from 1861–1862, and later was known for his Western views of the building of the transcontinental railway, also those of the King Survey of 1860. Employed by the Union Pacific Railroad in 1868 through 1870, he produced over 500 negatives that were later copied.

Savage, Charles R. (1832-1909)—Originally from England, he settled in Salt Lake City, Utah, where he photographed the Mormons and scenery such as the Rocky Mountains. He also recorded portraits of the Utah and Shoshone Indian tribes and fine railroad views. Green mounts were used in the 1870s.

A. Russell, A. J. Colfax and Party at Echo City, Union Pacific Railroad Views.

B. Russell, A. J. Snake Chiefs, Union Pacific Railroad Views.

C. Savage, C. R. Devil's Slide interior, Union Pacific Railroad Series.

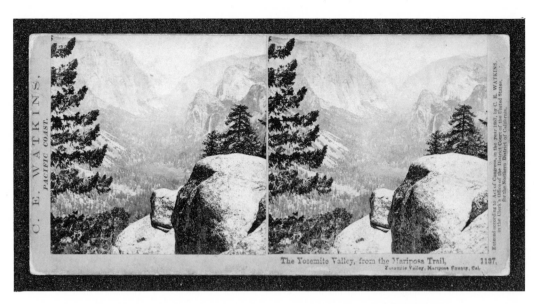

Watkins, C. E. The Yosemite Valley from the Mariposa Trail, 1867.

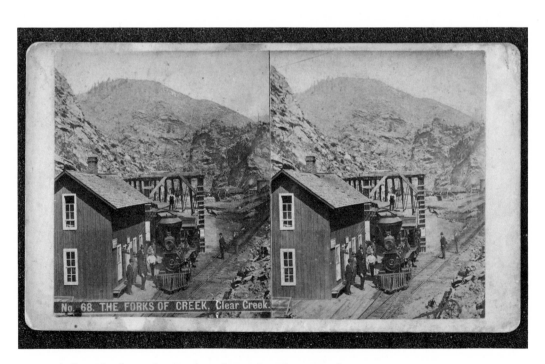

Weitfle, Charles. The Forks of Creek, Clear Creek.

Taber, I. W.—Operated a San Francisco portrait studio in the same building as Carleton Watkins, and in 1873 to 1874 began printing from Watkins' "Old Series" of negatives and some originally by Hart. Sixty to seventy of Watkins' negatives were imprinted with Taber's name only, but Watkins' negative numbers remained.

Watkins, Carleton E. (1829-1916)—The second photographer to visit Yosemite, he printed mammoth views of the area in 1861 and published portfolios in 1863. From 1864 to 1874 he numbered the negatives on approximately 2,000 stereographs, and from 1860 to 1866 he labeled some of his views in manuscript. Other views were of the San Francisco area, the 1876 Centennial, the Sierra Nevada Mountains, Arizona, Seattle, and the Farallon Islands. Eadweard Muybridge was instructed by Watkins, and they were in partnership for a short while. Watkins' earliest card mounts were of ivory stock.

Weed, Charles L.—In 1859, he was the first to photograph the Yosemite Valley and produced 40 stereographs of the area. They were sold by Robert H. Vance, his employer in San Francisco, and also copied by the Houseworth firm without credit given for the negatives. Eventually he bought Vance's studio, and resold it several years later. Anthony of New York City also obtained some of Weed's negatives. Watkins trained with Vance, and was a competitor of Weed in the early days of his career.

Weitfle, Charles (b. 1836)—Of Central City, Colorado, from 1878 through 1885, he produced documentary views of the development of mining towns in Colorado, Wyoming, and Utah. He was a German immigrant who opened a photograph studio in Washington, D. C. in 1860. By 1878 he was firmly established in the West, with a publishing operation in Denver and a branch office in Cheyenne, Wyoming. He is known to have acquired negatives from William Chamberlain, Ben Hawkins, and Charles Thurlow (after Thurlow's death.) In the early 1880s he moved his main studio from Central City to Denver. Most of his holdings were destroyed by a fire in his Denver studio in 1883.

Whitney, Joel E.—Of St. Paul, Minnesota, he supplied landscapes and wilderness subjects to the east. His cartes de visite of Minnesota scenery and local Indian tribes in the 1860s indicated his natural inclination toward documentary photography. Whitney's stereographs, in his series "Gems of Minnesota Scenery," are spectacular, as are the poignant view of settlers who had just escaped from an Indian attack. He also photographed the Sioux and Winnebago tribes.

BACK EAST

Documentary photography was also occuring in the major Eastern cities, as well as all over the country. The New York City studios of Edward Anthony (1818–1880) and his brother Henry T. Anthony (1814–1884) began experimenting with "instantaneous" stereographs in 1859 by the wet-plate process. Some of these views were taken right from the studio windows, with the bustle of street traffic and human franticism captured for all time. Mathew Brady (1823–1896) had the leading New York gallery and took twenty photographers with him to record the drama occurring not in the streets, but on the bloody battlefields of the Civil War.

Alexander Gardner (1821–1882) was one of those photographers, and broke away from Brady in 1863. He became official photographer to the Army of the Potomac, along with O'Sullivan and others. Bridging the gap between East and West, he was official photographer for the Union Pacific Railroad in 1867, and the next year he recorded government dealings with the Indians in Wyoming.

In 1862 the Anthony studios published a stereograph series of Brady negatives titled "The War for the Union," which by 1873 totaled over 900 views. The earlier mounts were of yellow stock, and later issues were mainly on the familiar Anthony orange mounts. Other photographers of note in the East were:

Barker, George—Fascinated with the effects of ice and snow, he photographed unusual formations at Niagara Falls, and, on the other hand, promoted the Sunny South in stereographs of Florida in the 1890s. His views of hunting parties in the 1880s showed his intense interest in the sport, and his views of the 1889 Johnstown Flood showed a sense of the dramatic.

Barnum, Delos—Of Boston. Barnum did an "American Historical" series of the city in 1859 on ivory mounts. He published over 2,000 views of Boston and other cities, as Niagara and Saratoga until about 1875.·

Bierstadt, Charles—Also photographed Niagara Falls, Southern scenes, Yosemite Valley (1873) and the Holy Land among others. Charles was in partnership with his brother, Edward, in New Bedford, Massachusetts from 1860 to 1866.

Kilburn Brothers—A prolific publisher of stereographs from Littleton, New Hampshire, he began issuing views of the White Mountains in 1865, and recorded all the popular sights of the country including Yosemite in 1871.

Moran, John (1832-1903)—Of Philadelphia. He was the brother of the noted artist, Thomas Moran. In the 1860s he photographed historical landmarks, the Sanitary Fair of 1863 in Philadelphia, and other areas in Pennsylvania. He is noted for his architectural studies, and also served on the Selfridge Expedition.

Soule, John P.—Produced a multitude of fine stereographs during the 1860s and 1870s, of his city of Boston and other cities in Massachusetts. Most of his images show an intense blackness and clarity that must have been envied by other contemporary photographers. There is evidence that some of his views of Niagara Falls and other areas were later pirated for use as "copy" series.

A. Anthony, E. No. 188, Broadway on a Rainy Day, Anthony's Instantaneous Views.

B. Bierstadt, Charles. No. 1214 Grisly Giant, Mariposa Grove, Yosmite Valley.

C. Moran, John. No. 201 Exchange, Philadelphia.

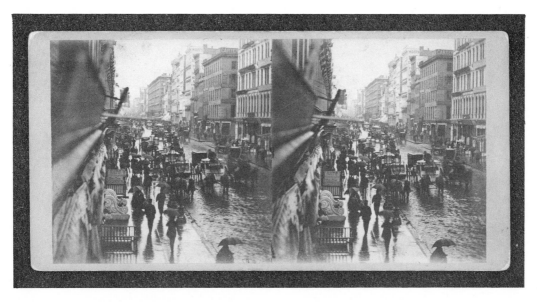

A

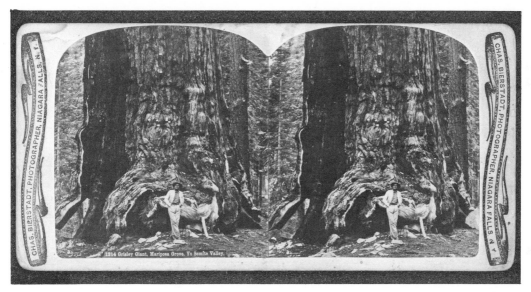

B

C

A

B

C

EXHIBITIONS

Views of exhibitions range from the Crystal Palace and Great Exhibition in London in 1851, to the Panama-Pacific Exhibition in San Francisco in 1915, and even a few after that. Thousands of views were taken of just the World's Columbian Exposition of 1893 in Chicago, but there are some stereographs of special interest. Those by William England of the International Exhibition of 1862 are some of the finest ever produced, particularly of exhibit displays. The London Stereoscopic Company sold over 300,000 of his views.

D

E

A. B. C. Soule, John P. Exterior and interior views of the Niagara Falls Suspension Bridge.

D. E. Exterior and interior views from the Centennial Exhibition of 1876.

William England of London and F. Charnaux of Switzerland have already been discussed for their quality contributions to the development of the stereograph, but others of equal notoriety were:

Bedford, Francis (1816-1894)—Of London. In 1862 traveled with the Prince of Wales to the Near East, and produced 175 views from the trip. He also had a photographic series titled *North Wales Illustrated and Devonshire Illustrated.*

Braun, Adolphe (1811-1877)—French photographer of the Alps and upper Rhine, he remained in Germany after 1871.

Brogi, G.—Of Florence, Italy, producer of local views from the 1860s through the 1880s.

Disderi, Andre Adolphe-Eugene (1819-1889)—French photographer noted for inventing the carte de visite format, and also produced stereographs in the 1860s and 1870s.

Fenton, Roger (1819-1869)—Of England, was the first wartime photographer in the Crimean War, and helped to found the Photographic Society of London. He also photographed sculpture studies and still lifes in the 1850s.

Frith, Francis (1822-1898)—English landscape photographer known particularly for his views of Great Britain, Europe, and the East. He scratched his name in the corner of his negatives. The publisher—Negretti and Zambra (mounts initialed NZ)—published over 100 of his Near East views.

Good, Frank M.—Known for his Eastern Series of about 250 titles. He specialized in framing subject matter by using architecture or unusual landscape formations.

Naya, C.—Of Venice, Italy. Naya photographed mainly architectural studies of the area in the 1860s and 1870s.

Ponti, Carlo—Also of Venice, published his own views as well as those of Naya in the 1870s and 1880s.

Wilson, George Washington (1823-1893)—Of Aberdeen, Scotland, was a wet-plate photographer known for his instantaneous images. By 1880 he boasted that he was the world's largest publisher of views. Sometimes his brief exposures were made by covering the camera lenses with his hat for an instant. Other scenes are of architectural interiors and artistic landscapes. Wilson used albumen paper toned with gold chloride, because he preferred the clearness and depth of field achieved. Queen Victoria was one of his clients. His prints are usually signed G. W. W.

A. Sommer & Behles. A Roman temple ruin, c. 1866.

B. Braun, A. View of a valley in Switzerland, c. 1862.

C. Frith, F. No. 491, Mosques and city walls, Views in Egypt, London Stereo-scopic Company.

A

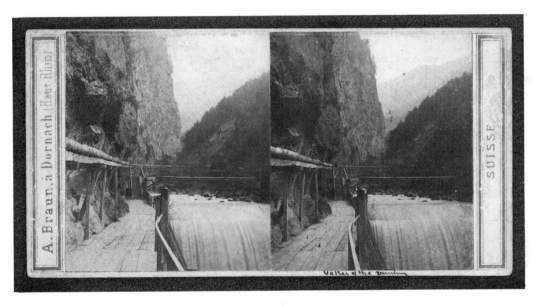

B

C

99

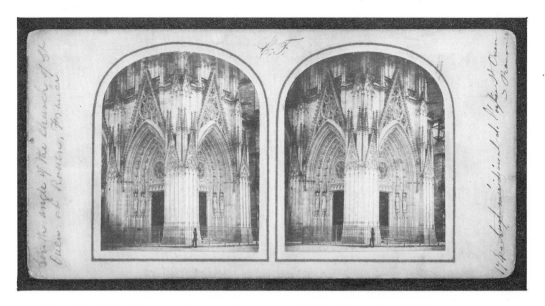

Church of St. Quen at Rouen, France, c. 1857. Photo by C. F.

Wilson, G. W. Melrose Abbey, The North Transept.

GENRE VIEWS

A genre view depicts scenes from everyday life, although what might seem ordinary to one individual may, in fact, be quite unusual by another's standards. The stereograph photographer had another option open to him other than documentary or scenic photography; he could use his imagination to create interesting staged subjects. By the late 1850s, scenes were being composed in studios to illustrate fairy tales (Lake Price's, *Robinson Crusoe and Friday*—1857); Hablot Knight's (Phiz); amusing version of Shakespeare's plays (1857); and sentimental views from life by J. Elliot (1856.)

The stereograph had become an entertainment medium rather than simply an instructional tool. People laughed at outlandish predicaments, such as the bulkiness of a woman's crinoline as she squeezed into a coach, or felt a kinship with a family struggling with a "temperance" problem. F. G. Weller of Littleton, New Hampshire, began publishing his views of a comic and sentimental nature in 1870, and his negatives were in constant production until the 1890s. Other genre publishers of note were E. & H. T. Anthony (Young Idea Series); Loescher & Petsch (Gems of German Life); and the London Stereoscopic Company (Caudle's Curtain Lectures.)

Victorian hobbies and tabletop arrangements also appeared on the double-framed mounts. The phantom "Skeleton Leaves" were actually the flowers and leaves of plants which had been soaked in chemicals to remove the soft particles. After the parts had dried, they were arranged in bouquets or memorial offerings. William England produced his "Beautiful in Death" skeletal arrangement in 1858; John P. Soule published a number of skeleton plant still lifes arranged by a Mrs. I. L. Rogers of Springfield, Massachusetts, in the 1870s. Many were in the form of memorials to presidents.

Actual skeletons in miniature appeared in "Diables Journey in Hell," a tableau series which first appeared as French transparencies. The tissues were produced from 1868 to 1874, but reprints were used on standard mounts for many years after. Other tabletop scenes utilized models of ships or scaled figurines.

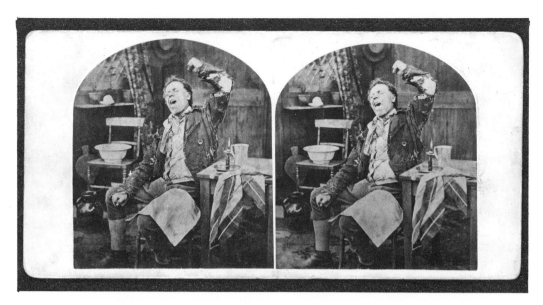

"Saturday Night," genre staged scene.

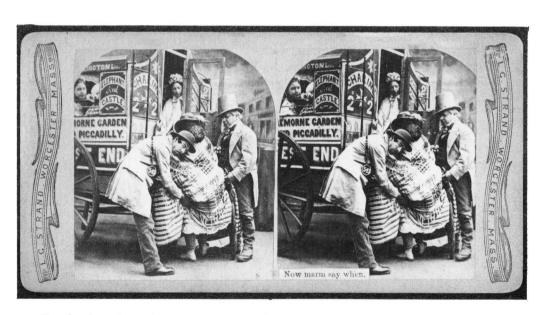

Comic situation, "Now marm, say when."

Lincoln memorial, dissected leaves. Anthony's Stereoscopic Views No. 4807.

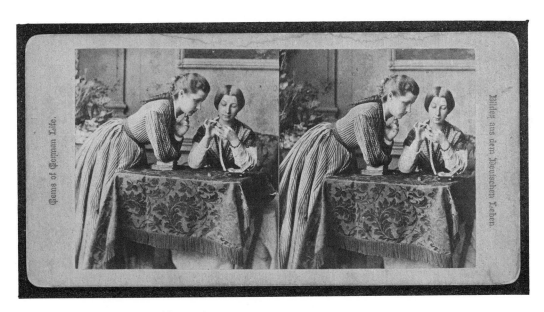

Gems of German Life Series.

PHOTOGRAPHICA

In an 1844 calotype by Hill and Adamson, Sir David Brewster observed that the ghostly image of a boy had remained after a brief exposure. Therefore, after he invented the lenticular stereoscope, he experimented with "transparent pictures," or spirit photography. This was accomplished by marking a spot in the staging for an individual, and then the person withdrew after a few seconds of exposure. William England, the Kilburn Brothers, F. G. Weller, and others experimented with this procedure.

Besides photographic techniques, this category includes any stereographs which depict a photographer or their studios. William Jackson, Eadweard Muybridge, and many amateur camera artists were photographed on the overhanging rocks at Glacier Point in Yosemite. Photographers also often appeared as white-jacketed models in landscape scenes, or their equipment, tents, and mule teams were pictured as evidence of hardship. Studio interiors or exteriors are of particular interest, especially if displays of photographs are visible.

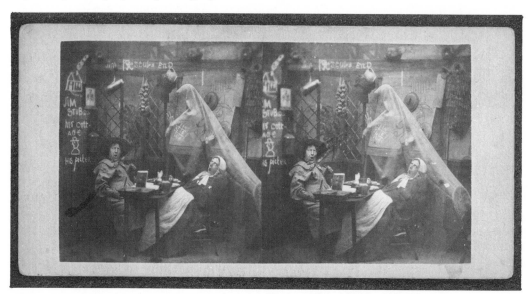

A

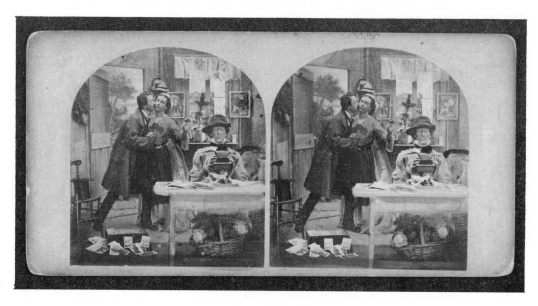

B

STATUARY

Statuary subjects are quite prevalent, ranging from exhibition arrangements to small town artists' endeavors. William England is known for his yellow-mounted stereographs of "Gems of Statuary by Eminent Sculptors," which frequently showed a statue reflected in a mirror. The celebrated "Rogers Groups" of the 1880s were published by several companies, and probably were an inexpensive method of acquiring one of the popular groupings. The erection and display of statues as war memorials, exhibitions, and cemetery monuments were also pictured in stereo photography.

C

A. Spirit photography. Unidentified mount, c. 1870.

B. Stereo viewer, "An optical delusion things seen and things not seen."
Note stereographs on floor.

C. England, W. Mirror image of Gems of Statuary.

D. The Wounded Soldier, John Rogers statuary grouping.

D

Many stereographs by Northern publishers depicting Negroes were offensive, either by passing off black-faced whites as Negroes or placing Negroes in outlandish situations. On the other hand, Southern photographers like J. A. Palmer of Aiken, South Carolina, and J. N. Wilson of Savannah, Georgia, showed a sensitivity in their portrayal of plantation workers and mill hands.

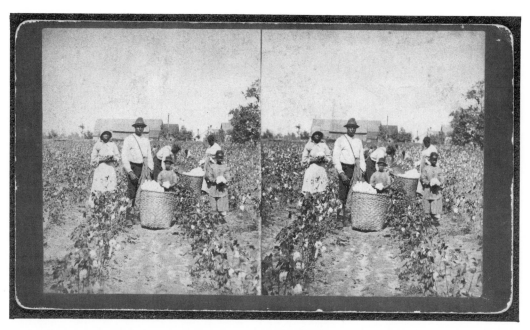

Wilson, J. N. Picking cotton, views of the South.

Turpentine distillery, Florida, America Illustrated Tropical Series.

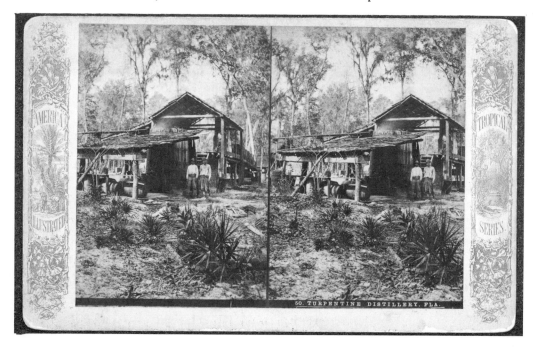

TECHNOLOGY

Stereographs were photographic records of man's technological advancements, from scientific explorations to mechanical inventions. L. M. Rutherford's close-up photographs of the full moon, in 1862, created a sensation that encouraged publishers to feature other planets, comets, and eclipse views.

Engineering feats such as the construction of bridges, launching of ships, building of railroads, drilling of tunnels, and mining of materials, all were recorded in stereo photography. Inventions—the telegraph, electric light, telephone, and even the camera—were also pictured during the various stages of development.

The photographing of caves produced a unique problem of how to find artificial sources of light. The first "magnesium" views were made in 1866 by Charles Waldack. Transportation advances chronoleged man's economic growth, from donkey carts to a car in every garage. The launching of balloons and the flight of dirigibles are of particular interest to collectors today, perhaps as evidence of how far man has come in technological improvements over the last one hundred years.

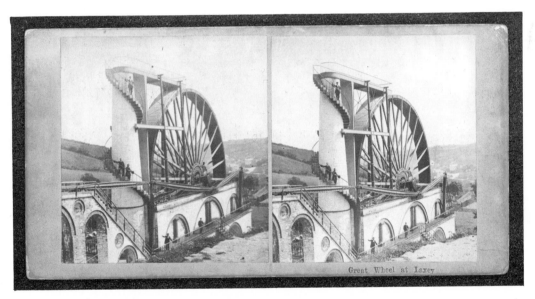

The Great Wheel at Laxey, Isle of Man. Known as Lady Isabella, the pump was built in 1854 to raise water from the mines.

Building of the Hoosac Tunnel, Hurd & Smith's Series. Notice photographer's wagon in top tunnel view.

WARS

The Crimean War was the first of a multitude of wars to be recorded either in actual battle scenes or in aftermath. It is believed that Roger Fenton of England photographed some of the Crimean soldiers, although no calotypes have been definitely identified. Stereographs of British troops have been dated to 1855, and the Austro-Italian War four years later was well documented by French and Italian photographers.

The American Civil War brought brutality into one's own parlor by way of the stereoscope, a haunting morbidity that continued through World War II with the display of body-strewn battlefields. Although Brady, through the likes of Gardner, O'Sullivan, and Barnard, produced a graphic record of the Civil War, it was unfortunate that the viewpoint was mainly of Northern scenes of action. Stereograph views of Confederate armies are rare, although scenes of destruction and eventual monuments are more common.

Other wars that were photographed were the Franco-Prussian War, Boer War, Macedonian War, Spanish-American War, Russo-Japanese War, and World Wars I and II. Minor skirmishes were also recorded, such as Eadweard Muybridge's 50-card set of the Modoc Indian War in 1872.

Remains from the Austro-Italian War, "Entrance to Magenta," showing marks of the balls on the buildings, c. 1859.

A

B

C

By the turn of the twentieth century stereo photography was a worldwide enterprise. Beginning in the late 1870s, door-to-door salesmen retailed stereographs, and soon publishers—the Kilburn Brothers, Underwood and Underwood, Keystone View Company, and H. C. White Company—followed suit.

B. W. Kilburn reorganized the family business in 1877, expanded their list of subject matter, and utilized new production methods. His experiments with the bromide-gelatin dry plate, from 1882 through 1894, produced stereographs lacking crispness; but after 1895 his views regained sharp detail.

Underwood & Underwood (brothers Elmer and Bert) began distribution in 1882 on a small scale, and by 1901 the company was producing 25,000 views a day. They became specialists in boxed travel sets, slip-case sets, and educational sets. Production was halted in 1920, but for the next few years the rights to use some of their negatives was given to the Keystone View Company.

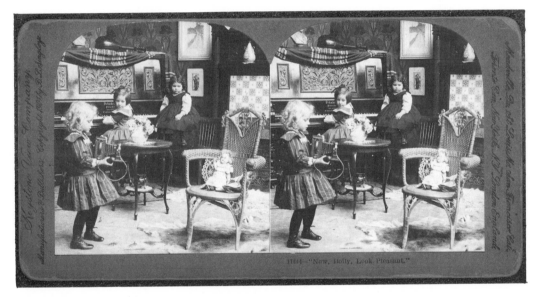

D

A. *No. 3049, View of Ft. Sumpter, showing a mingled mass of debris, shot, shell, and broken gun, War for the Union Series, E. & H. T. Anthony & Co.*

B. *Dead Confederate soldier in the trenches, reprint issue by The War Publication and Exhibition Co., Taylor & Huntington, c. 1880's.*

C. *Muybridge, E. Panorama of lava beds from Signal Station at Tule Lake Camp South, The Modoc War, c. 1872.*

D. *"Now, Dolly, look pleasant," Keystone View Company.*

Keystone was started in 1892 by B. L. Singley, and by 1940 over 40,000 titles had been offered. Singley took the educational possibilities of stereographs one step further with cards for different grade levels, teachers' manuals, and guide books to accompany the Keystone sets.

The H. C. White Company of Vermont, although a smaller concern, did produce quality stereographs beginning in 1899. Their "Perfec Stereographs" and "Aladdin Deluxe" series indicated the advantages of mechanized developing. Unfortunately mass production and the corresponding availability of "snapshot" cameras brought an end to the golden days of the stereograph. But historians and collectors are preserving the rich visual heritage of the stereograph, especially through organizations such as the National Stereoscopic Association.

Refining Oil Views of the Pennsylvania Oil Region, published by Frank Robbins, 1878.

O'Sullivan, T. Darien Expedition, No. 41, Head Waters of the Limon River, published by E. & H. T. Anthony & Co., c. 1871.

Hillers, J. K. Ku-Ra-Tu and Mu-Pates, Indians of the Colorado Valley, Powell Survey, 1874.

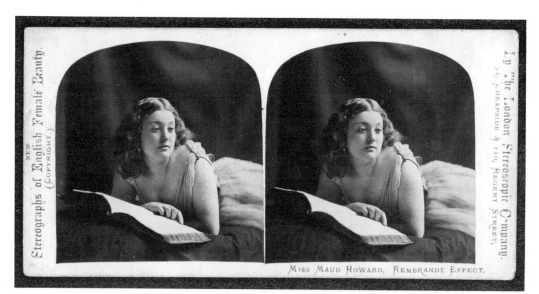

A

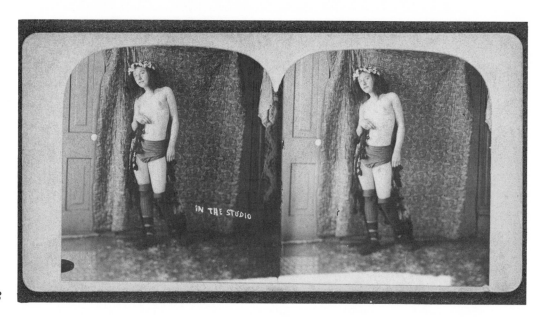

B

A. Rembrandt Effect. Miss Maud Howard, by The London Stereoscopic Company.

B. Risque sterographs were often privately produced such as "In the Studio".

C. Ice scene in Switzerland, interior of a glacier.

D. England, W. View of Switzerland, The Alpine Club imprint.

E. Charnaux, F. Tourists traveling over the snow.

C

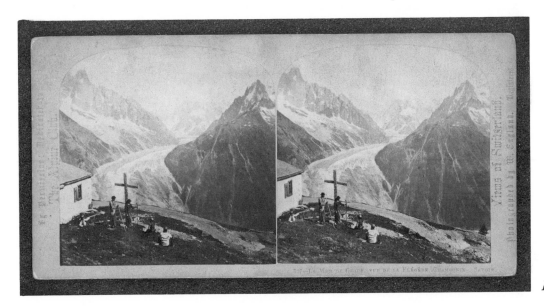

D

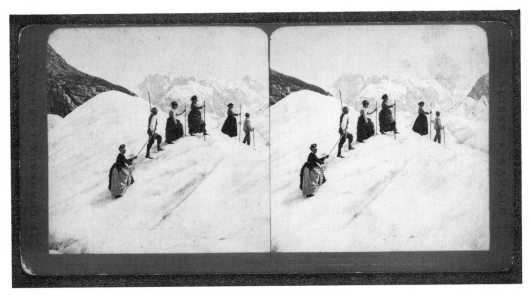

E

A

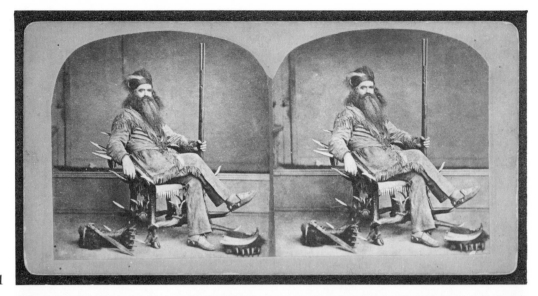

B

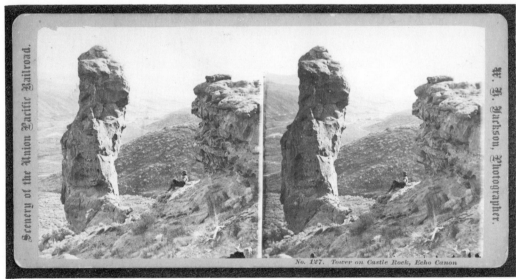

Scenery of the Union Pacific Railroad.

W. H. Jackson, Photographer.

No. 127. Tower on Castle Rock, Echo Canon

C

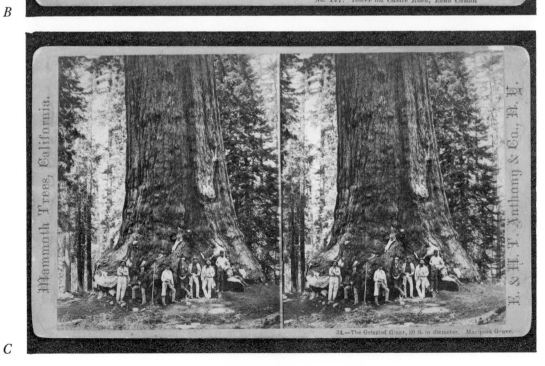

Mammoth Trees, California.

E. & H. T. Anthony & Co., N. Y.

34.—The Grizzled Giant, 90 ft. in diameter. Mariposa Grove.

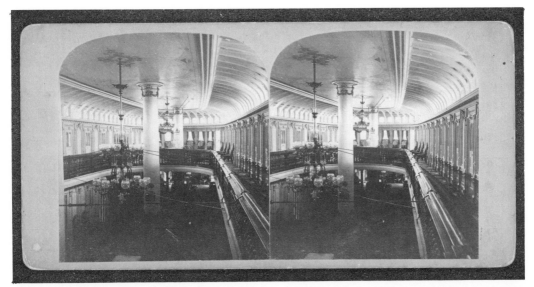

D

E

A. *Chair made of elkhorn, presented to President Lincoln. Reprint from Mathew Brady original.*

B. *Jackson, W. H. Tower on Castle Rock, Echo Canyon, scenery of the Union Pacific Railroad.*

C. *Anthony, E. & H. T., The Grizzled Giant, Mammoth Trees of California.*

D. *Interior of the steamer Bristol, The Saloon.*

E. *A balloon ascension in Dawson, Yukon Territory, 1900.*

Large studio camera and ornate paint-ed backdrop.

Postcard-seller, "I am spending by last penny for you."

CHAPTER V
The Postcard,
Pictures Through the Post

In an interview in *The Practical Photographer,* the British photographer Frank Sutcliffe stated, "Absolute failure, yes, that is what photographers, who try to make a living by making pictures, see staring them in the face at the beginning of the year 1897." Yet many photographers were just starting careers supplying negatives to picture postcard companies, or perhaps their negatives were turned over to view-card publishers to settle debts.

Unfortunately many of the fine photographers who had gained recognition with their cabinets, stereographs, or mammoth prints, did not think much of the new medium. As Sutcliffe was quoted in an 1892 article in *The Photographic News,* he pondered, "Why do people buy local views? Because they are offered such exquisite examples of photographic art? No. All the tourist wants is something to remind him of the places he visits." William Jackson of Colorado and Francis Frith of Riegate, England, were exceptions—they realized the opportunities that awaited them in both the publishing and photographing of the picture postcard.

Postcard display in the window of the Erie Phonograph Company.

At the same time that instantaneous photography had been perfected, the picture postcard appeared. Although the first pioneer postcard can be traced to an 1869 issue in Austria, photographs were not successfully reproduced onto card stock until almost twenty-five years later. Illustrations in the form of souvenir greetings were seen soon after the postcard was introduced in Europe; viewcards were published on a regular basis in Zurich, Switzerland, beginning in 1872.

Over twenty years later, in America, Hugh Chisholm was experimenting with processes that would reproduce a view onto a postcard, for he had traveled widely in Europe and realized that the picture postcard was not just a passing fancy. Chisholm pioneer cards were issued on government postals (PC7) and featured color multiview lithographs with phrases such as, "Greetings from Portland, Maine." The Chisholm Brothers had specialized in publishing photographic view albums and it was a natural progression into the view-card market.

Hugh C. Leighton was another publisher from the Portland area who produced pioneer view cards, and undoubtedly was a relative of the Chisholm Brothers for his middle initial stood for Chisholm. Both had their cards printed in Germany, as did many of the other contemporary publishing houses. In 1910 Leighton became an associate of Valentine and Sons of New York, and Dundee, Scotland.

After the opening of the Columbian Exposition in Chicago in 1893, the souvenir card gained in favor. The "Goldsmith" postals were determined as the official issue of the exposition, but several private publishers also issued views. Actual views from photographs, rather than artistic renderings, date to at least 1893 with an issue by Matthew Northrup of Buffalo.

Other publishers of city souvenirs, mainly of the multiview type, included the American Souvenir-Card Company of New York City (Patriographics); E. C. Kropp

Jackson, W.H. No. 115, Pulpit Terraces, Yellowstone National Park, Detroit Photographic Co., one-thousand series.

1533 — CHIEF BUCKSKIN CHARLEY. (UTE)

*No. 1533, Chief Buckskin
Charley, Ute, by E. H. Mitchell
from a retouched W. H. Jackson
negative.*

of Milwaukee; Arthur Livingston of New York City; and American Souvenir Company of Boston.

Beginning in approximately 1895 to the turn of the century the *"Gruss Aus"* continental card gained popularity in Europe, and the United States followed suit with multiple-view *"Greetings From"* souvenir cards. After the Postal Act of May 19th, 1898, the pioneer period ended and the private mailing-card era began. Privately printed cards had to be titled "Private Mailing Card" until December 24th, 1901, when "Post Card" replaced the title.

During this time backs had been reserved for the address only, making it necessary to leave a space on the front for a message. This was accomplished by offsetting a view or cropping a photograph into a "vignette." This procedure limited the development of the photographic postcard until the "divided" back appeared after March 1, 1907.

In Great Britain picture postcards did not arrive until September 1, 1894, when adhesive stamps were permitted on private cards. The extensive collecting of views began after February 1, 1897, when back messages were allowed. By the 1880s the publication of view cards in Euorpe had spread to several countries, with the greatest popularity obtained with the German *Gruss Aus* of the following decade.

DETROIT PUBLISHING COMPANY

The leading producer of United States picture postcards was the Detroit Publishing Company that secured the rights to the photochrom process from Switzerland in 1897. The first issue in 1898 of about 100 views carried backs with open cursive lettering of "Private Mailing Card." These colorful multiple views are unnumbered, but feature "The Photochrom Company, Detroit" in minute lettering which can be seen on careful scrutiny of the face of the card.

Souvenirs were available from Niagara Falls, California, New York, Colorado, and other tourist areas. The second issue of 1899 of 35 identified scenics displayed vignette views and hand-lettered titles. The back is the same as the first issue, but without identification as to the publisher.

The noted Western photographer, William Henry Jackson, joined the Detroit Photographic Company as a director and photographer in 1898. He brought with him many of his glass-plate negatives, particularly those dating from the 1870s when he was a photographer for the United States Geological Survey. Therefore some of the second series of vignette cards published by Detroit bear identifiable Jackson images.

In the Yellowstone Series, views included, "The Tetons, from Jackson's Lake," "Mammoth Hot Springs," and "Norris Geyser Basin—Yellowstone National Park." From 1899 to 1901 Detroit published a numbered one thousand series, with numbers reaching in the 500s. A card from this series, copyrighted in 1900 and identified as view number 115, was titled, "Pulpit Terraces, Yellowstone National Park." The vignette was taken from an 1871 plate of Jackson's previously titled "Mammoth Hot Springs, Gardiner's River." Since the postcard negatives were hand-colored it was a simple matter to slightly alter photographs, and Jackson himself enjoyed supervising the coloring of the lithographic plates.

For instance, card number 5121, "Castle Geyser, Yellowstone Park" (1906), is a retouched version of Jackson's "Hot Springs and Castle Geyser, Yellowstone." Other identifiable Jackson views include numbers 5614 and 6756 of the "Mount of the Holy Cross, Colorado."

Henry G. Peabody, an established photographer of Pasadena, California, was selected by Jackson to photograph outdoor scenery for the Detroit Publishing Company. Despite associations with the Soule Photo Company of Boston (marketed his view booklets of Yellowstone Park and the Canadian Rockies) and the photographer Alexander Hesler of Chicago, he was honored to be chosen by Jackson and accepted the job.

The Detroit Publishing Company went into receivership in 1924, when Jackson was 81, but a limited number of contracted issues were completed until 1932. There is some question as to the number of negatives left in Denver, the remainders from the W. H. Jackson Photographic and Publishing Company. The Library of Congress has retained 20,000 photos and 30,000 glass-plate negatives from the Detroit Publishing Company. The State Historical Society of Denver, Colorado, has a collection originating from the Edison Institute in Dearborn, Michigan, of 52,000 Jackson negatives, including 7,000 of Colorado scenery and 57 albums containing various sizes of prints from the Detroit Publishing Company.

Prior to entering the souvenir postcard business, for nearly a decade the Detroit Publishing Company had supplied photographs to other firms. Evidently this was when Edward H. Mitchell of San Francisco obtained negatives by William Henry Jackson and others to be eventually published under the Mitchell imprint. The Detroit one thousand series includes several numbered cards that have been matched with identical Mitchell backs as numbers 30 through 32.

Another explanation offered is that Mitchell may have bought sheets of cards from Detroit with the color lithography completed, and printed the backs with the Mitchell imprints. View cards were still in limited circulation at the turn of the century, and perhaps Detroit was not concerned about overlapping business territories with the West Coast Mitchell. Most of the cards involved are views of San Francisco, or Jackson's Indian portraits. The divided-back Mitchell card No. 1533, "Chief Buckskin Charley-Ute" is a retouched portrait by Jackson from a negative taken c. 1874. The top feather and intense coloring was added, obviously to disguise its use. Buckskin Charley also appears in an identical Detroit version numbered 5245, although a writing space is left on the front.

The question remains as to whether negatives such as this example were purchased directly from Jackson before his association with the Detroit firm, or were deliberately pirated. There are some deltiologists who claim that the Detroit titles under 100 were actually Mitchell views; but a purchase of a recent set of ten cards of Yellowstone vignettes contained three cards from the second series, and the rest had Detroit imprints from the one thousand series.

Possibly the Detroit Hawaiian views, with imprints of Wall, Nichols Company, Ltd., were distributed by Mitchell, since they were a known subsidiary. The Art Litho. Company was also a subsidiary of Mitchell, and associations were formed with M. Rieder of Los Angeles, the American Souvenir Company, and various smaller companies.

ROTOGRAPH COMPANY

During the golden age of the postcard, from 1905 to 1912, The Rotograph Company of New York City was one of the leading publishers of fine photographic views. They specialized in scenes and landmark views from the major Eastern cities, the printing being accomplished in Germany. Early cards in the black-and-white series show marked contrast, with vignette fading at the bottom on the front for writing short messages.

The first issues bear a large trademark of "Sol-Art-Prints" in ornate letters on the reverse. A unique numbering system consisted of capital letters, lower-case letters, and numbers. For instance:

"A" represented a black-and-white view.
"H" a hand-colored view.
"N" a night view.
"O" opalette real photograph.
"FA" a framed black-and-white view.
"FE" a framed machine-colored view.
"PA" a double folder of black-and-white views.
"XS" a real photograph.

Lower-case letters referred to subsequent printings, such as "a" for a second printing. Thus the popularity of a view can be determined by the number of printings, or an increase in the lower-case letter.

Although Rotograph specialized in souvenir views, they also published a few comic series on bromide paper such as those featuring sporting scenes, posed animals, and characterized portraits. Contracts were offered to other distributors, and anyone who supplied a quality photograph and an order of over 3,000 cards could become a supplier.

The Rotograph Company. A 186 a, 14th Street,
West from 3rd Avenue, New York City.

CURT TEICH & COMPANY, INC.

Founded in 1898, the Curt Teich & Company of Chicago is one of the oldest United States-based publishers of postcards. Early rotographed cards featured a slightly vignetted view with a writing space, and often unsightly objects were eliminated or retouched from the original photograph.

A customer could indicate colors to be added by submitting a tissue overlay with a photograph; colors were marked by a corresponding numbered color chart. The final proof of the card was then added to a "gang-run" sheet of several cards, allowing the publisher to reduce costs and printing time. The company's name or initials "CT" were printed somewhere on the card even when supplied to a wholesaler. The first ten issues featured pebbled stock, and are desirable collector's items.

ALBERTYPE COMPANY

Based in Brooklyn, New York, the Albertype Company produced a few series of pioneer view cards with the characteristic monotone black-over-green printing. The process was termed an "albertype," a forerunner of the photogravure method. Evidently the company specialized in publishing books of photographs, and postcards were produced only on a contract basis. A set of thirty-six black-and-white unofficial vignetted views were produced for the Pan-American Exposition, and official sets for the South Carolina Interstate Exposition, and others were to follow. Later many view-card series were hand-colored and supplied to small-town outlets larger publishers tended to ignore.

OTHER PUBLISHERS

By 1905 most jobbers and manufacturers of postcards had more work than they could handle, and local views were in the best-selling category. It seemed that every major business and even minor concerns plied their location or product by the use of postcards, from New York City Department Stores to the local small-town newstand. A selection of publishers indicates the diversity as J. A. Cochran's Big Store; the W. T. Ridgley Calendar Co.; the press of Frank N. Green; Lake George Souvenir Co.; and Mrs. Minnie E. Brooke of Chevy Chase.

Newspapers supplied series of cards as promotional devices, included either within the newspaper itself or in exchange for coupons. Such companies included Union News; Metropolitan News; Albany News; American News; Monterey News; Wolverine News; St. Louis News; and numerous others. Banks, insurance companies, railroads, restaurants, and other businesses also used the postcard as an advertising medium.

With the purchase of some postcard stock and a camera, any amateur photographer could join the fad. In 1903 the number 3A Folding Pocket Kodak camera was introduced which took a postcard-size photograph of 3¼ by 5½ inches. Prints could be made on cards with preprinted backs, and the age of the "snapshot" postcard began.

Edward Mitchell has already been mentioned as a major western supplier of souvenir view cards; but M. Reider of Los Angeles, and Charles Weidner of San Francisco, were equally prolific. Charles Weidner photographed his own views and then had his cards printed in Germany by a Lewis Glazer. Those cards using numbers before one hundred bear a partnership name of "Goeggel." Later this was dropped.

Weidner offered cards for the Panama-Pacific Exposition in association with The Albertype Company of Brooklyn. M. Reider was issued contracts for several series of color vignette views with the Mitchell firm, but sets, such as of the San Francisco earthquake of 1906, or of Indians, were also published independently.

Curiously few of the major photographers of the West, who had gained success through the stereograph and other mediums, had their photographs identified as postcard views. Perhaps the idea of mass production was a deterrent. Jackson was an exception because he was involved with the actual quality of the card's reproduction. Certainly stereographs were produced *en masse;* but many of the photographs marketed to postcard publishers were doctored, so that the postcard retained little semblance to the original photograph.

It is of interest to the deltiologist to determine whether or not some unidentified photographs by noted photographers did indeed wind up as postal displays, either intentionally or unintentionally. By such research the photographer finally receives credit for his original photo masterpieces.

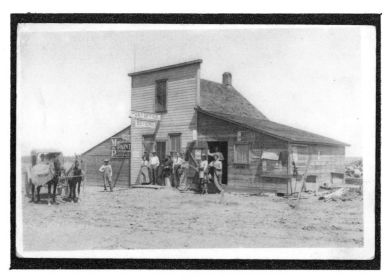

The Post Office and stage office in Boyero.

The negatives by the noted that may have been displayed in the postcard medium reads like a photographer's Who's Who. The frontier photographer L. Alton Huffman eventually had some of his Indian portraits reproduced as postcards, and it is probable that Asahel Curtis had access to some of his older brother's (Edward S. Curtis) negatives. Edward S. Curtis was a photo historian who had lived with the Indians and became the official photographer of the Harriman Expedition.

Asahel was a photographer for the Northern Pacific Railroad Company, and had his Yellowstone views published in color by Curt-Teich American Art in the 1920s and later. Darius Kinsey (1871–1945) recorded, by way of the camera, the Pacific Northwest loggers and various Indian tribes. Some of the Oregon view cards of loggers posed beside mammoth trees look suspiciously like Kinsey setups, although none have been firmly identified as such. A small foldout view set, with Kinsey vignette photographs, has been seen attached to a mechanical postcard.

The Utah photographer C. W. Carter had his views reproduced in souvenir booklets for publisher Frank S. Thayer of Denver, and it is possible that some of the Carter negatives were later used on Thayer's postcards of Western scenery. Perhaps Arnold Genthe's photographs of the San Francisco earthquake, or Thomas M. McKee's portrayal of the Mesa Verde and the Ute Indians, also appeared as postcards. To be correctly identified, it is only a question of cross-referencing by a determined deltiologist.

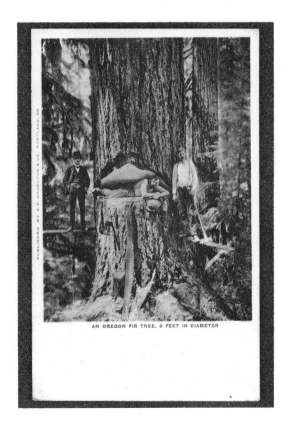

An Oregon fir tree, nine feet in diameter, with lumbermen posed in a style reminiscent of Darius Kinsey.

One Western photographer was proud to display his name on the lowly souvenir postcard. F. Jay Haynes continued to showcase his love for Yellowstone Park by receiving a concession for a photography studio there in 1884, and did not turn over his business interests to his son, Jack Ellis Haynes, until 1916. The 1900 catalog of Haynes' views lists sets of "Haynes Souvenir Postal Cards of Yellowstone National Park" for ten and fifteen cents.

Because Haynes was concerned with quality he could not find an American color-printer who met his standards, and for several early issues he sent his hand-colored photographs to Leipzig, Germany, to be printed by Lewis Glazer. The publisher E. C. Kropp of Milwaukee also reproduced some of Haynes' Yellowstone views on cards with undivided backs. An interesting sidelight to Haynes' character is that he saved the stock of all of his outdated views, and eventually offered them for resale as "nostalgia" when a new market was created.

His son, who preserved much of his father's photographic equipment in a museum in Bozeman, Montana, noted that about 90,000 color postcards of the obsolete Canyon Lodge and Canyon Hotel were stored for posterity. Imprints noted on Haynes' views included: Haynes-Photo (sepia-toned); J. E. Haynes (after 1916); and Haynes Studio Inc., Bozeman, Montana (Curteich-Colortones).

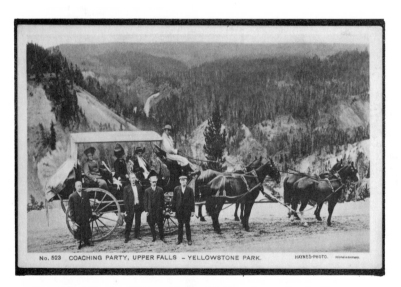

Coaching Party, Upper Falls, Yellowstone Park, Haynes photograph.

Recently the International Museum of photography at George Eastman House in Rochester, New York, listed a selection of French postcards as an aquisition. Cards by Dix and Furia, with love verses aimed at soldiers of World War I, colored by stencils, were thought worthy of retention. Correspondingly, collectors are gradually realizing that foreign photographic postcards are beautifully executed both in composition and technique.

Most of the 1905–1920 tinted cards of French, Belgian, German, and other European manufacture were bromide prints made on paper coated with an emulsion of silver bromide in gelatin. Even the "Real Photograph" cards by The Rotograph Company noted the fact on the cards' reverse that they were printed in England on "bromide paper." Unlike United States photographers and publishers, there was a tendency to sign one's name—by way of initials—to most of the view cards.

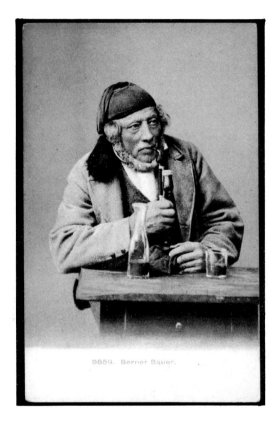

Excellent German portrait studies of Berner Baur and Berner Bauerin.

C-1. Cartes de visite album, c. 1860s.

C-3. The Album de Costumes des Pays-Bos held 12 carte-size tinted portraits of native costumes, published by A.Jager of Amsterdam.

C-2. Foldout leather-and silk cartes de visite pocket album; held 14 cartes.

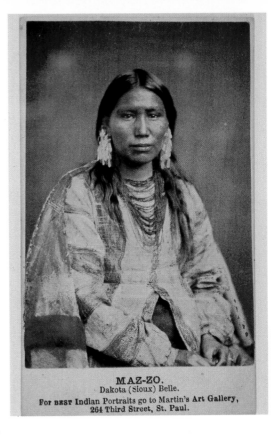

C-4. *Maz-zo, carte de visite of a Dakota Sioux Belle, by Martin's Art Gallery of St. Paul.*

C-8. *Tissue stereograph of stage beauty.*

C-5. *Genre cartes de visite, tinted art reproductions of paintings by G. G. Fish, published by J. P. Soule of Boston in the 1860s.*

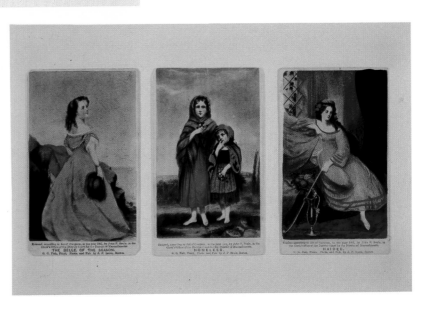

131

The following listing of some of the producers of quality photographic post-cards may be of assistance.

A. Blaschke—photographer of Zurich.

A. G. Steglitz—Berlin, associated with N. P. G. (Neue Photographische Gesellschaft.)

A. P.—A. Papeghin, Paris—Tours.

Bamforth & Co.—publishers, Holmfirth, England and New York.

Bx freres—Paris.

Dix—France.

Dr. Trenkler Co.—Leipzig and Coln, Germany, Italy, etc.

E. A. Schwerdtfeger & Co.—London.

Edition Photoglob Co.—Zurich (associated with Detroit Publishing Co.)

E. L. D.—E. Le Deley of Paris.

E. M.—E. Malcuit, photographer and publisher, Paris.

F. F.—F. Fleury of Paris.

F. Frith & Co. Ltd.—Reigate, England (Cox's Series, Frith's Series.)

Fototipa Thomas—Barcelona.

Francesco Pineider—publisher of Florence, Italy.

Furia—Paris.

J. Geiser—Algeria.

J. H. Schaefer—Amsterdam.

Judges LTD—Hastings, England.

L. L.—Levy Fils & Cie, Paris (L. Levitsky, photographer.)

Levy et Neurdein Reunis—Paris.

London Stereoscopic Company (LESCO.)

M. D.—Marcel Delboy, Bordeaux, France.

N. D.—Neurdein et Cie of Paris (published some of L. Levitsky's views.)

P. Gaude—photographer and publisher of Grenoble, Switzerland.

Raphael Tuck & Sons—England, Saxony.

Richter & Co.—Naples.

Rotograph Co.—England and New York.

Sazerac—photographer, France.

Stengel & Co.—Dresden, Germany.

Valentine & Sons—Great Britain, Canada, New York and Boston.

Verlag, Wehrli—Kilchberg, Zurich.

W. H. Ribelin—Hutsville, Ontario, Canada.

French postcard shop. Note displays.

Photomontage: "Thirsty Greet-
ings from Vienna," published
by Lederer & Popper of Germany.

C-6. Theatrical cabinet, by Reichard & Lindner of Berlin.

C-7. Woman by a window, cabinet by J. C. Schaarwachter of Berlin.

C-12. Newsboy of New York City lithoprint of Fanny Ward, 5 3/4" x 8 3/4" mount.

C-15. No. 5886 Taqui, A Moki Snake Priest, by Detroit Photographic Co. (W. H. Jackson negative); No. 5614, Mount of the Holy Cross, Colorado, by Detroit Publishing Co. (W. H. Jackson negative); No. 1540, A Group of Ute Indians, by Edward H. Mitchell.

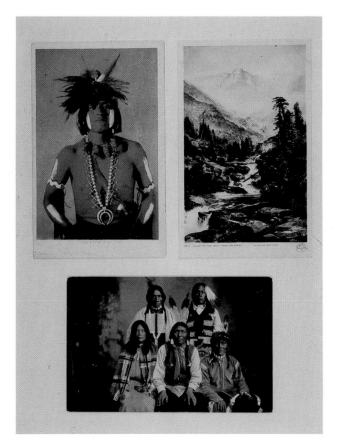

C-16b. "If this is me, I cannot see, how you can fail to love but me." by Furia (handcolored).
C-16a. "Kisses from France," by Furia (handcolored).

Live-model statuary study, "The Good Pal," published in Germany.

Art-photography, woman with horse, by N.P.G. of Germany.

Stereoscopic postcard, Nice, La Jetee, Vues Stereoscopiques, by Julien Damoy of France.

136

Peking, published by Hans Bahlke of Peking, c. 1911.

*Occupational: The Fisherman by
L'Hirondelle of Paris.*

C-13. Postcards: The Tetons, from Jackson's Lake, second series by Detroit Photographic Company (W. H. Jackson negative); No. 113 Fish Pot, Hot Spring, Yellowstone Lake, Thomas Moran fishing (W. H. Jackson negative) by Detroit Photographic Company; No. 10100, Oblong Geyser Crater, Yellowstone National al Park, Haynes-Photo.

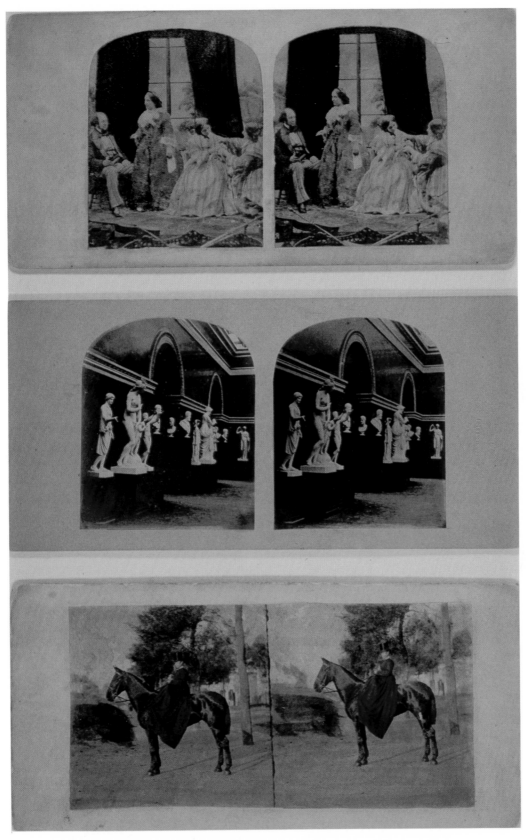

C-9. Stereographs: Colored salt print or calotype, c. 1856; Gallery of Greek Sculpture, c. 1858. London Stereoscopic Company; Horse and female rider, c. 1870.

The English firms of Bamforth & Co.; Francis Frith & Co.; The London Stereoscopic Company; Raphael Tuck & Son; and Valentine & Co., deserve special mention for their contribution of photographic views.

Raphael Tuck & Sons established outlets in Paris, Montreal, Berlin, and New York, and were mainly proponents of capturing the public's taste in art reproductions. By the 1880s the Tuck name had been firmly identified with the production of fine greeting cards, children's books, chromo-novelties, and oleograph prints. Beginning in 1898, Tuck issued postcards on a regular basis as sets of chromographic views. Their numbering system was sometimes sporadic and duplicated letter-number combinations, but over 100,000 designs have been recorded.

Early color work was accomplished in Bavaria, although some black-and-white printing was done in London. United States views included a Chicago Series, St. Louis Series, Hudson River Series, Heraldic Series, and hundreds of other points of interest.

Bamforth & Co., of Holmfirth, were producers of photographic comics and song sets. The use of painted backdrops was revived by Bamforth as stage settings to display his living models. Two to four cards in a set recorded, progressively, a song, a hymn, or a sentimental saying. Photomontage was used to highlight the dream of a sweetheart, or the vision of a departed soldier. Retouching might record a steadfast angel watching over a sleeping child. Whatever the technique, the Bamforth cards were designed to be tearjerkers.

Long-established firms in publishing paper-based products include James Valentine and Sons of Dundee, Scotland, and The London Stereoscopic Company. In 1895 Valentine applied the collotype process to the manufacture of picture postcards, which soon superseded his work in the production of pictorial stationery. The earliest series were on court-size cards and featured multiviews. By 1905 the firm employed over four hundred people who operated fifty machines in the production of postcards. The photographers Underwood and Underwood, of New York City, supplied many color views that were reprinted by Valentine, and distribution was also made in Boston.

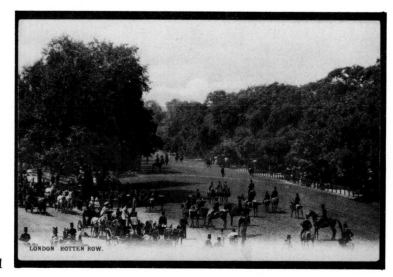

A

Another former supplier of stereographs, The London Stereoscopic Company, printed divided-back views of Great Britain under the "LESCO" series imprint. This company should not be confused with the London and Suburban Photographic Company which produced nearly 11,000 "real-photograph" postcards per hour by using a rotary press.

Francis Frith, previously mentioned for his contributions to photography, established his business at Reigate. During the 1870s he concentrated on compiling a collection of views of all the places of beauty in the British Isles. These were to be reproduced and offered to stationers as local views. The photographer Frank Sutcliffe was given a commission by Frith to take a series of views of Yorkshire abbeys and castles. Frith advised him not to include any "figures" in the landscapes or in architectural studies because he felt that the photograph could not sell if there were people in it. Frith said that, "It is the view itself they (the public) are willing to pay for, and is all they want."

Despite this advice, Sutcliffe decided that the inclusion of people did not spoil a photograph either pictorially or technically. The publisher F. Frith & Company survived until recent years, and produced fine sepia-toned and other picture postcards in series as "Cox's" and "Frith's."

A. London Stereoscopic Company, London, Rotten Row.

B. F. Frith & Co. Windsor Castle, Curfew Tower, sepia-toned.

B

C-10. Stereographs: Exterior view of Crystal Palace at Sydenham, interior view, and No. 4217, The Kauterskill Fall, near the Laurel House, by E. & H. T. Anthony & Company.

142

C-11. *"Sentinel Rock," Glories of the Yosemite Series, No. 71 "Niagara in Winter," by E. & H. T. Anthony & Co.; and No. 5714, "Devil's Brook, Cressom Creek," by E. & H. T. Anthony & Co., (all hand colored).*

Sometime during the 1880s, the publishing business founded by the photographer Francis Bedford was bought out by the Frith firm. Bedford had experimented with composite prints made by combining more than one negative to produce a final print. For instance, a negative of a cloudy sky was superimposed over a landscape and the negatives were pieced together into a homogeneous print. Albumen prints with the F. Frith and Company imprint have been attributed to Francis Bedford, who was just one of the major photographers to realize the advantages of combination negatives.

Hippolyte Bayard of France, Oscar Gustave Rejlander of England, William Notman of Canada, and Eadweard Muybridge of the United States also perfected the technique of combination or photomontage. The latter was accomplished by gluing portions of pictures on top of others and rephotographing the assemblage.

The photomontage technique was used extensively in the picture-postcard industry. About 1885, a Japanese photographer made a collage of over 1,700 photographs of the heads of children and reproduced them on a single print. This procedure was similar to the Victorian pastime of cutting out pictorial engravings from magazines and pasting them on a single sheet of paper.

Naturally postcard publishers realized the appeal of "trickery" as a buying gimmick, and photomontage easily adapted to comic situations. The tiny heads of babies appeared as flower buds, or in unlikely locations such as a knot in a tree. The heads of women were just as popular, particularly to form letters of names or greetings. View cards of a large metropolis became "visions of the future," with the addition of fantastic flying machines in the sky. Hitler was an easy target for photomontage pasteups; during the war his portrait appeared on postcards placed in many embarrassing situations.

Beginning in about 1905, the tall-tale or freak postcard gained favor with publishers. This also was a photomontage technique of combining two or more photographs rather than negatives. Perhaps the picture of a huge potato was cut out from a photograph and glued onto the print of a railroad boxcar, and then a final photograph was taken.

The trickery usually involved an exaggeration in size, and an understatement in the caption. For instance, the caption might read, "Rabbits are scarce here, only got one," and the photograph would show a rabbit as large as the hunter. The most common copyright date for these photo-cards is 1909, and the names of publishers frequently seen are those of William Martin of Kansas City; Archer King of Table Rock in Nebraska; Oscar Erickson (Photo Art Shop); Edward H. Mitchell of San Francisco; A. S. Johnson Jr.; and F. D. Conard of Garden City, Kansas.

Martin's photographs are among the finest, for he utilized action of his figures and correct scale for all his photomontage work. Subjects embraced oversized fruit, vegetables, fish, grasshoppers, and rabbits, in combination with flying machines and the new fangled automobile. Postcard publishers still use a similar *trompe l'oeil* technique to produce the mythical "Jackalope" (rabbit with antelope horns) and the "fur"-bearing trout.

Photomontage, "Utah's Biggest Crop."

Photomontage, "Hands Across the Sea," by Rotary Photo.

Photomontage, "A Unique Bungalow," 1909, by Martin Post Card Company.

Photomontage, advertisement for the Jefferson Glass Company.

STUDIO SNAPSHOTS

Amusement park and temporary studios offered snapshots that could be carried home as a prize. Backdrops of characterized individuals in bathing attire or Western duds had holes to poke one's head through and thus produced a comic memento of the day. Other postcards had photographs of heads added to a caricature and then rephotographed.

Multiphotography, which had been a popular studio attempt at trick photography, emerged again with the postcard. This unique process utilized two touching large-size mirrors, arranged at approximately a 75-degree angle to produce five reflections of the sitter. The customer posed with his back to the camera, and the reflected images revealed profiles and three-quarter positions. With the inner edges of two large-size mirrors touching, a full-length pose could be achieved.

Most of the *multigraph* postcards seen have a person seated at a table, frequently holding playing cards as if he were playing the game with four identical partners. In France, the technique was used for photographing criminals to obtain a number of different portraits with one exposure. Although this c. 1910s novel method was a common studio "come on," it is certainly a highly collectible photographic curiosity.

Studio poses, c. 1912.

Multiphotography or mirror photography, c. 1910.

Amusement park studio novelty, "Taking on Weight in Hot Springs."

FAMILY SNAPSHOTS

The Kodak camera brought about candid photographs that could be sent through the mail by way of postcard preprinted backs to family and friends all over the world. The cyanotype, recognized by its intense blue coloring, was also used by amateurs to produce postcards. Discovered in 1842 by Sir John Herschel, the process was achieved by placing a prepared blueprint paper in contact with a negative, and then exposing it to light. The print was then washed with water to fix the image. This procedure was inexpensive and simple, and thus appealed to those who showed a temporary interest in photography.

Although examples are generally amateurish, they are of interest as a novelty. Family portraits and snapshot postcards of common events dating from the early part of this century are often ignored by collectors, but they are sure to be recognized one day as "capsule" photographs of a way of life.

Reversed negatives, Kodak 2½ inch diameter images.

TYPES COLLECTED

Real photographic postcards can be divided into obvious categories such as animals, main streets, western scenes, transportation, photomontage, greetings, personalities, and occupationals. It is difficult to place a price tag on such cards, because often the intrinsic value lies in the "eye of the beholder." A collector of views from a certain city may be willing to pay a much higher price for an obsolete street scene than one who simply collects main streets.

Artist-signed greetings have long been the favorite of deltiologists, but within the last few years there has been a noticeable increase in the demand for photographic view cards. Whatever one's interest, condition and clarity are indicators of the best buys in the market.

If photography is a hobby, it is very rewarding to experiment with copying and enlarging these postcards; unnoticed details, such as a sign or a person's clothing, may aid in identifying an unmarked card.

A novelty during World War I was to photograph thousands of sailors or soldiers in arrangements, as a flag.

Horse-drawn fire engine, Niagara Company No. 2.

VIGNETTING

The vignette was a photographic procedure used mainly on early issues of view postcards to eliminate details at the edge of the card and leave more space to write a short message. After the postal regulations of March 1, 1907, were passed, a written message was allowed on the back of a card; this eliminated the need for vignetting.

The process was accomplished by preventing light from falling on certain portions of the printing paper. A mask, such as an oval, was cut out and briefly held between the printing paper and the lens of the enlarger. A slight jiggling of the mask caused diffusion and a softer edge to the print. "Burning in" was an opposite procedure of fading the background into black instead of white, and "dodging" involved holding back a certain amount of light from a specified local area so that it would print lighter.

Advertising: Home Economy
Oil-Gas Burner.

Bamforth & Co. Second in the
series, "The Vacant Chair."

151

Independence of Mexico celebration, 1910.

A

A. *Calendar for 1909, with Art Nouveau decorations, by Rotary Photo.*

B. *Occupational: Thomas Gerber, "The reasonable price carpenter and builder."*

C. *Bobby Leach and his barrel after his perilous trip over Niagara Falls, July 25, 1911.*

D. *Oscar E. Nulf and his outfit.*

B

BOBBY LEACH and his Barrel after his perilous trip over Niagara Falls, July 25th, 1911
(Copyright 1911, U.S.A. & CANADA, by Bobby Leach.)

C

D

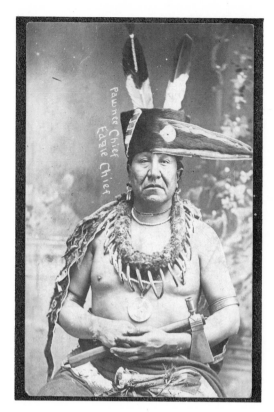

Pawnee chief, Eagle.

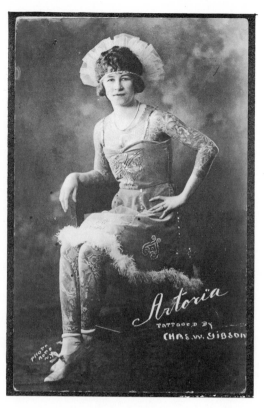

Artoria the tattooed lady.

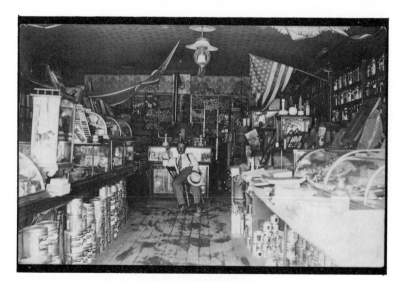

Interior of general store, c. 1908.

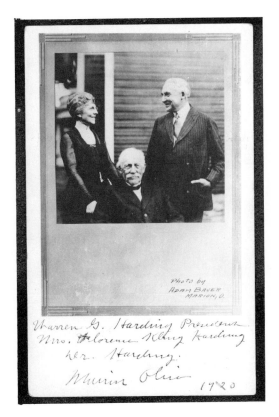

President Warren G. Harding
with his parents, Marion, Ohio,
1920.

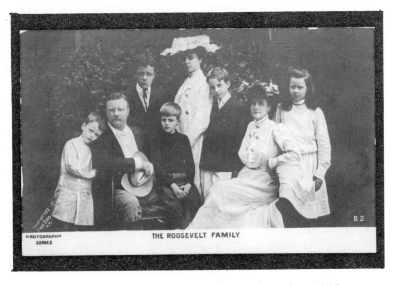

The Roosevelt Family, Rotograph Series, 1903.

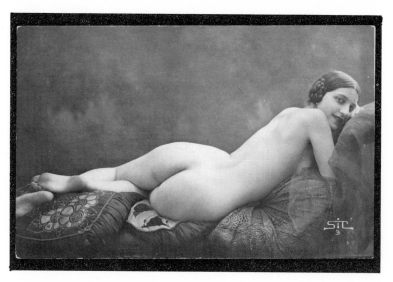

Nude study, by Sic of France.

Photomontage, female study by N. P. G. of Germany, tinted.

Lightning photograph, c. 1910.

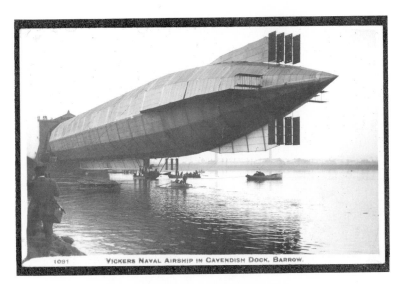

Vickers Naval Airship in Cavendish Dock, Barrow.

A

B

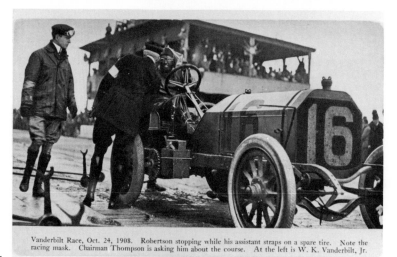

Vanderbilt Race, Oct. 24, 1908. Robertson stopping while his assistant straps on a spare tire. Note the racing mask. Chairman Thompson is asking him about the course. At the left is W. K. Vanderbilt, Jr.

C

A. *Transportation, day line steamer Washington Irving, 1913.*

B. *Closeups of locomotives, like this 1917 Engine. No. 28, command a premium.*

C. *Vanderbilt Race, October 24, 1908.*

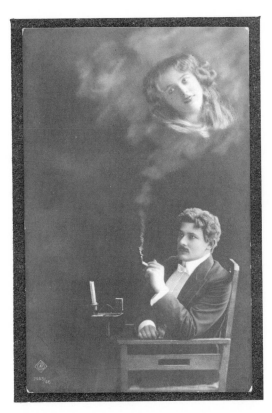

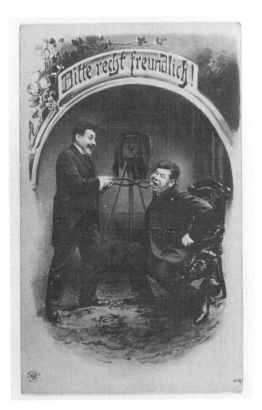

Photomontage - Woman within the smoke of a cigarette.

Photographica, "Bitte recht freunlich!" (smile).

Baiser d'Amour, by Neo-Phot of Paris, France.

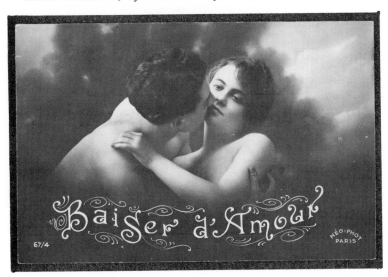

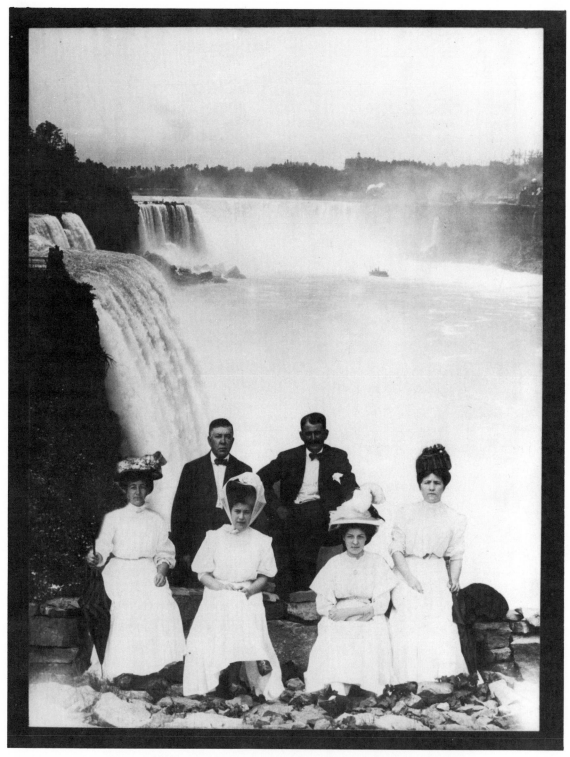

Tourist grouping, superimposed over backdrop view of Niagara Falls.

CHAPTER VI
The Remainders,
Reminders of People
and Places

The most popular sizes of card photographs have been discussed in previous chapters, but there were hundreds of other sizes of photographic prints ranging from a minette novelty to mammoth views. The carte de visite photograph was often left as a remembrance when calling at someone's home; but there were also actual photo visiting cards available for a nominal investment.

A carte or cabinet portrait was sent to a calling-card company, the photograph was reduced, duplicated, and fastened to individual name cards, then returned to the customer. Most sold for fifty cents for a dozen cards. But special orders, such as those with emblems of societies, were slightly more expensive. Occasionally one might find a business card with a photo attachment of a place of business dating from the 1870s or 1880s, but these are more uncommon than the visiting card portraits.

A card of 1½ by 3 inches used during the 1860s, was found that pictured an oval photograph of Harmony Mill in Cohoes, New York. The novelty had been supplied by "Crane's Dental and Photograph Parlors" in Cohoes. It is no wonder that some clients of the late nineteenth century assumed that having a photograph taken was an unpleasant experience.

*A unique business combination, a dental
and a photograph parlor, c. 1860's.*

161

A. Miniature. Child, local scene on painted backdrop.

B. C. Photographic visiting cards, c. 1880s.

D. E. Minnettes or gem photographs.

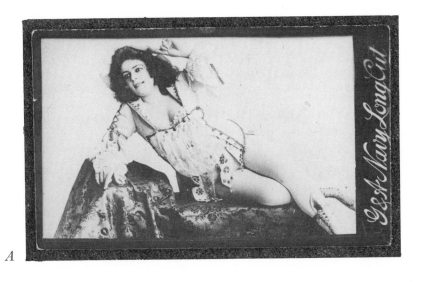

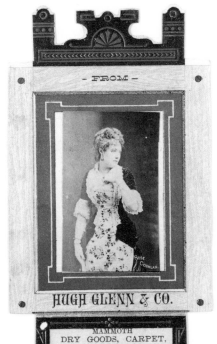

A

B

C

D

A. *Tobacco card, risque study, G. & A. Navy Long Cut.*

B. *Trade card, Rose Coghlan in theatrical pose.*

C. D. *Miniature tobacco cards. C., Col. Cody; D., Lyla Cavenaugh.*

MINIATURES

Normal items reduced to miniature size have always held a certain fascination, and once photographers discovered how to reduce prints the possibilities were endless. Actually the idea probably developed from the carte de visite multiple images. First, four photographs could appear on a single print, then eight, and so on.

Miniature items could be produced cheaply, but they did not achieve extreme popularity because there were no albums to display a collection. Ferrotype albums appeared in miniature form in the 1860s, but the card photograph was too thick to be trimmed for such use. It was difficult enough to fit cartes de visite into their relegated album slots.

A c. 1870 photographer from Troy, Ohio, offered 1½ by 2½ inch photographs, mounted on yellow stock, at fifty cents for a dozen. The portrait of a small girl leaning on a balustrade featured a painted backdrop of a local waterfall view. "Minettes" appeared to be miniature cabinet photographs and developed contemporarily with the cabinet. Of only 1¼ by 2 inches in size, the minette pictured portraits or views, and usually listed a photographic supplier on the reverse.

Some photographers preferred other names for prints of this size, such as "So-Kute" photos available for twenty-five cents a dozen. The advertisement further stated, "How to get them: Send any ordinary photo, well wrapped, with twenty-five cents and three one-cent stamps. As soon as finished, I will return original photo unharmed, with twelve So-Kute photo copies, same size as this, postpaid to any part of the world. Groups same price, E. A. House, Gadsden, Alabama."

TOBACCO AND TRADE CARDS

Because of their similar size, sometimes cigarette-card photographs of the late nineteenth century are misclassified as cartes de visite, but they certainly were not used for visiting purposes. If a gentleman left a tobacco card in a calling-card tray he might never be welcomed again!

Noted personalities of the day were popularly depicted on cigarette and tobacco cards ranging in size 1½ by 2¾ inches to 2½ by 4 inches. Actresses were the most common subject, for their scanty costumes and risque poses attracted purchases of male-oriented products.

It is doubtful that the personalities received any renumeration for these photographs; they were probably copied from cabinets and cartes de visite which had already been mass-produced. In the smaller size there were brands like Sweet Caporal, W. Duke Sons & Co., and Admiral Cigarettes; larger sizes included Sweet Lavender, G. & A. Navy Long Cut, and Lorillard's Climax Plug.

The actual photographs were simply paper prints attached to a cardboard backing. In 1885 a small slide-cigarette box was introduced by the firm of Allen & Ginter of Richmond, and a picture card was inserted into each box. The fad caught on, both for cigarettes and insert premiums, and by the next decade nearly every tobacco manufacturer had entered the market.

Besides eight different series of stage personalities, Allen & Ginter enclosed photo cards of dogs, race horses, views, presidents, ships, cigarette-making girls, girl baseball players, and girl cyclists. Obviously a series with "girl" in the title appealed to the male audience. Duke Sons & Company was probably the largest producers of such cards with photograph series labeled Photos from Life, Living Pictures, Spanish-War Leaders, and Sunny South Series.

Lorillard supplied postcard-size inserts that sometimes featured ten portraits of actresses on a single card. Generally collectors prefer cards which are identified as to the picture and brand; higher prices are obtained for the larger cabinet size and unusual subject matter. Cigarette cards were popularly collected both in this country and in England in the 1930s and 1940s, with guide books issued and clubs formed. Dealers in paper antiques today are noting an upsurge in interest for quality tobacco inserts, particularly for sports-related topics and identified stage personalities.

A few tradecard series were published brandishing photographs, but evidently they were not as desirable as the colorful chromolithographed product and business cards. One example, die-cut to the shape of an artist's easel, had a photo portrait of the actress Rose Coghlan fastened to the center of the card. Although the photograph was identical to the small actress-type of cigarette inserts, in this case the portrait was encouraging sales to a "Dry Goods, Carpet, and Stationery House" in Utica, New York.

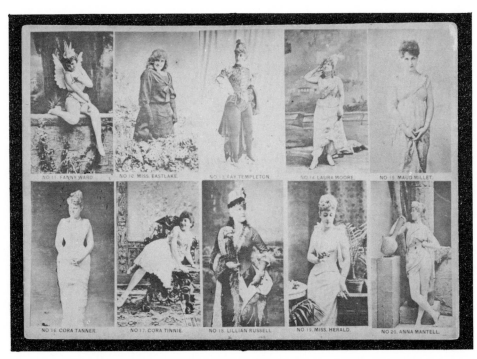

Tobacco card of stage personalities, 3 by 5 inches, published by Lorillard tobacco.

Another card seen was about the size of a postcard, on purple paper stock, and featured an advertisement for "Fine Boots and Shoes" on its reverse. The front displayed a 2 by 3 inch photograph of the ruins of the Alliance, Ohio, opera house. The approximate date of the card could be discovered by uncovering the date of the tragic fire. Such a card may be of historical importance and "one of a kind."

Other trade cards of interest to collectors are those picturing old cameras, or advertisements for photographic galleries. The Lion Coffee Company produced a set of colorful die-cut trade inserts which, when assembled, became a dollhouse-size photography studio complete with a customer. It seems rather ironic that some photographers sought the aid of the lithographer for advertising purposes, although the trade card would be viewed again and again in a child's scrapbook.

KODAK PRINTS

One of the most famous advertising slogans of all time, "You push the button, we do the rest," was based on a revolutionary camera invented by George Eastman in 1888. During the early 1880s, Eastman was perfecting his so-called "American Film," a suitable camera, and a printing service. If supplied with a customer's negatives, he offered silver-print or bromide-paper enlargements ranging in size from a 10 by 12 inch print up to a 30 by 40 inch print. He combined all his innovations into a small box of only 6½ by 3¼ by 3¾ inches and labeled it the "Kodak" camera. The dry-gelatin process had considerably simplified matters for using a plate camera; but the Kodak camera was aimed at attracting the amateur market rather than the professional artist. One had only to:

Point the camera,
Press the button,
Turn the key,
Pull the cord.

Few collectors other than photo historians have realized the importance of the Kodak No. 1 circular images of 2½ inches in diameter. It was the first time that a camera responded instantaneously to an occurence. Planning was out of the question, because there was no aiming device other than an arrowhead stamped on the leather case for the camera. The meniscus lenses made a photograph that was sharp only in the center, so Eastman masked-off the edges in the camera and thus produced a circular print. The composition of the photograph was generally off-centered or not considered at all, but this lack of professionalism brought about a needed freshness to the medium.

The unique barrel shutter of the first models of the Kodak were set for the speed of approximately 1/20 second. The camera was purchased with a load of film for one hundred exposures and a notebook to keep a memorandum of each negative. There was no film counter, so the notebook also recorded how much film was left to be exposed. Specimens and directions for filling out the blanks referred to facts such as "Brilliant instantaneous pictures can be made only in clear sunlight; they cannot be made at all in cloudy weather."

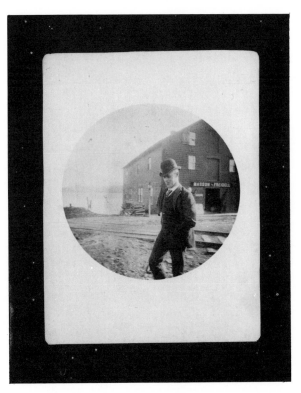

Kodak No. 1 2½ inch diameter image.

Early Kodak reverse, The Eastman Company, Rochester, New York.

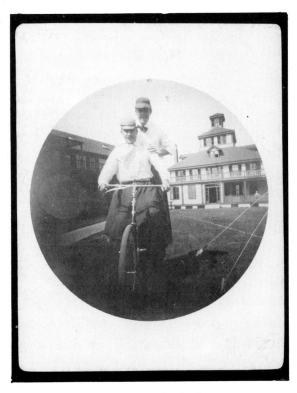

Kodak No. 2, 3½ inch diameter image, taken c. 1896.

When the last exposure was taken, and the film-winding key would not turn, the photographer had several alternatives. For a fee of $10.00 he could mail the camera (containing film) to the Eastman Dry Plate and Film Company in Rochester, New York, for processing. The photographs, mounted on white or chocolate frames, would be returned to the customer and a new film placed in the camera.

The more professional procedure was to remove the film in a darkroom and send it alone to the Eastman Company, or do the complete processing oneself. The Kodak mounts were 4 1/8 by 5 1/8 inches with rounded corners, gilt edges, and a floral-design back that featured a small advertisement for the Kodak camera.

In 1889 the Kodak No. 2 camera was released. It was a slightly larger version and produced a 3½ inch diameter image. This model took only 60 exposures, but the chocolate mount and decorative Kodak reverse was retained. It should be noted that the success of the first Kodak camera surprised George Eastman himself despite his claims of simplicity. In a letter on July 15, 1888, he shyly admitted, "The Kodak is a great success among the professional photogs. I hardly thought they would take hold of it so quickly..." By the next year the staff at the company was handling the contents from 60 to 75 cameras, or 6,000 to 7,000 negatives a day.

In 1891 Eastman simplified the process further by manufacturing a camera using film that could be loaded in daylight because of the protection of an opaque paper leader. This system was perfected by Frank A. Brownell, and the Kodak camera known as the "Brownie" was nicknamed after the inventor. Subsequent Kodak images, after the No. 1 and No. 2 models, were square or rectangular. Early examples from the 1890s generally have chocolate mounts and Kodak backs.

Velox print showing the size and quality of negative made with the No. 1A Speed Kodak, Eastman Kodak Company. (2 3/8 by 4 1/8 inch image.)

During the popularity of the stereoscope there were instruments patented that could be used to view stereographs as well as single-image photographs. Known as stereo-graphoscopes, directions instructed owners to reverse the lenses, and then "shut the sliding picture-holder up as far as it will go, hold the picture in the hand and move to the right or left, up or down, to get the proper focus."

Some models featured an upper lens for viewing photographs, engravings, or other single views, and a lower lens for stereograph views. Simple graphoscopes were also available, with lenses approximately 4½ inches in diameter and a sliding tele-scope movement. Cabinet-size stereoscopic mounts were utilized for single-image graphoscopic views, and examples have been noted by Francis Bedford, Laton A. Huffman, and numerous others. Additional sizes of graphoscopic views listed in the Ward's 1894 catalog were 8 by 10 inch mounts of World's Fair Photographic Views, 18 by 22 inch views of the World's Fair, and 10 by 12 inch scenes of Chicago's environs.

As mentioned in the first chapter, numerous sizes of mounted images were available to studio customers—Victoria, Promenade, Boudoir, Imperial, and Panel. Generally the larger the size, the more expensive the purchase. Mounts could also be ordered from stationery houses or catalogs for the photo hobbyist on which to paste his finished prints.

"A good picture is worthy of a good mount," proclaimed the Montgomery Ward Catalog for 1894, therefore higher prices were asked for heavier stock, gold trim, and fancy colors. The edges could be ordered either flat, beveled, serrated, or crenate (scalloped). Naturally one requested mount sizes according to the size of print obtained, but amateurs frequently mounted images on leftover stock.

Huffman, L.A. Graphoscope view of Fort Keogh, Montana, where Huffman had a workshop in 1878.

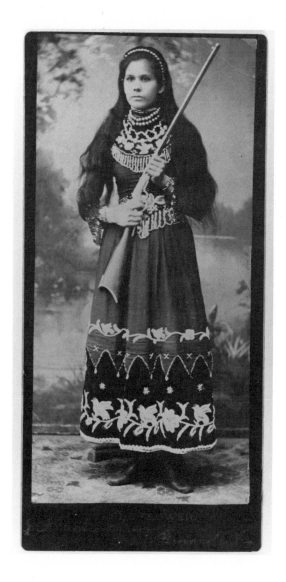

*Prarie Flower, with rifle,
imperial portrait.*

*Supposedly this is a view of
natives of the Philippines, boudoir
size.*

Artistic pose with soft focusing,
c. 1902.

The boudoir and imperial size of mount was introduced in the latter decades of the nineteenth century as a means to capture a larger format. The boudoir, of 5¼ by 8½ inch mounted board, was often used for scenic views such as F. J. Haynes tourist attractions in Yellowstone, or W. H. Jackson's mining towns of Colorado. On the reverse of a Haynes mount he advertised, "Boudoir views of Northern Pacific, Yellowstone Park, Pacific Coast, and Alaska. Catalogue free. F. Jay Haynes, official photographer, N. P. R. R., 392 Jackson Street, St. Paul, Minnesota."

The imperial mount, measuring 6 7/8 by 9 7/8 inches, lent itself to photo painting. Contemporary accounts describe the imperial as embellished portraits, with less time taken in posing by the photographer and a cheaper quality of workmanship. Because of the size, full-length poses could be amply displayed, and the studio's resident artist had a larger "canvas" on which to display his talents. The majority of small-town photographic galleries at the turn of the twentieth century were still enamored with the idea that art work had to be intertwined with the photo-mechanical process.

Thus it is also fairly common to find imperial mounts used for photomontage experiments (as a photograph of a woman's head used to simulate a statue) and for art reproductions. Even Napoleon Sarony perpetuated this idea through his "living pictures," or photographs of theatrical personalities that were heavily retouched to imitate works of art. An example of this tendency toward depicting "living statues" is seen in his 1883 portrayal of Mary Anderson (1859–1940) as Galatea.

Photomontage, portrait statuary, imperial mount.

According to the *Catalogue of Photographic Reproductions of Works of Art*, published by the Soule Photograph Company (successor to John P. Soule) in 1887, there was a great demand for art reproductions to be used as teaching aids. Thousands of mounted photo illustrations could be ordered on imperial, medium (11 by 14 inches), panel (4 by 8¼ inches), large (16 by 20 inches), or extra size (20 by 24 inches) tinted boards. Subjects ranged from original paintings and frescoes by old masters, to sculptures, architecture, views, engravings, drawings, and paintings by modern artists. Incidentally, unmounted photographs could be displayed in "Art Collection" albums, with pages made of double-faced amber cardboard, hinged with linen, and bound in Turkey Morocco.

A method for mounting photographs was suggested as follows: "Paste the edge nearest the binding or back part of the book (using very thick flour paste) so that the print may turn with the leaves. The print is then assigned its proper place in the book, indicated by pencil dots, and pressed down with thin blotting paper." Directions were also given to prevent wrinkling and curling of the image, undoubtedly convincing any customer he should have spent the extra pennies for "factory" mounts.

Spirit photography, skeleton playing cards with a ghostly figure.

A great number of photographic novelties were short-lived because of their unpractibility or unpopularity. A series of album cards produced by C. Taber & Co. of New Bedford, Massachusetts, featured tinted carte de visite genre subjects, and a bible verse attached to cabinet-size cardboard stock. Cabinet portraits of lyricists and performers were sometimes pasted to sheet-music covers, especially during the 1880s. J. S. Wooley of Ballston, New York preferred 2¼ by 2½ inch mounts for advertising his "Views of residences, parlors, outdoor groups, etc., a speciality. Largest and finest variety of Stereoscopic views of Saratoga on sale. Instantaneous process exclusively."

Another oddity that had limited success was the 2½ inch square image mounted on diamond-shaped boards. The novelty accounted for many cockeyed portraits in standard albums which had no slots for "diamonds."

PLAYING CARDS

One of the first souvenir decks of playing cards bearing photographs was published by the cigarette company of W. Duke & Sons. The 1882 advertising deck was illustrated with stage stars of the day, and duplicated many of the insert-card photographs manufactured by the firm. The golden age of the souvenir deck began in conjunction with the Columbian Exposition of 1893, and soon every major event, locality, or personality appeared on the faces of playing cards. The decks were bought in colorful slipboxes as remembrances of a visit or an occasion; the cards were embellished with gilt edges and chromolithographed backs.

Most of the souvenir decks were "wide," measuring 2½ by 3½ inches but many "narrow" decks of 2¼ by 3½ inches were also produced with oval photographs on the face. The majority of the standard decks were issued with jokers, and occasionally a descriptive or map-route card was included. According to Gene Hochman in his *Encyclopedia of American Playing Cards,* there are five different types of photographic decks:

pre-1898—oval vignette, no outline, sepia-toned, or black-and-white photographs;

c. 1898—ornate outline added to oval vignette, sepia-toned, or black-and-white;

c. 1901—monocolor-oval photograph with matching color outline, each suit may be in a different shade;

c. 1910—distinct edge to photograph, printed titles beneath oval, gray cast;

c. 1915 and after—round-cornered rectangular photographs.

Naturally many contemporary photographers who had works displayed through the mediums of stereographs, view booklets, or picture postcards, also had photographs reproduced in the souvenir-card format. The "Yellowstone Park Souvenir Playing Cards," c. 1901, bear identified F. Jay Haynes photographs and were published by the official photographer in St. Paul, Minnesota. Other familiar publishing names, usually associated with the picture-postcard market, were Chisholm Brothers; Edward H. Mitchell; Wall-Nichols; Fred Harvey; and M. Rieder.

*Unusual format, 2¼ by 2½ inch
photographer's mount for J.S. Wooley
of Ballston, New York.*

*Photographic playing cards from souvenir decks feature many views seen
on postcards.*

Railroad souvenir decks generally achieve higher price tags with dealers; but expositions, political, sports, stage, state, city, and park decks are also desirable. Entertainment decks portrayed stars of the day as court cards, and subsequently new stars were substituted on later editions. Political cards were seldom photographic, although sometimes a photograph was incorporated into a drawing or a caricature.

War cards began with issues published during the Spanish-American War, as one example that displayed photographs of warships on the four spots and officers on the court cards. Unusual photographic decks include views of the Boxer Rebellion (1901); prizefighters (1909); Hawaii (1901); American Indians (1900); movie Molly-O (1910); movie stars (1916); White Pass & Yukon (c. 1900); and the Great Northern Pacific Steamship (c. 1920.)

EXHIBIT CARDS

Remember putting a coin in the vending machine at the penny arcade in the amusement park, and receiving a card picturing your favorite movie star? The name of the largest supplier of those machines was the Exhibit Supply Company of Chicago, and the postcard-size photographs were dubbed "exhibit" album cards. Of thick stock, most of the cards depicted entertainers, sports personalities, pinups, planes, automobiles, and other items of interest in the 1920–1935 period.

Later the series were reproduced, and usually there is a marked lack in quality in the reprints. The true exhibit card has a blank reverse, or limited information as to the supplier, although those with postcard-printed backs were also dispensed in the vending machines. Most were printed in black and white or monotones but some series like the Western Star Playing Cards, were published in brilliant single colors. Identified cards—transportation model or personality—are generally preferred over unidentified exhibits. Standard sets included 32 or 64 cards, and thousands of the photographic type have been recorded.

Dedication ceremony, unidentified western location, c. 1890.

Midway entrance to Dreamland, Pan American Exposition at Buffalo, 1901.

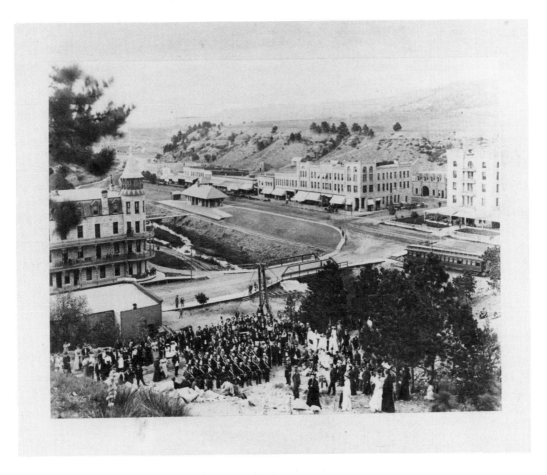

Tradecard, "Photography under a cloud."

Trade card for the photographer,
Hugo Broich of Milwaukee.

178

CHAPTER VII
The Advertisements,
Clues to the Studios

The advertisements for photographic galleries and stationery supply houses aid the specialist in determining the age, origin, and rarity of a photograph.

A photographer's studio might be only a sideline concern; a funeral director might specialize in post-mortem photography, or a tourist guide supply stereographs of local scenic attractions. There is no doubt that photography lured many individuals from profitable trades, and rightly so, for the likes of the bookseller Eadweard Muybridge, or the artist Laton Alton Huffman might never have been recorded in the medium.

It seems that the pioneer photographers who attained fame had a shared characteristic: they had an unquenchable thirst to achieve the finest quality in images. The portrait of the ship designer I. K. Brunel, quaintly posed before the wall of huge chains of the *Great Eastern* steamship, needs no identifying advertisement to indicate that a master photographer (Robert Howlett) had recorded the scene. Likewise the cartes de visite of Andre Disderi stand out in photograph albums in comparison to portraits taken by less-schooled practitioners. Still, it is rewarding to turn the card over and see the words, "Disderi & Cie" printed as undeniable proof of its worth.

Jacoby's Art and Photograph Gallery of St. Peter, Minnesota during the 1860s; notice the roof skylight on the side of the building. (2 by 3 inch advertising card).

Photographic auctions and sales attest to the fact that identified images by the noted demand a premium. Some photographers, of course, can be identified as easily by style as by imprint. Other photographers and suppliers of the late nineteenth century preferred to advertise their services on colorful trade cards. These small cards were printed in thousands of designs, and offered by storekeepers or inserted in product packages.

The photographer Hugo Broich, of Milwaukee, Wisconsin, was featured as a dapper gentleman, complete with smoking cigar, on a trade card advertising "Fine Photographs." A clothing store pictured a tongue-in-cheek cartoon of "photography under a cloud," with black patrons posed before a camera. Another trade card of a stationery house advertised a diverse Christmas stock that certainly would attract customers today: "Christmas cards, autograph and photograph albums, box paper, new and attractive holiday styles, ladies' and gents' wallets, stereoscopes, and views—from 50 cts. a dozen to 50 cts. each. Diaries for 1879, Xmas picture books, games, playing cards, and etc., chromos, embossed pictures, gilt stars and bands for decorating. John T. Bowler & Co., Bangor, Maine."

An advertisement displayed on the reverse of a pioneer postcard of the 1870s tried to showcase the advantages of becoming a self-employed photographer. With a complete outfit of the "Photographic Cabinet" one could earn more money in a single day than "a good mechanic gets for a whole week's labor, besides being your own boss." For the sum of $2.00 anyone could duplicate the smallest tintype, carte de visite, cabinet or stereoscopic view, with the greatest of ease. The word "quality" was decidedly absent from the advertisement, although the offer was made for only thirty days, "Knowing that every one sold is an advertisement for the sale of others." Evidently there were just as many financial success stories to be made in the photographic supply business as boasted by those taking the pictures.

A. Carte de visite gallery folder.

B. Photographer's engraved portrait on carte's reverse.

Usually a photographer who had a studio could make more sales by making a variety of albums, frames, and even apparatus available to customers. In their advertisements of the early 1860s the firm of E. & H. T. Anthony boasted that they were the first to introduce "photographic albums" into the United States, and manufactured a great variety ranging in price from fifty cents to $50.00 each. An 1863 Philadelphia photographer's advertisement in *The Saturday Evening Post* gives an overall view of an album's necessity as follows:

> Photographic Pictures are now taken so neatly, and are so cheap, as to leave no excuse for a neglect to gratify a relation or friend by leaving one's portrait in their hands. But photographs, singly or alone, will soon tarnish, warp, and lose their natural beauty. Hence the necessity of a Photograph Album, which is the crowning feature of the whole. It constitutes a "Family Record" for the display and proper preservation of the Card Photographs of the Family, or of friends and others, which for beauty of design and completeness of execution, has never yet been equalled. They are adapted to the pocket of the traveller, or the parlor and center table of every home, and are so useful as well as so pretty, that wherever one is introduced, more are sure to follow. They are, indeed, becoming a household necessity, as the Album in which a family group are all gathered together in this way, soon assumes inestimable value.

A

B

In a small Ohio town a photographer, who had his studio situated above a grocery store, noted on the reverse of his cartes that he was "practical" and sold all kinds of oval, square, rosewood, and gilt frames. Larger cities, such as Erie, Pennsylvania, or Syracuse, New York, had photographic studios which offered not only frames, but also machines, models, porcelain pictures, and copying services.

Whitney's Gallery in St. Paul, Minnesota, always had on hand stereoscopic card and parlor-size views of Minnesota scenery, Indian pictures, paintings, engravings, and copies of works of art. This advertisement appeared on the reverse of Whitney's cartes de visite together with the statement, "The plate from which this picture was made will be preserved, accidents excepted."

The larger the studio the more services rendered, especially in the area of art work. A portrait could be retouched with india ink, watercolors, or oil paints. Many examples seen were so heavily painted that there was little semblance to the original model.

Advertisements in newspapers for photographic studios can aid the historian in discovering the popular novelties of the day. For instance, during the Civil War, E. & H. T. Anthony of New York City, advertised cartes de visite of officers and stereoscopic views of "The Great Union Contest."

Twenty-five years later the war was nearly forgotten, and amateurs were avidly seeking photographic supplies rather than images. Thus the Anthony firm advertised in 1887 as "Manufacturers and importers of photographic instruments, apparatus, and supplies of every description. Sole proprietors of the Patent Detective, Fairy, Novel, and Bicycle Cameras, and the Celebrated Stanley Dry Plates. Amateur Outfits in great variety from $9.00 upward."

CARTES DE VISITE

Generally the plainer the reverse of a carte de visite, the earlier it dates. Most successful galleries went through a succession of imprint designs, like the Bradley & Rulofson studio of San Francisco.

The first imprint featured an eagle with the phrase "Successors to R. H. Vance, corner of Montgomery and Sacramento Streets." This was a square-cornered card with double gold-line framing on the front. Similar early designs featured an elaborate revenue stamp box within a green engraving, and a plain imprint with the statement "Depot of Patent Enamel Card Pictures." Later round-cornered designs included the Bradley & Rulofson name in script on tinted amber stock, and the familiar "Gold Medal" award displayed on the reverse of white-stock mounts.

The noted studios of England were quick to mention any favors made to the Royal Household, and dozens of galleries brandished the honor of being chosen as "photographers to Her Majesty the Queen." Besides listing awards received in exhibitions, some studios noted special attractions in the use of a skylight, an elevator, an instantaneous-process, or the "new" electric light.

One portrait of Abraham Lincoln was rubber-stamped on the reverse, "Sold by a one-armed soldier, price 25 cts." Small illustrations were also displayed on the reverse of cartes de visite—an engraving of a photographer, a photographic album, or an allegorical figure.

A. Notman's Photographic Company, carte de visite "instantaneous" photomotage advertisement.

B. This model ship floated in a pond in front of the E. B. Nock photography studio as an advertising gimmick.

C. Carte de visite imprint for I. W. Taber of San Francisco, c. 1870s.

CABINETS

The photographer's imprint on a cabinet photograph was decidedly more elaborate than that of the smaller carte de visite. Drawings of the studio might be given prominence, or an artistic rendering of draped figures, flowers, or a painter's easel. The stock and printing was usually tinted in monotone combinations, or highlighted with gold and border designs on the backs. Curiously, few cabinet reverses were used for advertising purposes other than to display a photographer's imprint.

One inventive jewelery firm pictured two salesmen in a cabinet photograph, complete with order forms in hand and store wares laid out on a table. Perhaps the photograph was not used for advertising purposes but rather as a memento of a short-lived business venture.

Photomontage, cabinet advertisement for a gallery
in Schuyler, Nebraska.

Cabinet reverse, Theo. C. Marceau of Cincinnati, Ohio.

Cabinet size studio advertisement for Wissler of Canton, Ohio.

Although most of the advertisements on stereographs took the form of a photographer's imprint or a listing of views, occasionally one can discover a card that features an unrelated product advertisement. Billboard advertisements were produced by the U. S. Stereoscopic Company on the reverse of some stereographs and consisted of six or more ads for various stores in a particular area. A reprint of the diablos "Voyage Thro the Lower Regions" carried a full label on the back advertising: "The Remarkable Cures of the Botanical Preparations—good for man or beast."

Another overall ad on a c. 1870 stereograph offered an inspection of a stationery store's stock of pianos and organs. Bicknell & Brokaw's bargain store advertised its wares of kitchen furnishings on the front edge of a yellow-mount series picturing stage stars of the day.

Pioneer Western photographers recorded interesting recommendations and subject titles in their elaborate imprints. Eadweard Muybridge mentioned that he specialized in coast and mining scenes. Chinese and Indians, a "vintage" in California, missions, the Modoc War, and Lava Beds. There is also text boasting of the Bradley & Rulofson status symbol: "The only elevator connected with a photography gallery." Another San Francisco photographer, J. J. Reilly, said that his views were "indeed, the best in the state." He further advertised on the pink backs of his orange-mounted cards: "Private residences photographed to order: also, animals and cemetery views made at short notice and at prices to suit the times."

Charles Savage listed subjects as groups of Indians and portraits of representative men of Utah; T. W. Ingersoll stated that he was the official photographer of the St. Paul Ice Palace and Carnival Association, local artist for *Frank Leslie's* and *The Graphic* as well as a supplier of lantern transparencies. Other stereographs listed sizes, prices, subjects, processes, and agent advertisements. Any selling attribute, such as the use of the Thomson-Houston electric light to take cavern views, was recorded. Prices usually ranged from $1.50 per dozen for photographic stereographs, to 85 cents for 100 lithoprint views.

Ironically, in the 1920s Sears, Roebuck & Company directed customers to sample their "new process" photo-colored stereoscopic work to form an idea of the "wonderful progress" that had recently been made in the field. Unfortunately the color-lithoprints caused the progress of the stereograph market to slide downhill, never to attain the pinnacle of success it had achieved with actual photographs.

Jackson Brothers stereograph reverse of second issue, 1869.

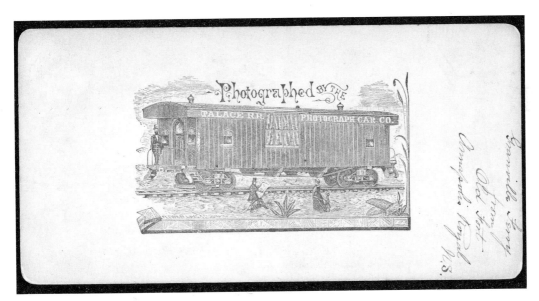

Stereograph reverse, Palace R. R. Photograph Car Company.

Joseph L. Bates of Boston advertised the Holmes-Bates stereoscrope, and J. D. Andrews listed his photographic wares in the 1876 issue of the Lady's Diary.

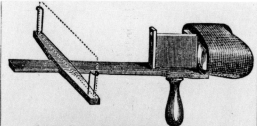

STEREOSCOPES

of the best quality, with the subscriber's patent improvements, for sale in any quantity, by

JOSEPH L. BATES,
BOSTON.

J. D. ANDREWS,

63 COURT ST., cor. of Cornhill, Boston,

EXECUTES ALL THE VARIETIES OF

PHOTOGRAPHS,

Including Card Visites, Minnettes, Cabinets, and also Copies from old and partially faded Daguerreotypes, which can be reproduced in Large Photographs. Persons having such Pictures, whether Daguerreotypes, Ambrotype Cards, or Tintypes, can depend upon having them Faithfully and accurately Copied, and Finished by the Best Artists in the City.

We are always in readiness to take Tintypes, Ferrotypes, etc., of Children; also, of Dogs, Cats, or other pets, and finish in the most perfect manner.

Machinery, Residences, Furniture, Patent Inventions, Photographed and Engraved upon Wood, in the best and most perfect manner.

N. B.—All the Horse Cars pass these Rooms.

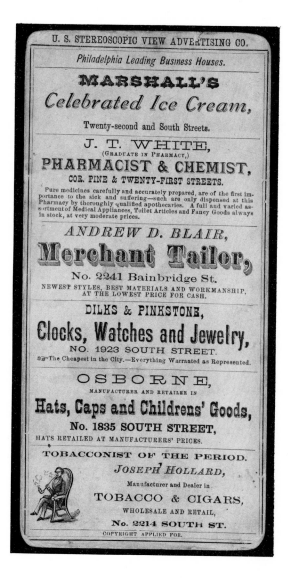

U. S. Stereoscopic View Advertising Company billboard ad on stereograph reverse.

POSTCARDS

"Get in the game, now is the time!" the 1911 postcard proclaimed in its advertisement. "You can make MONEY on photo postcards from your negatives" was a common ploy used to attract an amateur's interest, and was displayed on the front of a Multiprint Photographic Company Card. Other dealers in postcards advertised special offers on the address side. For example, the printers Newfield & Newfield of New York City offered lots as:

 250 of one subject $4.00
 500 of one subject $5.00
 1000 of one subject $8.00

From either photos, photo postcards, black-and-white cards, or from half-tone prints. Besides the above, we print eight more styles of view cards. Samples we will send you gladly, prepaid, free of charge. Without them you are losing money, and you don't know it.

Advertising postcards, with products pictured on the front or described on the reverse, often utilized real photographs. Farm machinery, stoves, tools, automobiles, factories, shipping lines, and household goods were commonly advertised; but photography-related cards are of particular interest to the photo historian.

In 1905 the Vincent Photo Company of Los Angeles printed a card advertising Kodak services. A man was pictured, undoubtedly through the use of photomontage, hanging precariously from a mountain ledge. The come-on was a big question mark with the phrase: "Do you use a Kodak?" Further advertising promoted that the Kodak was not only good but quick, and developing received up to 1:00 p.m. would be done by 5:00 p.m. the same day.

Another card, picturing a young woman sporting a camera, advertised Kodak Velox Postals. On the message side was printed: "The people at home can join in your vacation fun if you will take along a Kodak and send them Velox Postals, then afterwards you can make prints for your album. It's all very simple by the Kodak System. Let us show you."

Interiors and exteriors of photography studios are also of interest to collectors in order to reconstruct the workings and display setups of early galleries. To the nostalgia-minded they offer a means to travel back to a simpler and more structured time.

You can make money on Photo Post Cards from your negatives: We print them.

Interior views of a photographer's studio on a postcard, with displays of portraits.

*Postcard advertisement for
the Kodak camera, 1905.*

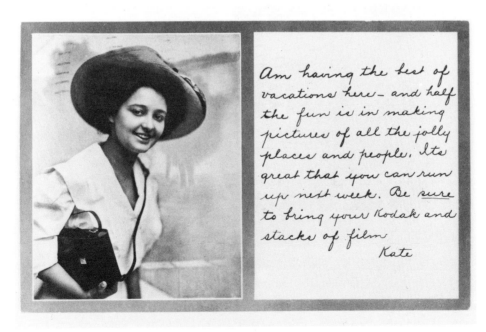

Kodak postcard advertising Velox Postals.

Postcard printer's advertisement, printed from "photos, photo post cards, black-and-white cards or half-tone prints."

CHAPTER VIII
The Photographers and Publishers, List of the Noted

The term "card photographs" covers a multitude of subjects related not only to the style and type of mount, but also to the particular classification of the image. Since the topic is broad, a collector can easily find a niche or field of interest. Photographs by common portrait galleries of the cities and makeshift studios of small towns are, of course, the most numerous among accumulations.

If one has a working knowledge of the noted photographers and publishers of cards, a pile of everyday portraits and views or postcards may become a treasure trove. Correspondingly, subject matter may overshadow the value of a "name"; a sensitive portrait of an Indian youth, although unidentified as to photographer, generally has more value than a celebrity portrait by an identified New York gallery. Whether a collection is formed with notability or subject matter in mind, it is the collector's advantage to increase his photographic knowledge.

Purchasing a reference library, visiting museums, attending photo shows, joining societies, and talking with fellow collectors aids one in becoming informed. Subsequently the following list is offered as a general guideline to the noted photographers and publishers.

PHOTOGRAPHERS AND PUBLISHERS

ABBREVIATIONS:

C -	calotypes	D -	daguerreotype	PC -	postcards
CAB-	cabinets	K -	Kodak	S-	stereographs
CDV-	cartes de visite	M-	miscellaneous	VB-	view booklets

NAME	MAIN MEDIUM	STUDIO OR ORIGINATION	PROCESS OR ASSOCIATION	MAIN SUBJECTS
Albertype Company	PC	Brooklyn, New York		pioneers, expositions, the South
American Souvenir Company	PC	Boston, Mass.		pioneers, multiviews
American Souvenir Card Company	PC	New York, New York	Patriographics	pioneers, multiviews
American Stereoscopic Company	S	New York, New York	succeeded Langenheim, 1861	scenery, landmarks
Andrieu, J.	S	France	initialed J. A.	Europe, Africa Near East
Anthony, Edward (1818-1888)	D, S, CDV	Washington D.C. New York City	instantaneous - 1858, joined H. T. Anthony, 1852	scenery, cities
Anthony, Henry T. (1814-1884)	D, S, CDV	Washington, D.C. New York City	instantaneous - 1858	scenery, cities
Art Litho. Company	PC	U. S. A.	subsidiary of E. H. Mitchell	views, pioneers
Bamforth & Company	PC	Holmfirth, England New York City		genre, songs, views
Barker, George	S	Niagara Falls		ice, snow, Florida, hunting, falls, the West, Indians
Barnard, George N. (1819-1902)	D, S, M	Chicago, Ill. Oswego and Syracuse, N. Y. Charleston, S. C.	assoc. with M. Brady	the West Civil War

Barnum, Delos	S	Boston, Roxbury, Mass.	until 1875	scenery, cities
Bayard, Hippolyte (1801-1887)	C, D, M	France	combination negatives	portraits, scenes
Bedford, Francis (1816-1894)	CDV, S, M	England		ruins, architecture, Holy Land
Bennett, Henry H. (1843-1908)	S	Kilbourn City, Wisc.		the West, Indians Japan
Bierstadt Brothers (Charles, Edward)	S	born, Germany studio: New Bedford, Mass.	1860-1866	the West, the South, Holy Land
Bourne, Samuel (1834-1912)	S, M	born, England Studios: Calcutta, India England	joined Charles Shepard in 1863	landscapes, India, Burma, Ceylon
Bradley, Henry W.	CDV, CAB, S, M	San Francisco	assoc. with Rulofson, pub. Muybridge views	portraits, views
Brady, Mathew B. (c. 1823-1896)	D, CDV CAB, S, M	New York City Washington, D. C.	historian	portraits, Civil War
Braun, Adophe (1811-1877)	D, CDV, S, M	France Germany after 1871		Alps, scenery, composites
Brogi, G.	CAB, S	Florence, Italy	1860-1880's	local views
Cameron, Julia M. (1815-1879)	M	born, India studio: England	soft-focus active 1863-1875	portraits, composites
Carbutt, John (1832-1902)	S, M	Chicago, Ill. Philadelphia, Pa.		the West, Civil War, railroads
Carjat, Etienne (1828-1906)	CDV, CAB, S, M	France	woodburytypes	portraits
Carter, Charles W.	S, VB	Salt Lake City, Utah		the West, Mormons, Indians

Chamberlain, William G.	S	Denver, Colo.	active 1860's-1870's	the West, Indians, railroads
Charnaux, F.	CDV, S	Switzerland		scenery, Alps
Chisholm, Hugh	PC	Portland, Me.		pioneers, views
Claudet, Antoine (1797-1867)	C, D, CDV, S, M	born, France studio: London		portraits, scenery
Continent Stereoscopic Co.	S	New York City	c. 1875-1885	general, views
Curt Teich & Company, Inc.	PC	Chicago, Ill.	initialed CT, began 1898	views
Curtis, Edward S. (1868-1952)	CAB, M	U. S. A.	photo historian	Indians, the West, railroads, expeditions, portraits
Daguerre, Louis (1789-1851)	D	France	invented, with Niepce, the daguerreotype - 1837	portraits
Detroit Photographic and Publishing Company	PC	Detroit, Michigan	photochrome process, 1897; first issue - 1898	pioneers, views
Disderi, Andre Adolphe-Eugene (1819-1889)	D, CDV, S, M	Paris, London	invented CDV - 1854	portraits, scenery
Downey, W. and D.	CDV, CAB, S	England		portraits
Eastman, George (1854-1932)	K	Rochester, New York	popularized dry plate - 1879; invented box camera, 1888	mechanical preparation
Edition Photoglob Company	PC	Zurich, Switzerland	assoc. with Detroit Publishing Company	scenery
Eisenmann, Charles	CDV, CAB	New York City		celebrities, human oddities
Elliot and Fry	CDV, CAB	London	active 1863-1905	portraits
Elliot, J.	S	London		sentimentals, still lifes

England, William (d. 1896)	S	London	assoc. with London Stereoscopic Co. until 1863	exhibitions (1862), Alps, statuary, views
Falk, Benjamin	CAB	New York City	active, 1853-1875	celebrities, portraits
Fay, E. B.	CAB	New York City	active, 1865-1875	photomontage
Fell, S. B.	CAB	Morrisburg, Ontario		portraits
Fenton, Roger (1819-1869)	C, S, M	England		Crimean War, landscapes, still lifes
Ferrier & Soulier	S	France		scenery, Alps
Frith, Francis (1822-1898)	S, M, PC	Reigate, Surrey, England		British Isles, architecture, Egypt, Holy Land
Furia	PC	Paris		female studies
Gardner, Alexander (1821-1882)	CDV, S, M	born, Scotland studio: Washington, D. C.	Brady's staff	Civil War, railroads, scenery, surveys
Gates, G. F.	S	Watkins, New York		local views, India
Genthe, Arnold (1868-1942)	M	born, Germany studios: San Franciso, New York City	active c. 1895	1906 earthquake, documentary, portraits
Gerard, Charles	S	Paris	initialed CG, 1860's	Paris, genre
Good, Frank M.	S	England		Africa, architecture, Eastern Series
Griffith & Griffith	S	Philadelphia, Pa.	began c. 1896	cities, Asia, Europe, humor
Gurney (Jeremiah) & Son (Benjamin)	D, CDV, S	New York City	son succeeded in 1856	celebrities, portraits
Hart, Alfred A. (1816-1869)	S	Sacramento, Cal.		railroads, the West
Haynes, F. Jay (1853-1921)	CAB, S, PC, VB, M	Morehead and St. Paul, Minn. Fargo, N. D.		the West, Indians, Yellowstone Park
Haynes, Jack Ellis (son of F. J.)	PC, VB	Yellowstone Park	succeeded F. J. in 1916	views

Herschel, Sir John	D, C	England	discovered cyanotype - 1842, invented 'Hypo' for fixing images	mechanical preparation
Hill, David Octavius (1802-1870) and Adamson, Robert (1821-1848)	C	Scotland	joined Adamson - 1843	portraits, landscapes, architecture
Hillers, John K. (1843-1925)	S, M.	born, Germany U. S. A.		the West, Indians, Powell's Survey, exploration
Hines, Thomas, J.	S, M	Manitou, Colo. Chicago, Ill.	active 1870's - 1880's	Barlow's Expedition, Indians
Houseworth, Thomas (& Co.)	CAB, S	San Francisco	succeeded by T. Houseworth & Co. in 1867	the West, scenery
Howlett, Robert (d. 1858)	S, M	London, England	Assoc. with London Stereoscopic Company	portraits, shipping, 'Great Eastern'
Huffman, Laton Alton (1854-1931)	S, M	Miles City, Montana		the West, badlands, Indians
Illingworth, W. H.	S	St. Paul, Minn.		landscapes, expeditions
Jackson, William Henry (1843-1942)	CDV, CAB, S, M, PC, VB	Omaha (with brother Edward)		Hayden Survey, the West, Indians, railroads
Jarvis, J. F.	S	Washington, D. C.		cities, general, British Isles
Kilburn, B. W. (Brothers)	S	Littleton, N. H.	B. W. began in 1865	Yosemite 1871, White Mountains 1865, cities, events, genre
Kinsey, Darius (1871-1945)	S, M	U. S. A.		the West, logging
Kropp, E. C.	PC	Milwaukee, Wisc.		pioneer views
Lafayette	CDV, CAB	from Paris, studios: Dublin, Glasgow, Manchester	began, c. 1865	portraits
Lamy, E.	S	France		scenery

Langenheim Brothers (Frederick, 1809-1879) (William, 1807-1874)	D, C, S	born, Germany studio: Philadelphia, Pa.	Assoc. with Negretti & Zambra, and American Stereoscopic Co.	glass views, scenery, landmarks
Lawrence and Houseworth	S	San Francisco, Ca.	began, 1862	the West
Leighton, Hugh C.	PC	Portland, Me.		pioneer views
Leon & Levy	S	France	active 1860's - 1870's	architecture, scenery
Levy, Fils & Cie	PC	Paris	L. Livitsky, photographer (also known as Sergei L'Vovich Levitskii; born, Russia, 1819-1898)	views
Livingston, Arthur	PC	New York City		multi-views
London Stereo-scopic and Photo-graphic Co.	CDV, CAB, S, PC	London, England	began, 1854, 'LESCO' on PC	exhibitions cities, scenery
Luckhardt, Fritz	S	Austria		portraits
Martin, William	PC	Kansas City, Kansas		photomontage, tall-tale
Mayall, John Jabez Edwin (1810-1901)	D, CDV, CAB	Philadelphia (D) London, Brighton		portraits
McKee, Thomas	M	U. S. A.		the West, Mesa Verde, Indians
Mitchell, Edward H.	PC	San Francisco, Ca.		views, tall-tale
Mora, Jose Maria (b.1849)	CDV, CAB, S	born-Cuba studio: New York City	began 1870, popularized painted backdrops	celebrities, portraits
Moran, John (1832-1903)	S	Philadelphia, Pa.	brother of artist Thomas Moran	landmarks, Selfridge Exped-ition
Morrison	CAB	Chicago, Ill.		theatrical portraits
Moulton, J. W. & J. S.	S	Salem, Mass.		scenery
Muybridge, Eadweard (1830-1904)	CDV, CAB, S, M	born, England studio: San Francisco, Ca.	Animal locomotion, 1887, motion pic-ture	the West, motion

Nadar (pseud-onym of Gaspar Felix Tournachon, 1820-1910)	CDV, M	Paris, France	aerial photo-graphy, 1858: photo interview, 1886	topographical, portraits
Naya, Carlo (1816-1882)	CDV, S	Venice, Italy	Assoc. with C. Ponti	architecture, scenery
Negretti (Henry, 1818-c. 1879) & Zambra (Joseph, b. 1822)	CDV, S, M	born, Italy studio: London England	began, 1850 initialed NZ	photo manu-factures, portraits, scenery, Frith's Near East Views
Newsboy	CAB, M	New York City		theatrical, portraits
Neue Photo-graphische Gesell-schaft	S, PC	Berlin, Germany	initialed NPG	female studies, genre
Neurdein, E. (et Cie or Freres)	S, PC, M	Paris, France	Freres after 1892, PC assoc. with L. Levy	panoramas, views architecture
New York Stereoscopic Co.	S	New York City	began 1859-1863	views
Notman, William (1826-1891)	D, CDV, CAB, S, M	born, Scotland studio: Canada	founded Notman Photographic Co. of Canada and U. S. A.	composites, views, Indians, portraits, Scenery
O'Sullivan, Timothy (c. 1840-1882)	CAB, S, M	Washington, D. C. New York City	Assoc. of M. Brady	Civil War, the West, Darien and other Surveys, portraits
Palmer, J. A.	S	Aiken, S. C.		the South
Peabody, Henry, G. (b. 1855)	M, PC	U. S. A., Boston	Assoc. of W. H. Jackson	scenery
Price, William Lake (1810-1896	S, M	England	began, 1854 tinted views	still lifes, composites, scenery, portraits
Ponti, Carlo	S, M	Venice, Italy	invented megalethoscope	ruins, scenery
Raphael Tuck & Son	PC	England, Saxony	PC's began, 1898	views, greetings
Rau, William H.	S	Philadelphia, Pa.		the West, scenery
Reilly, J. J.	S	Niagara Falls and California		the West, railroads

Rejlander, Oscar Gustave (1813-1875)	M	born, Sweden, studio: London	active 1860's	composites, portraits, art photography
Richebourg	S	France		scenery
Rieder, M.	PC	Los Angeles, Ca.		views
Roche, T. C.	S	New York City	M. Brady's staff	Civil War, the West, railroads
Rotograph Company	PC	New York City	Sol-Art Prints	scenery, land-scapes, genre, humor
Rulofson	CDV, CAB, S	San Francisco, Ca.	joined Bradley, 1863	portraits, scenery
Russell, Andrew J. (1830-1902)	S, M	the West and New York City		Civil War, the West, Indians, railroads, surveys
Sarony, Napoleon (1821-1896)	CDB, CAB, S, M	born, Canada studios: England, New York City		theatrical, portraits
Sarony, Oliver X. (1820-1879)	CDV, CAB, S	born, Canada, studio: London		theatrical, portraits
Savage, Charles R. (1832-1909)	S, M	born, England Salt Lake City, Utah		Rocky Mountains, the West, Indians, railroads
Sedgefield, W. R.	S	England	active c. 1842-1872	scenery, ruins
Silvy, Camille de	CDB, M	born, France studio: London, 1859		portraits, landscapes
Sommer & Behles	S	Naples, Italy		architecture, ruins, scenery
Soule, John P.	CDB, S	Boston, Mass.		genre, Niagara Falls, the West, Boston
Soule, William S	S, M	Fort Sill, Oklahoma	active 1860's - 1870's, brother of John P.	the West, Indians
Southworth, Albert Sands (1811-1894) and Hawes, Josiah Johnson (1808-1901)	D	Boston, Mass.	began c. 1850	portraits, scenery
Stacy, George	S	New York City	began, 1859-1864 initialed G. S.	'The Great Eastern', Civil War, parks, cities

Stolze & Co.	S	Berlin, Germany		female portraits
Sutcliffe, Frank Meadow (1853-1941)	CDV, CAB, M, PC, K	Whitby, England		British Isles, scenery
Sword Brothers	CAB	York, Pa.		theatrical portraits
Taber, I. W.	CDV, CAB, S	San Francisco, Ca.		portraits, the West, scenery
Talbot, William Henry Fox (1800-1877)	C	England	invented photograph, 1835; engraving, 1858; 'Pencil of Nature', 1844	portraits, scenery
Tamoto, K.	CDV, CAB	Hakodate, Japan		portraits
Taylor, A. & G.	CDV, CAB	London, England and other branches		portraits
Thayer, Frank S.	PC, VB	Denver, Colo.	published some C. Carter views	the West
Underwood & Underwood (Elmer, Burt)	S	Kansas, New York City and other branches		cities, wars, events, general, humor
Valentine (James, 1815-1880) & Sons	PC	Dundee, Scotland; Canada, New York City, Boston		landscapes, views
Wall, Nichols Company, Ltd.	PC	Honolulu, Hawaii	subsidiary of E. H. Mitchell	views
Watkins, Carleton E. (1829-1916)	CAB, S, M	San Francisco, Ca.	instructed E. Muybridge	the West, landscapes
Weed, C. L.	S, M		first to photograph Yosemite, 1858	the West
Weidner, Charles	PC	San Francisco, Ca.		expositions, the West
Weitfle, Charles (b. 1836)	S	Washington, D. C., 1860 Central City, Colo., 1878, Denver, Colo., Cheyenne, Wyoming		portraits, the West, mining
Weller, F. G.	S	Littleton, N. H.		comics, sentimentals

Wendt Studio	CAB	New York City		theatrical, portraits
Whipple, John Adams (1823-1891)	D	Boston, Mass.	D. of moon, 1849	portraits, mechanical prepartation
White, H. C., Co.	S	Vermont		landscapes, general
Whitney, Joel E.	D, CDV, S	St. Paul, Minn.		the West, Indians, scenery
Wilson, J. N.	S	Savannah, Georgia		the South
Wilson, George Washington (1823-1893)	CDV, S, M	Aberdeen, Scotland	began, 1852 initialed G. W. W., instantaneous method	architecture, ruins, scenery
Wiseman, Theodore	CAB	Lawrence, Kansas		1880's Civil War reprints, scenery
Zimmerman, C. A.	S	St. Paul, Minn.		the West, Indians

Price Guide

Animals

	Values
Dog wearing hat and spectacles, "reading" a newspaper	$ 7.00
Full-sized lamb, age seventeen years	6.00
Stuffed owl on branch	3.00

Children

Baby in elaborate carriage; by Defsaur of New York	2.00
Boy and toy house, 1865	8.00
Boy in wire chair, striped socks, checkered jacket, lace collar, hat with ribbons	2.00
Child, reverse has metamorphic drawing: "I have had my face drawn at F. E. Maas," Conneautville, Pa	5.00
Child surrounded with many toys and dolls	18.00
Child with toy dog and racket	5.00
Girl with large doll	5.00
Girl in Swiss costume; hand-tinted	8.00
Girl with china doll standing by a table; hand-tinted, revenue stamp on reverse; by Wm. A. Champ, Genesee, New York	7.00
Indian child in photo studio; by Howell, c. 1870	18.00
The McCarty Children; published by A. Walker, 1872	8.00
Tiny child: elaborate props, dwarfed by chair, hand-tinted; by Miss H. Emery of Bryan, Ohio, c. 1860s	4.00
Two girls: one on chair with doll, the other standing with doll buggy, hand-tinted	8.00
Welsh peasantry: two young girls in native costumes. Photographer C. Allen of Tenby	15.00
Young girl within a vignette, surrounded by a forest scene, c. 1880s. Upham & Laidler, Jamestown, N. Y	3.00

Civil War

Baker, Lt. John; seated, in uniform. Photographers: Bowdoin & Taylor of Alexandria, Va	12.00
Brady's Album Gallery No. 36, "Southwest View of Battery No. 1"; cannon in fortification, descriptive reverse	28.00
Brady's Album Gallery No. 482, "100 lb. Gun on Board the Confederate gunboat *Teazer*"; cannon on ship's deck with sailor; descriptive reverse	38.00
Davis, Jefferson; confederate president	17.00
Denniston, Lt. W. L. Full pose, sash; by Brady	9.00
Grant, General. Photographer: Morse	10.00
Hancock, Maj. Gen. W. S. Bust pose	8.00
Heintzelman, Maj. Gen. Brady negative published by Anthony; ad for Emporium on reverse	12.00
Jackson, General Stonewall; by Anthony	15.00
Johnson, Andrew. Bust pose	12.00
Lee, Maj. Gen. G. W. C. and Col. Walter Taylor after Appomattox; Taylor holding hat. From Brady negative	60.00
Meade, General; by Anthony from Brady negative	12.00
Percy, Dr. Henry, Louisiana C. S. A. (not in uniform.)	7.00
Reno, Brig. Gen. Jesse. Died September 1862. (Reno, Nev. named after him.)	20.00
Sherman, General. Bust pose, tax stamp and studio imprint of Gardner's Washington, D. C. on reverse	15.00
Soldier (Union) and wife; nine-button coat, epaulettes, sash, gloves, and high kepi; by Gurney	22.00
Stephens, Alexander, vice president of confederacy. Published by Anthony from a Brady negative	24.00
Thompson, Confederate Gen. Jeff. Seated in Brig. Gen. uniform;	

Missouri Guard confederate commander; by Anthony	$ 25.00
Two boys in Union uniforms, full poses; by E. J. Lecocq, New York	14.00
Union officer with foot officer's sword; from Brady's New York Gallery	15.00
Unidentified Union soldier	12.00
Wild, General, of Wild's Negro Regiment, lost his arm in battle; by J. W. Black of Boston	30.00
Young Negro soldier (Union), with jacket and kepi	20.00

Collections and Sets

Albums; three Victorian leather albums containing 83 cartes de visite, average wear	45.00
Artists; album filled with twenty portraits of famous artists, from paintings. The Powers Brothers, Florence, Italy	40.00
California photographers; three of children, two of adults	15.00
Celebrities; lot of eight celebrities, from engravings	25.00
Children; lot of five, closeups	5.00
Confederate album; nine including Jefferson Davis, W. H. Lee (Lee's son) and two scenes; by Anthony	150.00
Engravings; group of eight unidentified engravings	10.00
Family; thirteen family members from Ballston Spa, New York. Revenue stamps on reverse	9.00
Genre; foldout red-leather album with fourteen hand-tinted genre scenes	65.00
Set; "Miss Lilly Going to the Ball" and "The Return."	7.00
Navy, U. S.; four different men from U. S. S. *Marion*, 1880s–90, photographed in Yokahama, Japan	27.00
Negroes; seven different men, women, and children	55.00
Seasons: "Spring, Summer, Autumn, and Winter"; by John P. Soule of Boston, from original paintings by G. G. Fish	15.00
Sports; five players of a Boston baseball team	35.00
Statuary; twenty-eight views of various statuary photographed by D'Alessandri of Naples, Italy	100.00
Surgeons; five different Civil War surgeons, two dated 1864; photographed by Sam Cooley	75.00
Washington, George and Mary; portraits from engravings; two cartes, c. 1860s	6.00

Common People

Couple, full pose; backdrop, hand-blurred, c. 1860	2.00
Dated May 1863, portrait of a gentleman; engraving of the photographer, J. Celrod, on the reverse. Louisville, "Plain & Painted Photographs."	3.00
Gentleman; elaborate backdrop and props, drape, tree, and pillar	2.00
Gentleman from New Orleans: wearing plantation hat, watch fob; fancy props in background	4.00
Gentleman; Hawaiian studio; by Crabbe & Meek of Honolulu, c. 1860s	8.00
Girl holding French doll	10.00
Hand-tinted full pose of gentleman; by Bogardus studio	4.00
Man with open carte de visite album; by Burrell of Bridgewater, Mass., 1860s	5.00
Oval vignette of woman within simulated hanging frame, c. 1860	3.00
Portrait of a woman within an embossed vignette; by S. L. Dellinger, "artist in photography," Marietta, Penna	2.00
Woman; full pose, circa Civil War; penned note by soldier of Co. 7th Inf., Chattanooga, Tenn. on reverse	8.00
Woman in calico dress leaning on chair; hand-tinted	6.00

Woman in Danish costume; hand-tinted, titled in Danish and French.
Photographer: Hansen Schou & Weller.................................. $ 8.00
Woman in mourning dress leaning on stool; hand-tinted, published
by L. S. & P. Co., 579 Broadway, New York............................. 6.00
Woman on roller skates.. 7.00
Woman within paper folder; from Teeple's Gallery, Wooster, Ohio,
featuring an engraving of the building..................................... 4.00
Unidentified gentleman; published by E. Anthony from a Brady
negative.. 10.00
Young woman wearing elaborate jewelry; bust portrait....................... 2.00

Engravings

"Adversity"; seven-color tints, published by John P. Soule, 1866,
from an original drawing.. 10.00
Archbishop Hughes; from an engraving.. 5.00
"Belle of the Season"; copyright by John P. Soule, 1865, G. G. Fish
painter; five-color tint.. 12.00
Bridge at Johnstown Flood, 1889; published by George Statler,
Johnstown, Pa... 10.00
Brown, John; engraving.. 9.00
"Central Park, the Lake"; from Currier & Ives............................... 7.00
"Childhood"; from engraving.. 10.00
"Columbia's Noblest Sons"; vignettes of Washington and Lincoln,
apotheosis.. 12.00
Comic statue portrait, "Quatre Yeux Seulement?"............................ 7.00
"The daydreams of earlier youth come back—come back to me!"
From engraving... 3.00
Description of the person of our Savior...................................... 5.00
"Dropped stiches"; hand-colored, four tints, copyright 1864 by
John P. Soule, Boston, Mass... 7.00
"Emancipation"; published 1863 by John Soule of Boston, from a
painting by G. G. Fish... 11.00
"Feeding the Kittens"; from engraving.. 3.00
"Frightened Game"; from engraving.. 2.00
General Fremont; bust pose, from engraving................................... 7.00
General Grant and wife; from engraving....................................... 10.00
General Joseph Hooker; from engraving.. 9.00
General Winfield Scott, Secretary of War; from engraving.................... 7.00
General Sherman; engraving.. 6.00
General Tom Thumb and Lady; from engraving................................... 12.00
"Grandpa's Spectacles"; engraving.. 3.00
"Grant in Peace"; from engraving... 10.00
"Homeless"; six tints, copyright 1864 by John P. Soule, from a
painting by G. G. Fish... 9.00
"Hopes and Fears"; published by John Soule, from an original by
G. G. Fish; hand-colored... 7.00
Horse, "Erie Abdallah"; from drawing... 4.00
"I Cannot Sing the Old Songs, or the Late Home of a Union Soldier";
designed and published by N. Monroe, M. D., Philadelphia, Pa.,
1868... 8.00
"Just Nine Pounds"; J. Bufford engraving..................................... 5.00
Lincoln deathbed scene; from a drawing of an Alexander Gardner
composite.. 15.00
"Longfellow's Children"; from an engraving................................... 3.00
The Lord's Prayer; by Delwin F. Brown, New York, 1864....................... 4.00
"Making Up"; published by J. P. Soule, painted by G. G. Fish,
three-color tinting.. 7.00
"The Martyr"; copyrighted by John P. Soule, Boston, Mass., 1863,
from a painting by G. G. Fish, five tints of coloring.......................... 8.00
"Music"; published by New York Photo. Co., 1864; from a drawing.. 4.00
Napoleon at St. Helena; from an engraving.................................... 5.00
"The Old Stone House"; Guilford, Conn., from an engraving.. 6.00
"Papa's Boots"; from an engraving.. 3.00
"Peace"; published by John P. Soule, G. G. Fish painter, 1864,
five tints of color.. 15.00
"Portia, Wife of Brutus"; published by J. P. Soule of Boston, 1866;
from a drawing... 4.00
"The Shepherd Boy"; copyright by E. P. Barney, published by
New York Photographic Co.; hand-colored....................................... 6.00
Spencerian exercise, "King of the Forest"; executed with a pen by
Wm. Warren... 16.00
"Tom Thumb, at Home"; from an engraving...................................... 15.00
"Undine"; published by New York Photographic Co., 1866, from a
drawing.. 5.00
"View of the Great Coliseum for the National Peace Jubilee";
Boston, from an engraving... 12.00
Webster, Daniel; from an engraving... 5.00
"Wildflowers"; published by John P. Soule, from an original by
G. G. Fish, 1864.. 4.00
"A Wolf in Sheep's Clothing, or Jeff in Crinoline"; published in

1865 by J. A. Arthur, Philadelphia Photo Co., 730 Chesnut
Street... $ 20.00
"The Young Adventurer"; from an engraving.................................... 3.00

Famous People

Beecher, H. W. and Mrs. Stowe; full-length portraits........................ 18.00
Bernadette (Soubirous); kneeling, holding a cross........................... 8.00
Bishop, Anna; by Gurney, c. 1860s. (Theatrical.)........................... 12.00
Booth, Edwin, the actor; by J. Gurney of New York.......................... 14.00
Booth, J. Wilkes; three-quarter pose.. 22.00
Bryant, William Cullen; profile of the poet, by Sarony of New York.. 15.00
Chase, Salmon; by Brady Gallery.. 12.00
Colfax, Schuyler; by Whitehurst... 10.00
Clay, Cassius M.; abolitionist.. 15.00
Everett, Edward; statesman.. 10.00
Fisk Jr., James; politician... 12.00
Garfield, James; bust pose.. 9.00
Greeley, Horace; portrait of the journalist with facsimile signature
at bottom, by Sarony of New York.. 15.00
Johnson, Andrew; by Brady Gallery... 35.00
Lawlor, Josephine. (Theatrical.).. 6.00
Lincoln, Abraham; bearded bust pose... 14.00
Lincoln, Abraham, and son; retouched and pirated photograph from
Brady negative, sold by the Philadelphia Photographic Co.,
Chestnut Street... 16.00
Lincoln seated with son Tad, wife, and uniformed son, retouched and
pirated from Brady negative... 16.00
Lincoln, Mary; portrait... 18.00
Montage of twenty risque stage beauties..................................... 12.00
Portrait of a Siamese diplomat; by Tournachon, Gaspard Felix
(Nadar), 1861.. 250.00
Prince of Wales and family.. 8.00
Sumner, Charles; by Whitehurst.. 10.00
Webb, Captain Matthew. Swam the English Channel, and died at
Niagara Falls in 1883; unknown photographer................................... 14.00
Young, Brigham; portrait, facsimile signature on reverse—Prest. B.
Young, by Savage & Ottinger, Salt Lake City................................... 18.00

Occupational

Actor with pistol and sword, full pose, hand-colored; by Koenig.. 8.00
Actress, woman with plume hat and stage costume; by Douglass
Gallery of New York... 5.00
Baseball player, with hat and bat, Boston team.............................. 10.00
Bishop Potter, prelate; by Sarony... 9.00
Blacksmith, man in apron on anvil, c. 1870.................................. 12.00
Brooklyn regiment, 14th New York Inf., identified Union soldier in
three-button coat holding a kepi and 14th Inf. horn........................... 19.00
Man in colonial costume, holding a cello and bow............................ 11.00
Fishmonger; man holding a knife and standing by table of cut fish.. 7.00
Frontiersman in buckskin; by H. Cameron..................................... 15.00
Man in cowboy outfit; by George Savage...................................... 14.00
Mountain man with Kentucky rifle, pistol, and Sheffield Bowie knife.. 35.00
Musicians, three seated men, one is playing the violin; photographer
unknown... 4.00
Negro farmhand, straw hat, overalls. Photographer: Dake Green-
wood of Wisc.. 8.00
Priest in religious garb.. 4.00
Rawlinson, Grace. Three-quarter theatrical pose............................ 6.00
Rose Rand, full pose, actress... 6.00
Spanish-American War soldier, full pose, hat, rifle, backdrop.............. 7.00
"Weston"; leather chaps, whip, riding coat.................................. 8.00
Whaler in "P" coat, knee boots, cap, holding a harpoon; by Olaf
Ericsson.. 13.00

Oddities

Albino girl, portrait. Photographer: Charles Eisenmann of New York.. 17.00
Bearded lady, full pose; by Charles Eisenmann, the Bowery, New
York.. 18.00
Child peeking through plant; optical illusion............................... 10.00
Commodore Nutt and Miss Minnie Warren, as groomsman and
bridesmaid at Tom Thumb's wedding, facsimile autographs on
reverse, 1863. Published by E. & H. T. Anthony from a
negative by Brady... 18.00
"The Dreaming Iolanthe"; a study in butter by Caroline S. Brooks,
1876.. 10.00
Fat Lady; Phoebe Dunn, age seventeen, 437 pounds, 1866..................... 12.00
Fannie Casseopia Lawrence; redeemed five-year-old slave child.. 20.00
Fifty-dollar Bill; specimen, c. 1860s (Later forbidden by govern-
ment.).. 22.00
Flowers; still life, hand-tinted.. 4.00

"Ghostly" vision of woman behind man; by spiritual photographer William Mumler of Boston.. $30.00

Jo Jo the Russian Dog-Face Boy; side show attraction.......................... 17.00

Klu Klux Klan member in costume, c. 1878................................. 40.00

"Last in Bed Put Out the Light"; comic...................................... 7.00

Leonard, Henry, "The Fisherman is Laughing," agent for Heidelberg College, Ohio. Comic text on reverse, c. 1868........................ 5.00

Leonard, Henry, of Basil, Ohio, that survived a snowstorm in a straw pile, 1868... 10.00

Midgets Admiral Dot and Major Atom standing by a table; by C. Eisenmann of New York..................................... 18.00

Midget Commodore Foote (Charles Nestel); by Gurney............... 15.00

Overweight boy, seated pose.. 8.00

Parents with midget child.. 15.00

Post mortem, dead child displayed on tabletop.......................... 18.00

Post mortem, dead child on black-draped couch; by C. Donner..... 16.00

Rock of Ages, sculpture... 3.00

Thin Man, circus attraction, with wife and child; photographed by C. Eisenmann of New York..................................... 17.00

Mrs. Tom Thumb; by Charles Fredericks of New York................ 16.00

Tom Thumb, wife, and child. (Photograph based on falsehood.).. 18.00

Tom Thumb and bride in later years... 12.00

Two wax figures in costumes, 1865... 8.00

Zarate, Senore Lucia, eighteen-year-old midget.......................... 12.00

Zobedia, Zoe, the "Bush-Haired Girl"; by C. Eisenmann of New York.. 12.00

Outdoor Scenes

Artisian Lithia Springs; buildings. Photographer: J. N. Randill.. 7.00

Asylum for the insane, Jacksonville, Ill., c. 1869..................... 9.00

Cache, Cave, Head of Echo Canyon. Photographer: C. W. Carter of Salt Lake City, Utah... 10.00

Cemetery monument; unidentified.. 7.00

Courthouse; Corinth, Mississippi.. 20.00

English building; woman in grass in forefront.......................... 6.00

Frontier town; drugstore, plank walks, dirt street..................... 13.00

Frontier town; horse-drawn wagons hitched in front of building, windmill in background... 25.00

Gloucester Cathedral, No. 2660, from the south-east. Photographed by Francis Bedford, photographer to the Prince of Wales............. 18.00

Hotel au Guillaume Tell. Photographer: F. Charnaux of Geneve.. 13.00

House and surrounding property; taken by Goodell, a "traveling photographer."... 12.00

Kalamazoo, Michigan, main street; horse-drawn wagons, dirt street, buildings. Photographer: Schuyler C. Baldwin..................... 15.00

Landscape; trees and stream, c. 1860s; by H. N. Robinson of Maine.. 8.00

Lawn tennis, c. 1870... 9.00

Maine, August; statehouse and grounds, c. 1880; by Dunton of Augusta... 8.00

Mardi Gras; New Orleans, 1881... 12.00

Masonic Temple of Boston; five-story building, c. 1870.............. 6.00

Model ship on pond, photographer's ad on side; by E. B. Nock, of Cleveland, Ohio.. 14.00

Savannah, Georgia; two 1860s views of Bonaventure Cemetery and an overview of city... 15.00

Sawmill; two views, c. 1860s.. 14.00

Steam engine, c. 1860s... 7.00

Steamship *Spain*; (National Line) with plan of cabins on reverse.. 20.00

Summer house, tramp art; H. M. Sedgwick studio, Granville, Ohio, 1873.. 10.00

U. S. Senate platform.. 15.00

Unusual bridge, people on it. Photographer: Mosley of Newbury-port, Mass.. 8.00

Victorian home, gingerbread decorations.............................. 12.00

CABINET VALUES

Animals

	Values
Cat with toy organ-grinder posed with small monkey displaying hat, titled "An Organ Recital"; copyright by L. A. DeRibas of Boston............	$ 16.00
Parrot on perch, with balloon expression coming from beak, "Go to Wissler for your photographs"; By Wissler of Canton, Ohio; copyright 1889...........	22.00
Pug dog on couch............	4.00
Several live baby ducks............	8.00
Small horse and colt, "An Equine Lilliput"; 1885............	8.00

Children

Baby in wicker carriage.. 10.00

Baby with dog, studio pose.. 8.00

Baby with toy horse on wheels; published at Omaha, Nebraska. $ 11.00

Boy in "Express"-brand wagon, pulled by pony.......................... 16.00

Boy on broom "horse"... 6.00

Boy on a swing; by Bowery of New York.................................. 10.00

Boy holding ball for dog.. 8.00

Boy on "Police"-brand wagon.. 10.00

Boy with a dog nearby on a table... 7.00

(Two views): Boy using pump, and girl holding pitcher to catch water; barefoot boy holding fishing pole, fish, and can of bait.. 14.00

Boy with rabbit; studio pose.. 10.00

Children: boy holding hoop, girl holding toy shovel and pail; studio props; by Y. Montignani of Bridgeport, Connecticut.................. 8.00

Girl and large bisque-doll; by B. Korn of Cleveland, Ohio, "Instant-aneous Portraits of Children.".............................. 12.00

Girl sitting by fake tree holding a book on her lap; by Judd of Chicopee Falls, Massachusetts..................................... 4.00

Boy holding switch, in studio; by Thomas Harrison, Central Music Hall Studios, "Porcelain Enamel Finish.".......................... 6.00

Small girl standing beside a baby in a carriage with large bisque doll.. 13.00

Small girl in stage costume.. 6.00

Small girl posed beside a toy horse on table; by A. J. Davison of Hartford Connecticut.. 9.00

Three children: one with flag, another with drum, and a third holding violin; outdoors.. 10.00

Twin boys, studio pose.. 5.00

Two girls standing beside a chair holding an open book; by H. B. Chase of Pandora, Ohio.. 3.00

Two children in winter clothes, posed with a sled in a studio.. 10.00

Collections

(Four) firemen cabinets.. 32.00

(Three) views of scenery in Florence, Italy, c. 1870s.................. 25.00

(Three) views of various members of Eastern tribes in native dress. Copies of earlier negatives by Great Central Photo and Copying Company, Galesville, Ettrick & Melrose; Wisconsin.................. 18.00

(Four) cabinets of various individuals; by Taber of San Francisco.. 16.00

(Three) cabinets of oddities: one giant with normal-sized man; George Levasseur, a strongman, lifting a group of men on his back; and the Horvath midgets of five members; all by Wendt Studio... 35.00

(Three) men in uniform with swords; by the photographers Tuttle, Beebe, and Ryder... 9.00

(Fifteen) opera personalities in an album................................ 95.00

(Four) views: two children with dog; child in chair with dog; boy on tricycle with dog; woman with dog seated on an animal hide.. 20.00

(Six) views of the destruction caused by the Johnstown Flood, 1889; by Holcomb & Hunter of Salina, Kansas.......................... 50.00

(Three) views of a hunter with shotgun and a dog; by Gardner of Utica, New York.. 15.00

Common People

Baby in huge studio-fabricated shell beside painted backdrop of an ocean; by Elite of Pittsburgh, Pennsylvania........................ 8.00

Bearded man pointing rifle, standing beside a table with large plant; by G. Gfeller of Germany, c. 1880s............................... 9.00

Black woman in velvet dress; by Randall of Detroit................... 12.00

Bridal couple, studio backdrop; by Jaeger of New York City, c. 1880s.. 4.00

Elderly gentleman in wheelchair; by Charles M. Jones of Speedsville, New York.. 10.00

Embossed portrait of woman; by I. W. Taber & Co., Yosemite Art Gallery, I. W. Taber and T. H. Boyd, 26 Montgomery Street, San Francisco, California... 6.00

Family posed beside wicker furniture.................................... 2.00

Family sitting on fake lawn in a studio................................. 2.00

Five gentlemen in various poses: one pouring liquid from a bottle, another reading a newspaper, and others smoking; by Adams of Irwin, Pennsylvania... 8.00

Hand-tinted studio bust pose of a woman leaning out of a window; by J. C. Schaarwachter of Berlin................................. 18.00

Man in dapper outfit, smoking cigar, holding cane; by Edward D. Pierce &Co., Aberdeen, Mississippi.............................. 5.00

Man sitting at a table viewing stereographs through a viewer, and seated woman looking at a family album; by Edmondson of Norwalk, Ohio. "Portraits of animals and objects in motion a speciality."... 22.00

Man with beard; negative retouched so that beard is floor length; by Mowry of Ashland, Ohio....................................... 6.00

Oval portrait of woman; by Bradley & Ruflofson of 429 Mont-gomery Street, San Francisco, California. "Have the only

elevator connected with photography in the world." $ 6.00

Oriental boy in kimono, full pose .. 6.00

Portrait, man framed within bunches of grapes and vines; by
 Johnson's Nickle Plate Photo Parlors of Jamestown, Pennsyl-
 vania .. 3.00

Tinted portrait of a woman; by J. K. Stevens of McVicker's Theater,
 Chicago .. 4.00

Three women holding six flags; by Gates of Charleston, West
 Virginia .. 7.00

Woman in brass-buttoned dress, carrying an umbrella and satchel;
 by T. W. McDermott of Salem, Ohio 2.00

Woman, bust pose on trompe d'oeil simulated piece of paper, rolled
 edges; by Bolton of Millville, New Jersey 2.00

Woman in Gibson-girl type dress, c. 1890s; by American Aristotype
 Co., of Jamestown, New York .. 2.00

Woman leaning on bookcase and displaying her six foot-long hair
 to the camera .. 8.00

Women sitting on grass in woodland setting, c. 1890s 4.00

Woman with large cross around her neck; by Taber of San Francisco,
 California ... 3.00

Young woman seated at a table and looking at her mirrored image;
 by Sharpsteen of Marshall, Michigan 5.00

Civil War

Burnside, General; by Gurney, of New York City 13.00

Avery, General; seated pose, album on table nearby, sepia-toned.. 18.00

Rhodes, William; in Union uniform, bust pose, at age seventeen
 when he volunteered, 1861. (Note: died at home, 1862.)
 Copied from photo ... 18.00

Vaurlette, General; in Union uniform, was Mathew Brady's nephew
 and apprentice; by Handy of Washington, D. C. 20.00

Young boy in Civil War uniform, playing a drum, tent backdrop.. 25.00

Engravings and Art

Budge and Toddie (Helen's Babies); from a drawing. Copyrighted
 and published by J. F. Ryder of Cleveland, Ohio, 1881.. 5.00

Elephantine Colossus; an architectual triumph, built at West
 Brighton Beach, Coney Island, description on reverse: 175 foot
 in height, with 31 rooms, 63 windows 18.00

Engraving of Justice Statue; by Sarony of New York City 10.00

Ferris wheel; from an engraving by Brisbois of Chicago 8.00

General U. S. Grant's Tomb, Riverside Park, New York; from a
 drawing .. 7.00

Memorial to "Our lamented friend Doctor Isaac Barclay" 1822–
 1887: features a pen-drawing of the doctor at his desk, with
 books and bottles on shelving; by Blacburn of Youngstown,
 Ohio .. 12.00

Pope Pius IX; from a painting, hand-tinted, from the series "Cabinet
 Album." .. 20.00

S. S. *Havel* steamship; from an engraving, by W. Sander & Son,1892.. 14.00

Famous People

Barnum, P. T. autographed; by C. Eisenmann of New York City,
 1885 ... 50.00

Bartlett family, Wild West team; holding rifles 55.00

Bernhardt, Sarah; by Sarony of New York City 20.00

Booth, Edwin; seated pose, copyright 1889 by B. J. Falk, No. 330,
 Newsboy of New York City ... 25.00

Branscombe, Maude; by Mora, Broadway, New York City 10.00

Bryant, William Cullen; bust pose ... 15.00

Buffalo Bill's Wild West Show; Indian warriors and teepees 60.00

Emerson, Ralph Waldo; poet, 1803–1882 15.00

Fielding, Maggie; actress ... 8.00

Finlayson, Flora; in stage costume, cape, and tights, posed before
 a stucco backdrop; by Newsboy, No. 119, of New York City... 14.00

Forrest, Edwin; bust portrait by Sarony of New York City 12.00

Fox, Della; wearing fancy hat; by Morrison of the Haymarket
 Theater, Chicago, 1895 ... 8.00

Garfield, James; bust pose .. 13.00

General U. S. Grant and family at Mt. McGregor; taken June 19th,
 1885. Copied by Barrett of New York City 30.00

Gerrish, Sylvia; risque pose, by Newsboy of New York City.. 14.00

Greely, Horace; journalist (1811–1872) 24.00

Hayes, President Rutherford; portrait ... 16.00

Jefferson, Joseph; as seen in Rip Van Winkle, from a woodburytype,
 c. 1871, by Sarony Studios .. 50.00

Irving, Sir Henry; actor, (1838–1905) .. 7.00

Kaiser Wilhelm II; in uniform, with Augusta Victoria and their son,
 at Potsdam, 1887; by Selle & Kuntze of Potsdam 18.00

Lewis, Lillian as "Credit Lorraine"; bust pose, elaborate hairstyle;
 by Baker's Art Gallery, Columbus, Ohio $ 8.00

Lincoln, Abraham, bust pose, poor condition 18.00

Longfellow, Henry Wadsworth; poet (1807–1882) 15.00

"Lotta"; child in bonnet, sitting on a stump; by Sarony of New
 York City ... 12.00

Mitchell, Maggie; theatrical .. 8.00

"One Bull"; Sitting Bull's nephew, bust vignette; by Bailey, Dix &
 Mead, 1882, Fort Randall, D. T. (Dakota Territory.) 38.00

Patti, Adelina; portrait in feathered hat, copyrighted 1882, by
 N. Sarony ... 20.00

Pawnee Bill & May Lillie; with rifle, high boots, deerskin jackets;
 by Sword Brothers ... 80.00

Photographer's sample card of twenty-four political subjects 25.00

Robinson, Anna; theatrical, published by Newsboy of New York
 City .. 7.00

Sample card showing twenty famous women in various poses.. 25.00

Tempest, Marie; posed in stage costume with birdcage on her back;
 by B. J. Falk of New York City ... 22.00

Theatrical couple in elaborate Shakespearian costumes; hand-tinted;
 by Reichard & Lindler of Berlin .. 26.00

Queen Victoria; three-quarter pose, holding crochet-hood and
 material .. 17.00

Washington, Booker, T.; Negro educator 22.00

Interiors

Hotel room of D. D. Dare, Hotel Brewster; ornate furnishings; by
 Parker of San Diego, California .. 9.00

Indian school, White Earth, Minnesota; stove, flags, alphabet chart,
 seated children holding slates, c. 1880s 16.00

Mission interior, "Arizona Scenes Series"; by Buehman of Tucson,
 A. T. (Arizona, Territory) .. 15.00

(Two) views of the Palace Hotel in San Francisco before its destruct-
 ion in the 1906 earthquake. Hallway showing superstructure
 and six floors of columned woodwork. "Watkins New Cabinet
 Series," Yosemite and Pacific Coast, 427 Montgomery Street,
 San Francisco ... 35.00

Young man strumming guitar; seated in front of a piano 7.00

Objects

Chair; hand-made with cushion .. 6.00

Plow, hand; on display in a studio .. 14.00

Occupational

Acrobats Victorelli & Young Eldon; Cincinnati, Ohio 18.00

Acrobats; three, unidentified; in costumes 9.00

Building of an ale house; men and kegs, c. 1880s 8.00

Charity photograph; young man in ragged clothes, holding pamphlets
 and shoe-shining kit; by J. A. Foster of Adrian 15.00

Cobbler in leather apron, repairing shoes, sitting on a cobbler's bench.. 16.00

Corbett, Gentleman Jim; famous boxer in stance; by Newsboy of
 New York City ... 12.00

Cowboys; three Westerners, wearing hats and boots, posed before
 canvas backdrop ... 17.00

Doctor in office ... 8.00

Harpist; girl in fancy dress with harp; by Obermuller and Son,
 "Instantaneous Portraits," 888 Bowery, New York City 8.00

Man with early large-wheeled bicycle .. 25.00

Man with early two-wheeled bicycle, in studio; by A. Hillman,
 Buffalo, New York, ... 15.00

Miner in outfit holding tin bucket .. 16.00

Nurse in long white apron, cap .. 10.00

Pharmacist Sam Ridgeway, holding a medicine bottle as if dispensing
 it; by Graham of Titusville, Pennsylvania 14.00

Policeman in uniform and hat; protrait; by W. J. Wood, Stafford
 Springs, Connecticut ... 8.00

Railroad worker; wearing overalls, gloves, cap, and kerchief around
 neck; in studio; by Haines of Wakeman, Ohio 16.00

Rock Band Concert Party; members of the Till Family of Bayonne,
 New Jersey. Unusual instruments displayed; by Naegeli of
 New York City ... 15.00

Sports; two boys in oarsmen uniforms, with "P" on tank shirts;
 by Frey of Syracuse, New York ... 6.00

Violinist; young boy with instrument ... 4.00

Wagon filled with woven baskets and brooms, man and youngster at
 reigns of horse; by Rand & Taylor of Cambridge, Massachusetts,
 c. 1880s .. 7.00

Woman holding coronet .. 5.00

Woman with zither on nearby table ... 7.00

Oddities

Ahnetta, the snake charmer, in studio pose, with live snake around

neck; by Swords Brothers, "Professional Photographers," York, Pennsylvania.......................... $ 16.00

Blondin, James Hardy; hero of Niagara Falls, New York; in studio.... 18.00

Jumbo; circus elephant with trainer and two other men................ 22.00

Indian boy with long hair; bust pose, by F. A. Hartwell of Arizona Territory... 35.00

Indian mother in embroidered outfit; papoose beside her; studio pose; by Chandler of Akron, Ohio...................................... 30.00

Man in woman's dress, with fan.. 10.00

Man with wooden leg, holding a Bible, and a child with deformed foot; by Lewis J. McDade, Transvaal Afnemers (Africa.).. 14.00

Memorial flowers surrounding cabinet photo of two children; by Charles V. Hamer of Columbus, Ohio, 1889.......................... 3.00

Memorial floral bouquets on table and a sword on display; by Foster of Norwalk, Ohio.. 2.00

Mexican girl; by Cortell & Collom of New Mexico........................ 5.00

Midgets, three, posed, c. 1880; by Charles Eisenmann of New York City.. 18.00

Midge, W. Wimmer; full pose in white tie and tails; by Wendt of New York City... 14.00

Montage of ten views of "The Flood," arranged among grasses and cattails; by J. G. Hill, "Portrait and Landscape Photographer," of Monroe, Michigan.. 4.00

Mourning card; oval photo of boy, born 1871, died 1888.............. 4.00

Peek, Miss Myrtie; champion long-distance and Roman-standing lady rider of the world from Mendon, Michigan, born March 11, 1868. Timed exposure, two of the images show "ghost" images, one other full-length pose in costume........................... 30.00

Post-mortem of baby in a wicker carriage............................... 15.00

Post-mortem, small baby on cushion holding a flower; by George L. Lamson, La Fargeville, New York, 1888........................... 16.00

Post-mortem, young man in casket, holding his cap; by Bruce G. Fisher of Everett, Pennsylvania...................................... 15.00

"Steps-A Nes Perce Indian No. 3," shows Inidan who joined Sitting Bull and lost his hand and both feet, Fort Randall, Dakota Territory, 1882... 37.00

Studio advertisement, man standing with back turned looking at sign saying, "Photographs, best on earth for the money, by Wissler, 62 Jackson Street." Man is wearing pointed dunce cap with skull and crossbones motif, smoking pipe, and holding rifle; by Wissler of Canton, Ohio.. 25.00

Sutherland Family of Seven Sisters, displaying hair from three feet to seven feet in length, ad on reverse for hairgrower; by Morris of Pittsburgh.. 20.00

Tribe of nine aborigines with painted bodies, holding poles and bomerangs; "A Christmas and New Year Greeting," printed in gold, 1898... 26.00

Two overweight children, 217 lbs. and 158 lbs........................ 12.00

Young girl, seated, with pen held in right foot, writing a letter; by Rich's of Chicago, Illinois..................................... 18.00

Outside Views

Alaska, No. 5447—Indian Avenue, Sitka; overview of street, buildings, and cannons; by F. Jay Haynes of St. Paul, Minnesota.. 23.00

Baseball practice on field.. 15.00

Bath, New Hampshire; snow-covered bridge and small town; by Notman & Cambell of Boston...................................... 20.00

Berlin; statue of Frederick Wilhelm III; by Rommler & Jonas of Dresden.. 6.00

Boy on a horse near a two-story house; by Gerhard Gesell of Alma, Wisconsin.. 4.00

Building with large sign, "The Jewell Photographer," on second story; people standing before the windows, a watch and millinery shop below; by Jewell of Scranton, Pennsylvania..................... 14.00

Colorado; "View of Mt. Baldy on August 6, 1882, taken from Ft. Garland, a distance of twelve miles," railraod depot and boxcars in foreground.. 20.00

Cowboys on the Prairie; blind-stamped Huffman..................... 50.00

Dakota Territory; hospital and quartermaster's building, signal office, and Fort of Flagstaff; processed at Pembina, D. T., c. 1882; unidentified.. 25.00

Denver, Colorado; panorama, view No. 243.......................... 26.00

Denver mansion, No. 2260, "The Kittridge Residence, Colfax Avenue"; by William Jackson, c. 1880s.......................... 22.00

Football game in progress... 15.00

Fountain in town square, two men, trees; by J. Berubet of Clermont.. 7.00

G. A. R. related, Buffalo, New York. Main street decorated with flags and banners, trollies travel through huge display of G. A. R. letters... 14.00

Garfield's monument; Cleveland, Ohio................................. 9.00

Georgetown; from Griffith Mountain, No. 1810; an overview.

Descriptive reverse about Clear Creek Canyon of which the "principal occupation is mining"; by W. H. Jackson & Co., 414 Larimer Street, Denver, Colorado.............................. $ 27.00

Girl standing on grass beside a huge rock; by E. H. Decker of Narrowsburg, New York.. 4.00

Group of men standing in front of a store............................. 10.00

Hotel Del Coronado; by Parker of San Diego, c. 1890s.............. 8.00

Hotel Del Monte, Monterey, California, c. 1880s; by C. W. Johnson.. 10.00

Hotel Victoria at Interlaken; by R. Leuthold of Interlaken, Switzerland.. 8.00

House; two-story wood frame, surrounded by fence, family on porch, c. 1870s... 4.00

Indian mission school; pupils and teachers out front; by F. Jay Haynes of Fargo, D. T... 20.00

Leadville, Colorado, No. 633; South overview showing cabins and wooden buildings; by William Jackson......................... 40.00

Maine, Biddleford Pool; old boat in foreground, other vessels; by Coolidge of Boston, c. 1885..................................... 9.00

Man in horse-drawn carriage in an orange grove, California, c. 1890s; by Tresslar of Riverside, California........................... 9.00

Manitou, Colorado, No. 2000; an overview; by Wheeler.............. 20.00

Mission at San Juan Capistrano, Southern California, No. 10864.. 10.00

Missionary; Father Brown on donkey, native standing by a stone wall; by Wolfram of Akron, Ohio.............................. 15.00

Nantucket; town overview, c. 1885; by J. Freeman of Nantucket.. 7.00

Notre Dame Cathedral of Paris; unidentified........................ 10.00

Oil well; unidentified.. 8.00

Old inn, with horse-drawn stage, and driver (foreign).............. 9.00

The Old San Gabriel Mission, San Gabriel, California; Continent Stereo, c. 1870s.. 10.00

Parade and Fourth of July celebration in Salt Lake City, Utah, 1887.. 15.00

Paymaster Mine, Colorado; men near mining building, c. 1880; by Miller & Chase... 18.00

Railroad tunnel on Spring Creek; by Pollack & Boyden of Deadwood, Dakota Territory, c. 1870s................................ 16.00

Ridgeway Sanitarium, "The Last Resort for Suffering Humanity"; three-story structure with many people on the porch, man on bicycle out front; by John Kendall of Titusville, Pennsylvania.. 14.00

Royal Gorge, Grand Canyon, Denver Railroad, c. 1888; by Charles Savage.. 18.00

S. P. Davis photo studio, samples in the windows; by S. P. Davis.. 22.00

S. S. Corona & Anron, Glacier Bay, Alaska; by Goldsmith Brothers, Portland, Oregon, c. 1890s...................................... 20.00

Sailboats; pair of cabinets of America's Cup racing-sailboats in full sail, Valkyrie III and Defender, 1895.......................... 17.00

Salt Lake City, Utah, view of Assembly Hall; by Charles R. Savage.. 24.00

Sante Fe, New Mexico, "The Old San Miguel Church," No. 302; by Henry Brown, c. 1870s.. 18.00

Scenes (two) of a train wreck; unidentified.......................... 13.00

Soda Springs, Manitou, Colorado. Shows Cliff House, stream, other buildings; by Galbreaith, Harvey & Lyles........................ 20.00

Spanish-American War soldier with rifle, canteen, and other accouterments posed in woods. From Camp Alger, Virginia; by Roshon of Harrisburg, Pennsylvania.. 12.00

Steam-traction engine in use as a drive for a sawmill. Four of the crew are sitting on the engine, one is standing.................. 20.00

Stone chateau; by E. Boulle of France................................ 6.00

Storefront; New York Morse Horse-Clothing Factory, sign over door, workers in front... 13.00

Survey team, with tent, wagons, tools; unidentified................. 15.00

Tents, flags, horse, soldiers, caissons. 1880s reprint from Civil War negative... 16.00

Texas, No. 1–"The Alamo Built 1718", reverse has printed history, c. 1885; by Jacobson of San Antonio............................ 12.00

Tollgate, Pike's Peak Trail; five people by tollgate building, Rocky Mountain Scenery; by William H. Jackson & Co., Denver, Colorado.. 25.00

Views (two) from the Columbian Exposition; unidentified............ 20.00

William Penn House in Philadelphia................................... 8.00

STEREOGRAPH VALUES

Alaska	Values
No. 9191, Bound for the Klondike Gold Fields, Chilkoot Pass, Alaska. Hundreds of miners with supplies; copyright 1898, Keystone View Company..	$ 8.00
No. 9063, Dying Klondiker, 1898, orange mount; published by Keystone View Company..	7.00
No. 1332, The Principal Street of Gold Bottom, the Kondike, Alaska. Color lithoprint, cp. 1905; by T. W. Ingersoll........	3.00

No. P–9271, Reindeer and Sleds, Haines, Alaska; by Keystone View Company .. $ 3.00

Will Campbell, The only white boy on the Allenkaket River, Alaska; copyright 1909 by Keystone ... 5.00

Working No. 4 Bonanza, Klondike, Alaska. Color lithoprint; by Griffith & Griffith ... 3.00

Collections

Battle of Gettysburg; six views from artist's drawings, yellow and orange mounts; by Mumper & Company 10.00

California; nine views as Mills in Mendocino County, construction of a dam at Casper River, hand-tinted view of Twelve-Mile House, Yosemite Valley, etc., yellow mounts; by John Soule (Darrah Sale) ... 225.00

Coronation of Edward VII; four views; by H. C. White 17.00

Costumes Around the World; boxed set of 95 views (five missing) as Alaskan, Hopi Indian, European, Far-Eastern, etc.; Keystone View Company, c. 1900, (Darrah Sale) 230.00

Darien Expedition; nineteen views with scenes of foliage, huts, villages, and Moran lying in the jungle. Each view titled in Moran's hand on reverse, all photographed by John Moran, c. 1871. (Darrah sale) .. 725.00

Electric light views in the Luray Caverns, Page County, Virginia; by C. H. James, 1882 .. 30.00

Great Britain; twenty-five card boxed set, many overviews; by Keystone View Company .. 45.00

The Great War; one hundred views of World War I; by Realistic Travels .. 145.00

Last Buffalo Chase in America; thirty-card series, gray mounts; by N. A. Forsyth of Butte, Montana ... 75.00

Miscellaneous lot of twenty-three cards: nine of European scenes on yellow mounts, twelve scenes of war destruction in Spain, one tissue view, and a color scene of Germany; by Steglitz of Berlin.. 20.00

New Orleans and vicinity; twenty-nine views including street scenes and harbors. Photographers such as Mugnier and S. T. Blessing, c. 1870–1880. (Darrah Sale) .. 225.00

New York City; six views of Columbia College, the "EL", East River Bridge, etc. ... 10.00

Queen Victoria's Funeral; six views of coffin and mourners; by Excelsior Tour ... 45.00

Rodeo Series; seventeen views No. 33454–70, Century of Progress, 1933; by Keystone ... 35.00

Russian-Japanese War; one-hundred views, color lithoprints; published by Ingersoll ... 35.00

Russian-Japanese War; one-hundred view boxed set of military operations on the Japanese side of the War, 1904; by H. C. White and Co. (Darrah Sale) .. 375.00

Scenic America; three-hundred views, National Parks, Florida, Washington, D. C., etc. ... 200.00

Scotland; sixty-four views in cardboard-marbleized box, yellow mounts, landscapes by G. W. Wilson 160.00

Tour of the World; set of six-hundred views, with book and tele-binocular; by Keystone ... 365.00

A Trip Through Sears Roebuck & Co.; fifty view boxed set.. 35.00

U. S. Navy; twenty-five lithoprints, sailors at work, c. 1900... 50.00

A Wedding from "the proposal" to "alone at last"; by H. C. White Co., 1902 ... 25.00

World War I; sixty-five views of field action, observation balloon, etc.; by Realistic Travels of Britain 90.00

Yellowstone; ten views of Old Faithful, Hayden Valley, etc., tan mounts; by F. J. Haynes .. 45.00

Yosemite Valley; boxed set of twenty-four views; by Underwood & Underwood ... 40.00

Yosemite; seven views of giant trees, group scene, coastal waters, and mountain landscapes, yellow mounts, early 1860s; by Carleton E. Watkins. (Darrah sale) 225.00

Comic Views

"An' it's me tooth! God Bless you, Doctor dear!" Woman with ice pack; Underwood & Underwood, 1901 3.00

The French Cook; twelve views, 1905; by Kilburn Brothers.. 20.00

"I am Going to be Married"; black man holding flowers; tinted, cream mount, square corners .. 7.00

"The Love Song of Today"; elaborate Victorian setting, bear rug, vase, tea set, etc., tan mount; 1900, Underwood & Underwood.. 2.00

"Mrs. Brown returns, unexpected," No. 44, lithoprint, 1898; by T. W. Ingersoll ... 2.00

Photomontage, No. 11466; "In Olden Times, if folks were good, the stork would bring a baby sweet and fair"; No. 11467, "But now, alas! Those times are past. He brings a 'teddy' bear." Keystone View Company .. 8.00

The Sick Dolly, No. 312; dolls and doll furniture; by Weller.. $ 4.00

"You Can't Have My Doggie"; girl and dog, 1891; by George Barker.. 3.00

Disasters

Boston fire series of 1872, closeup of fire apparatus, soldiers; by Kilburn Brothers .. 40.00

Boston Fire, "The Ruins of Trinity Church," November 1872, yellow mount; by Soule ... 9.00

Burning of Barnum's Museum; ruins hung with ice after the fire of 1868 ... 9.00

Engine "Charles Miller," Utica & Black River R. R., exploded at Watertown, 1872, purple mount ... 14.00

Great Flood of the Ohio River at Cincinnati, February 1883, five views; by G. F. Gates .. 15.00

Johnstown Flood; six cabinet-size views; by Holcomb & Hunter of Salina, Kansas ... 50.00

Locomotive Stinger after a boiler explosion in February of 1868; by Sanborn of Lowell, Massachusetts 25.00

Maine; three views of the battleship, two after being wrecked, 1898, tan mounts; by Keystone View Company 10.00

Mill River Flood of 1874; wrecked and displaced houses, orange mounts, two views; by Ireland of Springfield, Massachusetts...... 5.00

Palace Hotel, No. 8703; interior burned out after San Francisco disaster, 1906; published by H. C. White Co., the "Perfec" stereograph .. 5.00

The San Francisco Earthquake, April 18, 1906, No. 5326; City Hall, with a photographer in the forefront, gray mount. The Art Nouveau (Platino) Stereograph, C. H. Graves publisher, 1906.. 12.00

Eastern Cities

Along the noted Bowery, New York, U. S. A.; streetcars and horse-drawn moving van, gray mount, 1899; by Underwood & Underwood .. 3.00

Broadway street scene; an Anthony Gelatin-Bromide instant view.. 8.00

Building the New York City Subway; machinery and excavations; by Keystone ... 5.00

Canal Bridge, No. 6644, Erie Canal at Little Falls, New York, orange mount; by Anthony ... 6.00

Cresent House, Saratoga, New York; street scene, yellow mount; by Delos Barnum ... 5.00

Erie Railroad, No. 675, Starucca Creek and Viaduct; by E. Anthony... 6.00

Ford's Theater; unidentified mount .. 10.00

Fourth of July in New York City; scene on the Bay during the Regatta, c. 1860, yellow mount; by E. Anthony 24.00

Front Street in Marquette, Michigan, No. 324; stores, etc.; by Bailey & Whiteside ... 6.00

Glen Alpha, "Satan at the Bathtub"; Beauties of Seneca Lake, Freer's Glen; by Professor Towler, MD., (Amateur Exchange Club) ... 25.00

Grace Church, Baltimore, Maryland; tinted, yellow mount of 1858; by American Stereoscopic Co., Langenheim, Lloyd & Co.. 22.00

Grave of Washington Irving, Sleepy Hollow; American Views series.. 5.00

Grand Central Depot of New York City; by Ropes & Co 10.00

Hoosac Tunnel; magnesium light closeup of two workers; by Hurd & Smith ... 18.00

Horseshoe Falls at Niagara, camera and tripod in foreground; by George Barker ... 6.00

Hotel Southern, St. Louis, c. 1877; by Boehl & Koenig 7.00

Irving, A Shaker Village near Watervliet, New York; by Troy. 15.00

Lake George, New York; two men by lake, c. 1860s; blind-stamped Delos Barnum ... 14.00

Mather's Penn Oil Regions, Central House Petroleum Center; diamond-stack locomotive in mid-foreground 25.00

Meeting of the Massachusetts Historical Association; men and buildings; by American Stereoscopic Co., Langenheim, Lloyd & Co. .. 17.00

Natural Bridge of Virginia; two views from James Cremer's Stereoscopic Emporium, one with 1858 Langenheim label 30.00

Panorama of the great international yacht race, 1885, tan mount; by Kilburn ... 4.00

President's Mansion, Washington, D. C., U. S. A.; tinted, c. 1900, tan mount; by Underwood & Underwood 2.00

Private issue of the Kilburn house in Littleton showing, "Grandpa and Grandma, Mrs. Kilburn, and Lizzie." 50.00

Residence of Mrs. Samuel Colt, Hartford, Connecticut; by De Lamater... 5.00

Street scene, instantaneous view No. 5081, yellow mount, sign of E. Anthony's Gallery visible, by Anthony 35.00

"Washington, D. C. September 20th, 1892, Grand Review of the G. A. R."; tan mount; by William H. Rau, published by Griffith and Griffith ... 4.00

The White House, 1858; by Langenheim... $ 18.00
William Henry Hotel in New York, No. 853; from Lake George
 Series, orange mount; by D. Barnum.. 4.00

Expeditions

Clarence King Survey of the Fortieth Parallel, 1867–1869; three
 views by T. H. O'Sullivan, including "Geyser, Ruby Valley," etc.. 75.00
Darien Expedition, "Chipagana from the Hills"; overview, No. 18;
 by Anthony... 40.00
Darien Expedition; six views taken by T. H. O'Sullivan...................... 165.00
Fisk Expedition, No. 235, "Rendezvous," St. Cloud, Minnesota;
 by Carbutt... 50.00
Powell Survey, No. 100, "Trinalcove, Views of the Green River";
 by E. O. Beaman.. 20.00
U. S. Topographical & Geological Survey of the Colorado River; by
 J. W. Powell and A. H. Thompson. View of a waterfall, 1871–
 1872, gilt-edged... 18.00

Expositions

Boston Coliseum, 1869; photographed by Towle............................... 5.00
Centennial of 1876; four new Excelsior Series, orange mounts.. 12.00
Crystal Palace, Court of Monuments of Christian Art; tinted,
 blind-stamped; Paul Curtis, New York.................................... 5.00
Crystal Palace; the Royal Box shows the Princesses Alice &
 Helena, Prince of Leininger, and Prince Consort, 1859; by
 London Stereoscopic Co... 25.00
Jamestown Exposition; Indians in full dress, No. 14196; by Keystone 5.00
Jamestown Exposition–Opening Day April 26, 1907, "Some of the
 great warships in Hampton Roads," gray mount; Keystone
 View Company... 4.00
London Exhibition of 1862, "Machinery, Western Annex," No. 211;
 by London Stereoscopic Company.. 10.00
National Photographic Association Exposition at the Cleveland Bank,
 1870; interior view of displays; by E. & H. T. Anthony.. 100.00
Trans-Mississippi Exposition, "The Grand Court from the Roof of
 the Agricultural Building, Omaha, 1898; by Strohmeyer &
 Wyman... 7.00

Famous Personalities

Beecher, Henry Ward; full-length view, 1860, yellow mount; by
 London Stereoscopic Co... 10.00
Belmont, Miss; a fat lady, cream mount; by Ingersol of St. Paul,
 Minnesota... 6.00
Bryan, W. J., with his horse at Lincoln, Nebraska; by Underwood
 & Underwood... 6.00
Careno, M.; bust portrait of the pianist; by J. Gurney...................... 8.00
Dana, Brig. Gen. N. J. T. No. 2101; Anthony Prominent Portraits
 Series.. 30.00
Dickens, Charles; standing pose; by Gurney.................................. 45.00
Gladstone, the British Prime Minister; hand-colored, yellow mount,
 c. 1860s, fascimile signature on the reverse............................. 22.00
Grant, Lt. General, No. 2427; at his headquarters in Virginia,
 orange mount; from Brady negative by Anthony........................ 40.00
Grant, Mrs. Lt. General, No. 2096; full pose in studio, revenue
 stamp; Anthony Prominent Portraits...................................... 20.00
Greely, Horace; journalist and presidential candidate; by Gurney
 & Son.. 65.00
Harding, President, No. 18535, "Holds the Baby and Talks to the
 Farmers," Hutchinson, Kansas; gray mount; by Keystone
 View Company... 6.00
Harte, Brett; California writer; by Sarony of New York City.. 40.00
Hobson, Lieut. Richmond Pearson; the "hero" of the Merrimac
 standing on a dock beside boats, chains, etc., 1898; Underwood
 & Underwood... 10.00
Logan, Olive; actress, portrait; by J. Gurney & Son........................ 8.00
McKinley, President; 1901, six views of his funeral; by the Keystone
 View Company... 16.00
McKinley, President, and his eight chosen advisors at the cabinet
 room, Executive Mansion, Washington, D. C., 1900; by
 Underwood & Underwood.. 6.00
Pope Pius IX, 1860s; by D'Alessandro of Rome............................. 22.00
Pope Piux X on Papal Throne; by Underwood & Underwood.. 3.00
Roosevelt, Theodore; at his desk in the White House, 1903;
 Underwood & Underwood.. 8.00
Rousby, Mrs.; actress series; "Stereographs of English Female
 Beauty," c. 1860s; green mount; London Stereoscopic
 Company... 12.00
Speltereni, Signorian Marie. No. 197; in high rope performance
 over the Niagara River, 1872, orange mount; by Curtis.. 20.00

Washington, Booker T. No. 11960, with Carnegie and others at
 Tuskegee; by Keystone View Company.................................... $ 18.00
Wilson, President, with Brand Whitlock, World War I, No. 19265;
 by Keystone View Company.. 5.00
Young, Brigham; portrait with facsimile signature, Mormon Cele-
 brities Series, blue mount, c. 1870; by C. W. Carter.................... 50.00
Young Carver and the Wild Girl of the Forest; Carver aims to shoot
 apple off girl's head, orange mount; by W. L. Bacheldor of
 Durand, Wisconsin.. 16.00

Foreign

"Boalbec," No. 24, signed by Frith, c. 1859, gray mount; by Ameri-
 can Stereoscopic Co.–Langenheim, Lord & Company label.. 12.00
Canada Side, Horseshoe Fall; gentleman in foreground, tinted,
 cream mount; by London Stereoscopic Company...................... 12.00
China; view of man in native costume, orange mount; by J. F.
 Stiehm of Berlin, Germany, 1878.. 10.00
Egypt; the Sphinx and the Pyramid, No. 1,1860; by Frances Frith. 15.00
Egypt; Temple of Karnak, No. 171; Eastern Series.......................... 4.00
England; interior views of Abbotsford, No. 575 Entering Hall,
 No. 573 The Study; by G. W. Wilson.................................... 8.00
England; Devonshire Illustrated, No. 2433 Glen Lyn Waterfalls,
 No. 2441 Cottage at Watersmeet; both by Francis Bedford.. 12.00
England; No. 2863 Tintern Abbey, No. 1771 Chudleigh Boathouse,
 No. 176 Shakespeare's House; by Francis Bedford...................... 18.00
French nude, transparency; Societe Photographique, L. D'Oliver &
 Cie, Paris.. 27.00
Jerusalem; three panoramic views, yellow mounts; by Frank M.
 Good.. 10.00
Martinique, West Indies; Mount Pelee volcanic eruption, destroyed
 St. Pierre; by Underwood & Underwood................................ 3.00
Oberland Bernois; Nos. 511, 741, 1117 of ice and houses, yellow
 mounts, three views; by Braun.. 10.00
Switzerland; Alpine Club views; No. 212 Glacier, No. 239 Gorge,
 and No. 134 Lake Lucerne... 15.00

Genre Views

Circus parade, elephants and attendants, 1900, gray mount.............. 8.00
Children playing house with large dolls, No. 11490; by Davis.. 4.00
Croquet players, c. 1860s; by Morrison of Haverhill, New Hampshire.. 5.00
Diables, "Visite du Soleil a Satan" and "La Loterie Infernale";
 Diamond "H" reprints.. 5.00
Girl with camera and dog, "Teaching Fido how to focus," color
 lithoprint... 6.00
Hamlet, Act 3 Scene 2; hand-tinted, attributed to "Phiz," c. 1857.. 14.00
"Knowledge Under Difficulties," No. 1377; children being forced to
 attend school; "Group" Series... 3.00
"Mama wondered where Jessie could be"; child with doll, 1902,
 tan mount; Keystone View Company.................................... 3.00
"Parting Promise" No. 1010; Rogers group; by Bierstadt................... 8.00
"Returned Volunteer"; Rogers group, green mount........................... 6.00
"Rosa's Kittens"; cat and her kittens, yellow mount; by Parmelee of
 Windsor Locks, Connecticut.. 3.00
Sculptures of Queen Victoria and Prince Albert; (two views) c. 1856;
 by Disderi.. 8.00
Skating scene in 1866, No. 4801; orange mount; "Anthony
 Instaneous.".. 10.00
Skeleton leaves, No. 1165; photos of Cleveland and Hendricks
 surrounded, 1884; by Littleton View Company of New
 Hampshire.. 8.00
Skeleton leaves, No. 4809, Lincoln memorial; yellow mount; by
 Anthony... 10.00
The Soldier's Farewell; Spanish-American War soldier in uniform,
 1898; by the Atlas Stereographs of Chicago............................. 2.00
Still life with a "Brewster" viewer, guitar, etc., c. 1854; by T. R.
 Williams.. 60.00
"The Wedding"; couple and attendants before a minister, gray
 mount, c. 1860.. 5.00
Woman; a portrait, with muff; by Fritz Luckhardt........................... 4.00
Woman; seven views of a semi-nude, gray mounts; By Ex. Supply
 Company... 45.00
Woman at a window; studio pose, tinted, gray mount; Reynolds
 blind-stamped.. 6.00

Hunting

"Before the hunt—getting ready for a fox chase"; eastern Kansas,
 hunters on horseback with dogs in forefront, 1903; by
 Underwood & Underwood.. 4.00
"The Hunters' Home," No. 5940; hunters with rifles, pelts hanging
 from house—bear hide, dead game, and dogs, tan mount, 1891;

by B. W. Kilburn.. $ 10.00

"Quail shooting in the stubble, a point lookout!"; two hunters
with shotguns, dogs, 1891, tan mount; by George Barker of
Niagara Falls, New York, "Gems of Instantaneous Photography".. 3.00

"The veteran bear hunter"; with rifle, orange mount, 1883; by
Kilburn.. 3.00

"Well! I've got all I want." Hunter with shotgun, looking at canoe
full of dead ducks, cream mount, 1898; by Liberty Bond
Stereo Views, Ingersoll.. 3.00

Indians

Chippewa deer hunters with rifles and snowshoes, No. 497; by
Zimmerman... 28.00

Farmer's house on Pawnee Reserve, No. 210; eight Indians, cart, and
buildings; Indians Series; By W. H. Jackson of Omaha, Nebraska.. 23.00

"Horseback, Comanche Chief"; lithoprint................................. 4.00

Indian boys playing on sand, Columbian River in Oregon, tan mount.. 12.00

"Indian Fur Camp on the Plains," No. P 23315; teepee, wagon,
Indians, furs drying, gray mount; by Keystone...................... 8.00

Indians talking in sign language to a cowboy, No. V23247, gray
mount; by Keystone View Company................................. 6.00

Indian Warriors in Council, No. P 23347; gray mount; by Keystone
View Company.. 7.00

Mow-Way, Comanche Chief; lithoprint.................................. 4.00

"Old Scar Face," No. 334; taking aim with his bow and arrow; by
Charles Weitfle of Central City, Colorado.......................... 26.00

Pueblo Tesuque girls, No. 46; carrying water, yellow mount; by
Bennett & Brown... 32.00

"Scene at Indian Payment, Odanah, Wisconsin," No. 738; squaw
with two papooses in canoe, yellow mount, some foxing; by
Whitney & Zimmerman of St. Paul................................. 25.00

Zuni Indian braves, No. 19 Wheeler Survey, 1873, Pueblo, New
Mexico; wet-plate camera in foreground; by T. H. O'Sullivan... 45.00

Occupations

"Bale of cotton, after pressing", Black workmen, cabinet mount;
by Wilson of Savannah, Georgia.................................. 5.00

Banana plant, No. 1917; workers and cactus, views in New Grenada,
South America; by Anthony... 4.00

Blacksmith in his shop with a black boy assistant, No. P 18206;
tools, and horseshoes, gray mount; by Keystone.................. 4.00

"Chain shop, State Prison, Boston"; interior view of furnaces and
chains; Peoples' Series... 4.00

Farming, steam-plow pulling six-hand plows guided by a farmer,
c. 1870... 9.00

"Harvesting," No. 147; threshers in Dakotas, tan mount; by F. J.
Haynes... 15.00

Hydraulic mining, Oregon, No. 13796; 1905; by Keystone............. 5.00

Making sugar in the North woods of New York, No. 5938; published
by Anthony, photographed by F. B. Gage.......................... 9.00

Polling logs in McCloud River at the lumber company's mill pond
near Mt. Shasta, California; 1902; by Underwood & Underwood.. 6.00

Railroad wreck on Tariffville bridge; cabinet-size, 1878; by N. R.
Worden of New Britain, Connecticut.............................. 13.00

Street sprinkler tanking up, No. 539; by Stoddard.................... 8.00

Textiles; four views of the American Print Works at Fall River,
Massachusetts, 1872; by Kilburn.................................. 25.00

Trains, No. 7090; general view of erecting shop, Baldwin Locomotive
Works, Philadelphia; by Keystone................................. 5.00

Whaling; blubber being lifted from dead whale onto boat; by
Freeman of Nantucket.. 18.00

Photographica

Alden's photograph-ferrotype rooms, banners across the interior of
the Providence, Rhode Island Arcade, No. 40, yellow mount.. 18.00

Cat-O-Graph-ic," Three Kittens Exploring a Wet-Plate Camera";
by J. P. Soule... 16.00

Girl looking into a Cadwell table model stereo-viewer; by G. Strand
of Worcester, Massachusetts....................................... 15.00

Interior of reception room of E. M. Johnson's Gallery at Crown
Point, New York; framed prints, viewer on table.................. 45.00

"J. A. French and his traveling photographic van"; van with adver-
tisements.. 35.00

Photographer eighteen stories up with stereo-camera on beam,
New York City; by Underwood & Underwood....................... 18.00

"A photographer's feat unparalleled, the photographing of so many
babies (twelve) in one group and getting them all still is a thing
probably never before accomplished," 1874; by Lewis of
Hudson, Massachusetts.. 8.00

"The Stereo Weno (Hawkeye)"; actual photos taken with the camera;
published by Kodak Ltd., England.................................. 12.00

Up the river from north mouth of second ravine, stereo-camera on
ledge opposite... $ 25.00

Railroad Series

Bear Valley and Yuba Canyon, No. 215; Central Pacific Railroad;
yellow mount; by Alfred A. Hart.................................. 16.00

Devil's Slide, interior, No. 117; Union Pacific Railroad, c. 1869,
green mount; by Savage & Ottinger, Salt Lake City, Utah.. 12.00

Eight-Mule Team with three wagons, No. 1286; Central Pacific
Railroad; by Thomas Housewerth & Company...................... 20.00

"Ranch on the Plains," No. 205; a frontiersman and his family by
their log cabin, Bridger Series No. 6, Union Pacific Railroad,
Smith's Rocky Mountain Scenery; negative by A. J. Russell.. 30.00

River and Canyon, No. 341, and Fourth Crossing of Truckee River,
No. 279, Central Pacific Railroad; by Alfred Hart............... 34.00

Roof of Snow Covering Central Pacific Railroad, No. 1291; 1869,
orange mount; by Thomas Housewerth.............................. 15.00

Summit Lake, at the summit of the Sierras; Central Pacific Railroad,
c. 1869, orange mount; by J. J. Reilly of San Francisco.. 8.00

View North of Fort Point, No. 86; roadbed, Central Pacific Railroad;
by Alfred Hart.. 20.00

Wilhelmina Pass, No. 161; 1868, Union Pacific Railroad; by A. J.
Russell... 16.00

School Events

Cornell University; students out front, yellow mount; by Gates of
Syracuse.. 4.00

Founder of Yale College; four views of the funeral of George
Peabody, 1869.. 45.00

Princeton Team, Champs of '93; scrimmage view, 1893; by
Underwood & Underwood.. 5.00

West Point; ships, cannons, and men, c. 1870 s; by George Barker.. 4.00

Yale versus Brown; 1924 football game in progress; by Keystone
View Company... 5.00

Southern Views

The Beach and the famous Auto Speedway of Daytona, Florida
No. 26972, c. 1920; by Keystone View Company.................. 9.00

Characteristic Southern Scenes; three views of blacks in cotton
fields, etc., orange mounts; by J. A. Palmer.................... 12.00

Charleston Market, No. 18; Seaver's Southern Series................ 7.00

Libbey Prison; barred windows; by Anderson of Richmond.. 13.00

Old Spanish Fort, St. Augustine, Florida, No. 618; by A. F. Styles.. 4.00

"Out for a Little Jaunt," Atlanta, Georgia, No. 10810; black man
in goat-drawn cart, tan mount; by Kilburn...................... 4.00

Pensacola, Florida, Santa Rosa Hotel (manuscript), c. 1863, early
mount... 9.00

"Products of Florida"; group of fourteen black boys, cabinet-mount;
Bloomfield's Historical Guide Series............................. 5.00

"Subject for Reconstruction" No. 635; black man by a shanty;
Scenes from Florida Series; by A. F. Styles of Burlington,
Vermont.. 8.00

Spirit Photography

Guardian Angels; two sleeping children in a crib, winged ghost
figures above, c. 1856, hand tinted; by Silvester............... 14.00

"Phantom Player Resting"; ghostly figure of a woman leaning against
a piano, and "Haunted Lovers," spirit woman standing by
couple, 1893; both by Littleton View Company for Underwood
& Underwood... 7.00

Spirit views (four); angels over child, woman ghost, "The Spector's
Visit," and a seated ghost... 18.00

Technology and Exploration

Dr. Kane's arctic dress; Smithsonian Institution, 1858; Langenheim
label... 25.00

Full Moon, No. 2630, c. 1877; by Kilburn Brothers.................. 4.00

Full Moon, from Prof. Draper's negatives, tan mount; by Underwood
& Underwood... 3.00

Eskimos and part of crew of S. S. Erie, Greenland, No. 13329; by
Keystone.. 5.00

Hawaiian exploration scenery; c. 1870s, Rainbow Falls; by H. L.
Chase, Hawaiian photographer..................................... 10.00

"The twin ships Windward and Eric—Peary Expedition, 1901, at
Nuerke, 800 miles from North Pole, Greenland"; gray mount;
Keystone View Company... 3.00

"Where ships will sail through a mountain, famous Culebra Cut,
finished depth 330 feet, Panama Canal," 1904; gray mount;
Underwood & Underwood.. 2.00

Tissue Views

"Border of the Rhine"; three views, yellow mounts, initialed "EL",

colored pinholes on reverse... $ 15.00

France; interior of church with stained-glass window; by Q. V.
Church... 5.00

Les Theatres De Paris, No. 5 Le Freyschutz, and No. 6 Mignon
Retrouve sa Patric; both by B. K. of Paris........................... 13.00

Diable, No. 3, "Paradis"; entrance to heaven, St. Peter in skeleton
arrangement... 10.00

Paris Exposition; eight tissues with "EL" stamped on yellow mounts,
three views have colored pinholes................................. 32.00

Peking, China; Second Court of the Forbidden City, the Imperial
Chinese Building, 1901; Underwood & Underwood..................... 7.00

Salle de Crimee (Palais de Versailles) No. 92; tinted and pricked view
of gallery war paintings; by E. Lamy.............................. 6.00

Transportation

"American Fire Engine," No. 97, at 1862 London Exhibition; by
London Stereoscopic Company...................................... 40.00

Ascent of Prof. Low's Balloon from corner of 6th Avenue and 59th
Street, No. 4114; by Anthony..................................... 75.00

Balloon ascension, No. 1683; crowds, zoo, at Woodward's Garden,
orange mount, slight stains; by C. Watkins 80.00

Balloon ascension from Thousand Island House, Alexandria Bay,
24th July, 1873; close-up, yellow mount, cabinet-size; by
A. C. McIntyre.. 30.00

Fire engine on duty; two close-ups of steam pumpers, 1902; by
William H. Rau, Universal View Company........................... 8.00

"The Graf Zeppelin," No. 32277T; in hangar at Lakehurst, New
Jersey; by Keystone View Company................................. 10.00

P. T. Barnum's Great Caravan entering Watkins, August 4th, 1871;
by G. F. Gates.. 16.00

Sailing ships on the Clyde River at Glascow, Scotland, No. 45A;
by G. W. Wilson... 6.00

Steam locomotive on tracks along the Columbia River by the Pillars
of Hercules, western Oregon, 1902; gray mount; by Underwood
& Underwood.. 3.00

Steamer Herman; deck view, c. 1880s, tan mount; Littleton View
Company.. 3.00

Steamer interiors; two views of the Steamer Montreal; by Joseph L.
Bates of Boston... 30.00

Steamer Providence interior; by Moulton.............................. 11.00

Steamship Great Eastern at the dock, Hammond Street, New York;
by Stacy... 60.00

Steamship Great Eastern in distance; tan mount; European Series
reprint.. 16.00

"Through the uncharted heavens she blazed the trail—Dirigible R-34
at Mineola"; gray mount; by Keystone............................. 7.00

Zeppelin flying over a German town, No. 18000; gray mount;
by Keystone.. 7.00

War-Related Views

Boer War, South Africa, 1899, "Royal Horse Artillery, Slingers-
fontein"; by Underwood & Underwood.............................. 3.00

Civil War, No. 587, Anthony's War View negatives, "Army Black-
smith and forge, Antietam, Sept. 1862"; by The War Photo-
graph & Exhibition Company...................................... 22.00

Civil War, artifacts from Gettysburg battlefield; swords, holsters,
flag, etc., c. 1870s.. 18.00

Civil War, No. 721, "Bringing in the Wounded"; by Taylor &
Huntington... 12.00

Civil War, No. 3339 Anthony War Views, "Church built by the
engineers at Poplar Grove near Petersburgh, Virginia"; from
Brady negative... 18.00

Civil War; "Eight-inch mortars, Brooklyn Navy Yard," c. 1870s;
cream mount; by Webster & Albee................................. 6.00

Civil War, No. 983, Anthony's War Views, "Execution of a Negro
soldier named Johnson at Hollow Square."......................... 15.00

Civil War, No. 2401, John Burns, Hero of Gettysburg; cabinet-size;
War Photo Company.. 20.00

Civil War, No. 1059, "Old Abe, the live Wisconsin War Eagle";
descriptive back, yellow mount; by H. H. Bennett................. 16.00

Macedonian War, 1897, "Fighting Priest and His Flock"; tan mount;
Underwood & Underwood... 4.00

Modoc War, No. 1619, "The Lava Beds," 1893; photographed by
E. Muybridge, published by Bradley & Rulofson.................... 25.00

Modoc War, No. 1630, "Warm Spring Indian Scouts"; photographed
by E. Muybridge, published by Bradley & Rulofson................. 45.00

Pittsburgh Railroad War, July 1877, No. 16; looking up the track—
men and twisted wreckage; by Bassford & Company.................. 24.00

Spanish-American War, "Dock at Tampa on the day of the sailing
for Santiago de Cuba," 1898; tan mount; by Underwood &
Underwood.. $ 4.00

Spanish-American War, "Our Grand Battleship, Oregon, (Aft)," 1898;
tan mount; by Underwood & Underwood............................. 3.00

Spanish-American War, 1898; three views of battleships, tan mounts;
by Rau for Griffith & Griffith.................................. 8.00

Spanish-American War, "Troop H—Captain Curry, Rough Riders,"
1898; troops in background, tan mount; Underwood &
Underwood.. 5.00

World War I, No. 14379, American Eagles, "Exhibition of American
Aircraft on banks of the Rhine"; bi planes, balloon, etc., gray
mount; by Underwood & Underwood................................. 18.00

World War I, five views of black infantry in training; by Underwood
& Underwood.. 25.00

World War I, British officer inspecting captured German tank
"Elfriede," Place de la Concorde, Paris, France; gray mount;
by Keystone.. 3.00

World War I, deck of the battleship Pennsylvania, No. 19147; by
Keystone View Company.. 3.00

World War I, eighteen views of French troops, gray mounts; by
Underwood & Underwood... 20.00

Western Views

"Alder Gulch Idaho," No. 1855; tree stumps by miner's cabins; by
F. J. Haynes... 12.00

"Big Horn or Rocky Mountain Sheep," No. 3518, Oryis, Montana;
cream mount; by W. H. Jackson, Denver........................... 15.00

California mammoth trees, No. 1281; cutting section of big tree,
Fresno County; by Soule.. 17.00

Camp on fire, Lake Mary, Colorado Territory, No. 437; cabinet-size;
by T. Hine... 10.00

Canyons and mountains, views No. 38, 76, and 97; on yellow
mounts; by Alfred A. Hart...................................... 30.00

"Cape Horn"; scenes in the Sierra Nevada Mountains, yellow mount;
by Alfred A. Hart.. 10.00

"Castle Geyser in Action," No. 4538; by F. J. Haynes, Yellowstone.. 7.00

Cathedral Spires, No. 519; Garden of the Gods Series, cabinet-size
mount; by Jackson of Denver.................................... 12.00

Cave Ruin of San Juan, No. 3708; Archaelogical Series, c. 1870s;
by W. H. Jackson of Denver..................................... 17.00

Chinese restaurant, Jackson Street, San Francisco; street activity,
orange mount; New Series by C. Watkins......................... 16.00

Colorado, Silverton miners loading supplies with burros and depot,
No. 5525, 1890; tan mount; by Kilburn.......................... 15.00

Cosmopolitan Hotel No. 181 and No. 191, The Old Mansion House
and Mission Dolores; orange mounts; by Thomas Housewort
& Company.. 28.00

Devil's Gate Bridge, Weber Canyon, Utah; green mount; by C. W.
Carter... 10.00

Eureka, Nevada; four views; by Louis Monaco........................ 65.00

Fishing on Long Bridge, No. 651, "Helios"; by E. Muybridge of
San Francisco.. 35.00

Fourth of July parade of 1883, Forest City, Iowa; stores and people;
by G. W. Elder... 7.00

Georgetown, Colorado, looking North; small town in distance, tent
in foreground, 1867, tan mount................................. 25.00

Geyser Springs Hotel, No. 876, "Helios Flying Studio," Sonoma
County, California; by E. Muybridge............................. 27.00

Historic view of people just after escaping from the Indian Massacre
of 1862 in Minnesota, No. 73; by Whitney....................... 75.00

Howe's Cave; interior view photographed by calcium light, orange
mount.. 12.00

"Inside the Crater Kilesuia"; hikers, etc., yellow mount; by A. A.
Montano of Hawaii.. 10.00

"Lancaster", San Francisco, No. 572; three-masted schooner,
broadside view, 1867; C. E. Watkins, Pacific Coast Series.. 20.00

Leadville, Colorado, "Robert E. Lee Mine"; miners, railroad,
buildings; by Luke & Wheeler.................................... 8.00

Magic Tower on the Union Pacific Trail; orange mount; by Thomas
Houseworth & Company... 15.00

"The Mammoth Petrified Stump," No. 517; cabinet-size; by F. Jay
Haynes of Fargo, Dakota Territory............................... 10.00

McCartney's First Hotel in Yellowstone, No. 223; European Ameri-
can Views, c. 1870s.. 7.00

Mount of the Holy Cross, No. 3101; cabinet-size, tan mount; by
W. H. Jackson.. 19.00

New Tabernacle, Salt Lake City, Utah, No. 1255; tan mount; by
C. Bierstadt of Niagara Falls, New York........................ 7.00

Rainbow Fall, No. 70, near Manitou, Colorado; cabinet-size,
c. 1870s; by Gurnsey of Colorado Springs....................... 7.00

"A Real Live Cowboy"; color lithoprint; by Ingersoll............... 6.00

"Robert E. Lee Mine, Leadville, Colorado; Stereoscopic Views of the Mining Camps of Colorado, cabinet-size, cream mount; by W. H. Jackson... $ 25.00

"Royal Gorge, Grand Canyon of the Arkansas, Col. U. S. A."; closeup of train, 1891, tan mount; by Kilburn............................. 4.00

Russian Hill, San Francisco; yellow mount, slight water damage; hand-signed by Charles Watkins...................................... 32.00

Salt Lake City, Utah; three views of the area, including the lake and the city, green mounts; by C. Savage of Salt Lake City, Utah.. 20.00

Salt Lake City, from the arsenal looking Southeast; by C. W. Carter.. 11.00

San Francisco, No. 780, the Cliff House; by Taylor.......................... 6.00

San Francisco, No. 150, Montgomery Street from Eureka Theater, instantaneous street scenes, 1865; by Lawrence & Houseworth. 28.00

San Francisco, California, No. 113; ships in bay, sign visible on building, "Edourt & Cobbs Gallery"; by Rielly........................... 30.00

Street scene in San Antonio, Texas; stores, horses, people; by Hardesty Company.. 23.00

Temple Block, Salt Lake City, Utah; showing Savage's Gallery and the Tabernacle under construction, tan cabinet mount; by Savage.. 30.00

Trout fishing in Pluton Creek, No. 921; Great Geyser Series, c. 1869; by Eadweard Muybridge................................ 16.00

Weber River, Bridge 32, No. 397; in the Weber Canyon Series; by A. J. Russell.. 7.00

Yellowstone views; three sepia-toned scenes; by Underwood & Underwood... 6.00

Advertising

	Values
Born's Stove; woman taking bread out of oven, printed script ad on front, ad on reverse for Rowlands Company; divided back..	$ 8.00
"Don't Resist!"; ad for Rock Island Plow Company, girl dressed in Western outfit; by the Rotograph Company; undivided back..	5.00
"May your troubles always be little ones"; child with globe; by the Rotograph Company; divided back...................................	4.00
Superior drills; woman standing beside a seeder; 1906, by Superior Drill Co.; undivided back...	4.00
Woman with bouquet; ad for Leechburg Hardware Company, Pennsylvania, ad on reverse; by the Rotograph Company...	4.00
Home Economy oil-gas burner stove, close-up, c. 1920s; divided back..	5.00
Pictorial Review; newsboy wearing apron saying, "Young Hustler's Division," holding magazine; divided back........................	5.00
"The Type F," and six bottom Engine Gang, Oil-Pull tractor, ad on reverse, c. 1912, color; divided back.................................	6.00

Alaska and Hawaii

"A large city in Alaska"; dirt street with a few wood-framed buildings, color; published by A. H. Co.; divided back...................... 3.00

Aloha Nui, interior view of a Royal Luau; printed in green, writing space on front; undivided back................................ 7.00

Post Office, Honolulu; horse-drawn buggies out front, tinted; published by Hawaii and South Seas Curio Co., Honolulu, c. 1914; divided back... 8.00

Disasters

Cartoon with three vignette photos of George C. Pardee, Brig. General Frederick Funston, and Mayor Eugene E. Schmitz, "The Response of the Nation After April 18th, 1906"; published by S. Levi, 1906; undivided back.................................... 10.00

Collection, twelve views of the destruction by the Johnstown Flood of 1889, c. 1906; various publishers.................................. 30.00

Flood of 1907, Wheeling, West Virginia; bridge, railroad station, and other buildings partially submerged, tinted; divided back.. 3.00

Flood at Burgettstown, Pennsylvania; two views of the railroad being carried away, and the wrecked auditorium hall on September 2, 1912; divided backs.................................. 3.00

Great earthquake and fire, San Francisco, 1906; steel framework of city hall stripped by earthquake; published by the American News Company, New York; undivided back.............................. 6.00

Newspaper; simulated front page of *The Commerical Tribune*, with 1906 San Francisco earthquake headline and breakthrough picture of a child; Commercial Tribune Souvenir; undivided back... 6.00

Pittsburgh Flood of March 1936; souvenir folder of eighteen views; by D. A. Feighly, published by Artcraft Lith. Co., Pittsburgh.. 5.00

Ruins of the Sherman House after the great fire of March 14, 1910, Jamestown, New York; divided back; published by E. H. Ketchum Co., Jamestown, New York...................................... 3.00

Schoolhouse afloat on the Ohio River, flood of March, 1907, passing under a bridge at Wheeling, West Virginia. (Floated over 100 miles. Published by J. G. McGrorey & Co.; divided back... $ 4.00

Spring flood, 1926, Center Street, Oil City, Pennsylvania; color view of flooding; by C. T. American Art; divided back....................... 1.00

Eastern Views

Ashtabula Harbor, Ohio; entrance to harbor by Lake Erie, trains and ships; by John J. Lee, 1907; divided back.................................. 3.00

A busy day at Atlantic City; beach crowded with bathers, small photo on reverse of Absecon Light, Atlantic City, 1903; by the Osborn Publishing Co., New York City; undivided back.. 2.00

City Hall and Smithfield Street, Pittsburgh; color; by Detroit Photographic Company; undivided back.. 2.00

Hotel Surf and Hotel Strafford at Ocean City, New Jersey; close-up, c. 1901; divided back... 2.00

Nauset Inn, Orleans, Massachusetts; old car out front; by H. A. Dickermann & Son, Taunton, Massachusetts; divided back... 1.00

New York City, No. A 186a, 14th Street, West from 3rd Avenue; instantaneous street scene, horse-drawn vehicles, people; by The Rotograph Co., 1905; undivided back.............................. 6.00

Olivet-Albion football game and gymnasium, 1902; by Frank N. Green; undivided back.. 4.00

Sand Artists' Exhibit, Atlantic City, New Jersey; color; by Sithens Post Card Co., Atlantic City, 1920s; divided back.................... 3.00

Scene along the Narrow Gauge of B. & O. R. R., No. 54546; by The Rotograph Co.; undivided back.. 3.00

State Street, looking north from Van Buren Street, Chicago, No. 62; tinted; by Curt-Teich & Co., 1905; undivided back.................... 3.00

Steamboat landing, Merepoint, Maine; color, 1911; by F. E. Merrill of Freeport, Maine; divided back.. 1.00

Upper Falls of the Genesse River, Rochester, New York, No. 7626; Souvenir Postcard Co. of New York; undivided back.................... 2.00

Weehawken, New Jersey, Post Office; fourteen postmen standing in front of building; by Baudish & Reipen, Union Hill, New Jersey, 1906. Private Mailing Card.. 4.00

Expositions and Events

Cascades and Manufacturers buildings, Alaska-Yukon Exposition, 1909, Seattle, Washington; color; by the Post Card Shop, Seattle, Washington; divided back... 3.00

Independence of Mexico; girl beside map of Mexico, tinted, c. 1910; divided back... 7.00

New York building at the Panama-Pacific International Exposition in San Francisco, ad on reverse for 1915 Autopiano, "selected as the official musical instrument"; divided back........................ 3.00

Steamer *Princess*, Ohio River view, Ohio Valley Industrial Exposition, Cincinnati, August 29 to September 24, 1910, ad for exposition on reverse; divided back.. 4.00

Foreign Views

Abbey ruins, Whitby, No. 3978; by Judges Ltd., Hastings, England, sepia-toned, divided back... 2.00

Alger, Les Rampes du Boulevard, No. 26; market scene; by J. Geiser of Algeria... 2.00

Cascade de Courmes; waterfall, color; by Edition Giletta Freres of Nice; divided back... 2.00

Dauphine, mountain climbers atop a glacier, No. 559; by P. Gaude of Grenoble, Switzerland; divided back.................................. 3.00

Japanese girl in costume; tinsel added, tinted; by N. P. G., Germany; divided back... 4.00

La Sorbonne, Cour d'Honneur, Paris; by Neurdein et Cie, Paris; divided back... 1.00

Ligenziandi Ragionieri 1909–1910; ninety-two class pictures; by Varischi & Artico, Milano, Italy; divided back............................ 3.00

London—Rotten Row; horses and crowd; by London Stereoscopic Company, "LESCO" Series, England; divided back.................... 5.00

Maison Cosse, Versailles, No. 339; close-up of the front of a French postcard shop with hundreds of cards on display, employees in doorway, made in France, divided back.................................. 12.00

Naples, Grand Hotel dining room; by Richter & Co., Naples, Italy; undivided back... 3.00

Paris, Gare de Vincennes; instantaneous street scene, people, wagons, postcard collector's rubber stamp on reverse, 1907; divided back... 4.00

Paris, Le Rue de L'Echelle; shops, early cars, florist stand, French stamp cancelled by favor on front, 1912, divided back.................. 5.00

Saint Nazaire; street scene with wagon, cafe; Artaud and Nozias printers; divided back... 4.00

Windsor Castle, Curfew Tower, No. 35442; wagons out front, sepia-toned; by F. Frith & Co. Ltd., Reigate, England; divided back... 3.00

Genre Views

"Abide With Me"; set of three, with mourning of child's death as a theme; Bamforth's Life Model Series, (England) New York City; undivided back... $ 10.00

"Busy with the typewriter"; early typewriter pictured on woman's desk, tinted; by M. B., 1910; divided back................................. 3.00

Child in grocery store; tins and packages on shelves, color, 1911; by Bamforth & Co.; undivided back.. 2.00

Indian with knife, standing beside a teepee, labeled, "Me kill you, picture man," 1908; by W. T. Ridgley Calendar Co., Great Falls, Montana; divided back... 4.00

"I want to see the old home again"; sailor by seaside backdrop; by Bamforth & Co., 1907; divided back.. 3.00

"Poking fun at the Merry Widow Hat"; woman with huge hat trying to go through doorway, advertisement, 1908; by I. Grollman; divided back.. 3.00

"The Vacant Chair"; series of three, with family recalling soldier lost in the war; by Bamforth & Co.; divided back......................... 10.00

"What funny things we hear"; woman holding shell to ear; by Rochester Photo Press of New York; divided back............................ 2.00

"What may the answer be?"; woman at table with old-fashioned telephone, color, 1910; divided back... 2.00

Woman with horse; artistic arrangement; sepia-toned; by N. P. G. of Germany, 1919; divided back... 8.00

Woman draped in material; photographed in 1899 by J. Schloss of New York City, "Fair Women" Series of Raphael Tuck & Sons, No. 3691, rototyped in Berlin; undivided back.............................. 7.00

Greetings

Easter greeting; small vignette photo of a man, inserted within colorful picture of roosters; divided back.. 2.00

General greeting, with 2¼ by 1¼ inch photo attached of the excursion Steamer *Christopher Columbus*; divided back.............................. 4.00

Loving Christmas greetings; child beside pillar, glazed surface, color, 1913; by Raphael Tuck & Sons, "Gem" Christmas Series No. C 3602, processed in Saxony; divided back.................................. 2.00

"Merry Xmas!"; boy on toy horse with wheels, girl with doll, Christmas tree, tinted; printed in Germany; divided back.............. 3.00

"Shocking! What a Stocking!"; Santa looking at large stocking on a fireplace, 1910, sepia-toned; Colonial Art Pub.; divided back.. 3.00

Souvenir greeting with 1¼ by 2¼ inch attached photo of a main street in Union City, Michigan, 1912; by R. Steinman & Co., St. Paul, Minnesota; divided back.. 3.00

"To My Valentine", seductive woman in off-the-shoulders gown, holding flowers, 1905, tinted; divided back....................................... 6.00

"With all good wishes"; mother and children with toy doll, drum, and hobby-horse before a Christmas tree, tinted, gold trim; by E. C. C., made in Saxony; divided back... 3.00

Indians

Apache Chief; James A. Garfield, No. 5243, 1899 (from William H. Jackson negative); color vignette; by Detroit Photographic Co.; undivided back.. 7.00

"Curley"; sole survivor of the Custer Battle; Throssel photo, Herbert A. Coffeen, publisher, Sheridan, Wyoming; divided back.. 6.00

Chief Buckskin Charley; Ute., No. 1533; bust pose, color, c. 1910; by Edward H. Mitchell of San Francisco; divided back.. 5.00

Natives of Kittitas Valley, Washington; two Indians on horseback, 1907; by the City Book Store, Ellensburg, Washington; undivided back.. 8.00

"Pretty-Old-Man," of the Crows, No. 6077, 1902; color vignette (W. H. Jackson negative); by Detroit Photographic Co.; undivided back.. 7.00

Pueblo Pottery Venders, No. 6502, 1911, color "phostint" card; by Detroit Publishing Co.; divided back... 4.00

"Sun Dance Arena," Vernal, Utah; Indian camp in distance, tinted, c. 1910; divided back... 3.00

Tuscan Joe, The Yaquis Prince; the only Indian singing English before the American public; from the *Billboard*, 1910; divided back.. 8.00

Ute Chief, "Tarboocheket," No. 5248; color vignette portrait (Jackson negative), 1900; by Detroit Photographic Co.; undivided back.. 7.00

Ute Children, (Jackson negative), No. 5251; color vignette, 1899; by Detroit Photographic Co.; undivided back... 7.00

Interiors and Exteriors

Dining saloon on the S. S. *Prince George*, 1914; Victor Postal; divided back.. 6.00

General store; cluttered with displays, canned goods, wallpaper rolls, proprietor on chair; divided back... 10.00

Grocery store; grocer and customers out front, many products and

signs; divided back.. $ 5.00

H. J. Boerth's Quick Lunch, Detroit, Michigan; color, people at counter, 1906; undivided back... 2.00

Ice cream shop at McKeesport, Pennsylvania; Tiffany lamps, Coca-Cola sign, etc.; by Eils Bros., Pittsburgh; divided back.. 5.00

Movie theater, "Today Joe Morrow's Real Wild West," c. 1915; large banner, people dressed in Western outfits; divided back.. 5.00

Post Office; outside view, horse-drawn delivery wagons, inside view of post boxes, Olivet, Michigan; by Frank N. Green; undivided back.. 6.00

Restaurants; four cards of interiors, c. 1907–1910, one in cave, another with painted frescoes, color, etc.; divided backs.. 8.00

Royal bakery and confectionery retail branch, and Egyptian Tea Room, Portland, Oregon, 1910; color; by Portland Post Card Co.; divided back.. 2.00

Storefront; horse-drawn dry-goods wagon out front; divided back.. 5.00

Todd's Pharmacy; 1906, cabinets and shelves filled with pharmaceutical products; undivided back... 4.00

Train interiors; two views on the Wabash Banner Limited between St. Louis and Chicago, dining car and library, color; divided backs... 7.00

Watch factory; with machinery and workers; divided back................. 3.00

Midwest and Southern

"A landmark of oildom near Youngsville, Pennsylvania"; columned structure of two stories, The Pennsylvania House, 1912; by Kropp Co., Milwaukee; divided back.. 2.00

Bird's-eye view of Mifflinburg, Pennsylvania; 1906, distant view of town, writing space front; undivided back...................................... 2.00

Callicoon Hotel, Callicoon Center, New York; two-story porch structure, people in foreground at a table, horse-drawn wagon, 1913; color; by G. V. Millar & Co., Scranton, Pennsylvania; divided back.. 3.00

Casino in Delaware Park, Buffalo, New York; color; 1906; by H. L. Woehler of Buffalo; undivided back................................. 2.00

Chicago; State Street, looking north from Van Buren Street, wagons, trollies, shoppers, Rothschild's Department Store, tinted, 1905, space front; by Curt Teich & Co.; undivided back...................... 4.00

Dinner in the cave, Mammoth Cave, Kentucky, 1907; by Art Manufacturing Co., Amelia, Ohio; divided back.. 3.00

Elk Street Market, Buffalo, New York; vendors, Coca Cola ad, color, 1915; by Curt-Teich Co.; divided back.. 3.00

Erie Canal at Schenectady; space front, color, 1905; by Robson & Adee of Schenectady; undivided back.. 4.00

Fish hatcheries, Put-In-Bay, Ohio, 1918, tinted; by The Albertype Co.; divided back.. 2.00

Gadsden, Alabama; two vignettes of the court house and Broadstreet, 1906; by C. F. Cross & Brothers; undivided back.......................... 2.00

Iron Mines, Waukon, Iowa; buildings, tressel, old car, 1911; divided back.. 3.00

New Richmond, Wisconsin, Main Street; horse-drawn buggies, wagons, stores, etc., 1910; divided back.. 3.00

Market Street, west from Eighth, Philadelphia, 1906; by J. Murray Jordan, Philadelphia; undivided back.. 2.00

Pine Buff, Arkansas, circus parade street scene; by H. G. Zimmerman & Co., Chicago; divided back... 4.00

Pittsburgh; montage of five small views, with a red heart attached containing twelve foldout views of the city, 1908; by J. W. Miller, Albany, New York; undivided back.. 5.00

Princess Theater, Chicago, No. 1434; color, 1909; by V. D. Hammon Pub. Co., Chicago; divided back... 2.00

Rockafellow Bath House and Hotel, Hot Springs, Arkansas; ad on front, color, c. 1910; divided back.. 3.00

Smiling black boy with straw hat; black printing on pale green, writing space front, 1901; by The Albertype Co., New York. Private Mailing Card... 7.00

Southern scenes of blacks within two vignettes, "Southern Pines, North Carolina," 1905; by Arthur Livingston, New York; undivided back.. 10.00

Watching the Steamboat, No. 134, space front, 1906; by Adolph Selige Pub. Co. of St. Louis; undivided back.. 4.00

Occupations

A Good Kill for Two, No. 140; hunters with birds they shot, dog in canoe, 1909; by R. Steinman of St. Paul; divided back.. 3.00

Beef-cooling room, Armour's branch, Gary, Indiana; by The Crose Photo Co.; divided back.. 6.00

Bands; the three bands of the House of David; divided back.. 5.00

Cambria Steel Company, Johnstown, Pennsylvania; by S. Langsdorf & Co., New York; undivided back... 2.00

215

Carpenter; Thomas Gerber "The Reasonable Price" carpenter and builder; tools hanging on side of building, man with rifle; divided back.. $ 7.00

Employees of the Weehawken Post Office in uniforms, bags posed outside of Post Office, 1906; by Baudisch & Reipen, Union Hill, New Jersey. Private Mailing Card........................ 8.00

Erie R. R. Shops, Meadville, Pennsylvania; by Harry H. Hamm, Meadville; divided back... 5.00

Group of well-dressed hunters with rifles, wearing straw hats; divided back.. 3.00

Gymnasium, and view of a 1902 football game in distance, Reed Field, Olivet, Michigan; writing space on front; by Frank N. Green, undivided back... 5.00

Hunters with over a dozen fox pelts and a dog; divided back.. 3.00

Man posed beside large lathe in machinery shop; divided back.. 3.00

Mine trolley, Scranton, Pennsylvania; two miners, c. 1906; by The Rotograph Co., New York; undivided back...................... 6.00

Ohio Pail Co. Plant, Middlefield, Ohio, before and after its destruction by fire in March 1907; divided back........................... 4.00

Ropemaking group at Fiji; by A. M. Brodziak & Co. of Suva, Fiji; undivided back.. 5.00

Small arms shop, Rock Island Arsenal, 1909; color; Rock Island Post Card Co., New York; divided back............................ 3.00

U. S. Lifeboat Station, Mouth of Chicago River, Chicago; color, seven-man crew standing in front of station, No. 217; by Franklin Post Card Co., Chicago; divided back........................... 3.00

West gun and carriage shop, Navy Yard, Washington, D. C.; men and machinery; by I. & M. Ottenheimer, Baltimore, Maryland; divided back.. 4.00

Woman at desk, typing; tinted; made in France, c. 1920s; divided back.. 3.00

Personalities and Their Homes

Admiral George Dewey; bust pose, Rotograph Series; photo by Ritzman of New York; undivided back.......................... 10.00

Anna Held; in stage costume, hugging two life-sized teddy bears; by Davidson Bros., Real Photographic Series; divided back.............. 6.00

Artoria, the tattooed lady, c. 1910; divided back................. 5.00

Bobby Leach and his barrel after his perilous trip over Niagara Falls, July 25th, 1911; divided back... 10.00

Birthplace of Hon. William McKinley, Niles, Ohio, c. 1908; by Ward's Pharmacy, Niles, Ohio; undivided back......................... 3.00

General Boum; a French midget, born in 1876, standing beside a chair, writing space front; undivided back.......................... 12.00

Gene Tunney and Jack Dempsey; in boxer trunks, with table of comparisons; divided back.. 8.00

Happy Jack Eckert; world's prize fat man, weight 739 pounds, seated pose, banners on wall; by Carter & Carter of Logan, West Virginia; divided back.. 7.00

Helmann; escape artist, handcuffed, captions added, 1910; divided back.. 6.00

Late General Booth, founder of the Salvation Army, 1829–1912; divided back.. 3.00

Late President McKinley on the famous front porch, Canton, Ohio, 1900; by Courtary of Canton; divided back......................... 6.00

Marian Draughn, No. 2724; tinted, tinsel; divided back......... 2.00

Oscar E. Nuff and his outfit; man standing by checkered pushcart with sign, "From East Palestine, Ohio to Washington, D. C."; divided back.. 7.00

Pauline Chase; Rotary Photographic "Circle Plate Series"; divided back.. 4.00

President Warren G. Harding and his parents, 1920; photographed by Adam Bauer of Marion, Ohio; divided back......................... 6.00

Pope Pius X, vignettes of the Pope and his family; made in Italy; divided back.. 7.00

Sarah Bernhardt; three vignettes of her appearance at the Colonial Theater, Cleveland, Ohio; by Adolph Selige, St. Louis; undivided back.. 6.00

South view of the home of artist Paul de Longpre, in Hollywood, California, color, No. 3235; by M. Rieder, Los Angeles; undivided back.. 2.00

Virginia C. Kemmerer, founder of a centennial, September 3, 1908 at Schellsburg, Pennsylvania; woman in wide-brimmed hat by doorway labeled 1808; divided back...................................... 3.00

Photographica

"Bitte recht freunlich!"; photographer acting as a dentist; by N. P. G. of Germany; divided back.. 8.00

"Do you use a Kodak?"; man hanging from cliff, 1905; Balloon Route Excursion ad on reverse; by Vincent of Los Angeles; undivided back... 14.00

Kniebes Studio, Norwalk, Ohio; montage of four interior views of a photographer's studio, 1908; divided back.......................... $ 12.00

Kodak advertising card; girl with camera lauds the Kodak; ad on reverse for Kodak Velox Postals; divided back...................... 15.00

Leiter's Photographic Studio; outside view, ad notes, "Special 500 photos $4.00 per dozen," 1908, Ohio; divided back................ 8.00

Photograph Company of America at Chicago; ad features girl with parasol; divided back.. 6.00

Photography Gallery and entrance to "A Trip to Rockaway," Silver Lake, Cuyahoga Falls, Ohio; "Tin-types and Photographs," on side of house, twelve foldout views, 1906; Rotograph Co., Germany; divided back... 10.00

Photographer posing a woman, "But gentle he soothes her and gives her a chair, takes lightly her hand and bends over her hair," large studio camera in forefront, color; Theochrome Series, Germany; divided back.. 5.00

Stereoscopic view No. 4, Nice-La Jetee, Series No. 7; people beside beach, "Vues Stereoscopiques"; by Julien Damoy, Paris; divided back.. 15.00

Photomontage

"A Kansas Air Ship"; huge grasshopper flying through sky with basket holding small girl, 1909; by M. W. Bailey of Hutchinson, Kansas; divided back.. 10.00

"A unique bungalow"; watermelon appears to be a house, black family outside, 1909; by Martin Post Card Co.; divided back.. 6.00

"Farewell" spelled out, with faces of women, floral decorations, 1907; by Rotograph Co., New York; divided back............. 4.00

Fliegerkampfe uber Paris; planes over Paris in battle, hand-tinted; divided back.. 12.00

Fantasy; man seated, smoke from cigarette forms woman's face above (photo); by N. P. G. of Germany; divided back............ 7.00

Fantasy; French soldier looking at letter, family appears in cloud; French postal; divided back... 6.00

Greetings; "Hope," with women's faces forming letters, 1906; Rotograph Co.; undivided back...................................... 3.00

Horse-drawn wagon loaded with oversized pumpkins, 1908; divided back.. 4.00

Man surrounded by drawings of various glass objects; ad for The Jefferson Glass Company, Follansbee, West Virginia, 1901; divided back.. 8.00

Men in old car chasing huge rabbit; ad for landseekers—$4 to $20 per acre; divided back... 4.00

"There is lots of good game if you go after it right"; hunters with large rabbit on pole, 1909; photo by W. H. Martin, North American Post Card Co., Kansas City; divided back............. 4.00

"Utah's Biggest Crop," one that never fails; montage of over one hundred children's heads, color, 1910; by Moon Book & Stationery Co.; divided back.. 5.00

"The way they dig potatoes in Washington," No. 1008; farmer digging up gigantic potatoes, 1907; by M. L. Dakes Photo Co., Seattle, Washington; divided back................................... 4.00

Risque Views

"Shall return to you with colors gay"; 1907, soldier and girl; Anglo Life Series; by I. M. Kline; divided back............................ 3.00

Nude views (two cards) of man hugging a woman, from shoulders up; "Le Baiser" series, printed in France; divided back.. 15.00

Woman in revealing filmy dress with flower garland; tinted; by Verlag Russegger & Co., Hamburg; divided back................ 7.00

Snapshots

Car, old convertible in ditch off a dirt road, c. 1915; divided back.. 2.00

Couple outside posed in prayer, man with rake, woman with apron, "Sweet Hour of Prayer"; cyanotype process, c. 1906; undivided back... 8.00

Family dressed for a ride in an early automobile; closeup; divided back.. 6.00

Family photo of a woman standing on the shore of a river, riverboat Cayuga in background; undivided back........................... 3.00

Lightning in night sky, c. 1908; divided back...................... 12.00

Man with gun, pretending to "hold up" two friends; divided back.. 1.00

Men standing by the boat Echo, lighthouse in distance; divided back.. 2.00

Multigraph; five images of a woman seated at a table, (mirro photography); by Marlborough Photo Shop, New York City, 1914; divided back.. 10.00

Sailors sitting on a cannon, 1917; divided back................... 2.00

Woman in fringed dress, seated in elaborate wicker chair; by Knauf of Canfield, Ohio; divided back....................................... 1.00

Women posed behind a cardboard moon; souvenir of Kresge's
Photo-Studio, Cleveland, Ohio; divided back................................ $ 2.00

Transportation

Airship, Toledo, Ohio (close-up); crowd waiting for takeoff, c. 1908;
photo by Van Loo; undivided back....................................... 10.00

Building a vessel at Waldoboro, Maine; color, c. 1909; by The
Robbins Bros. Co., Boston, Massachusetts; divided back............. 2.00

Early sight-seeing vehicle loaded with passengers, sign on side,
"Seeing Denver," photographer shop in background; divided
back.. 4.00

Engine house, Lafeer, Michigan, c. 1920; divided back................ 2.00

Engine room, Steamer *Greater Buffalo*; color; Tichnor Quality
Views; divided back... 5.00

Erie Station, Jamestown, New York; train arriving; by George H.
Monroe of Jamestown; divided back.................................... 3.00

Fire engine; close-up, four firemen on board; divided back........... 8.00

Fire engine; close-up of horse-drawn Niagara Co. No. 2, Pough-
keepsie, New York; by M. J. Walsh; divided back..................... 10.00

"First lap coming into north turn at the Indianapolis Speedway,"
Indiana; color-linen, by Tichnor, c. 1938; divided back.. 3.00

Interurban car; close-up with two conductors posed; divided back.. 6.00

Leaving Euclid Beach, Cleveland, for Cedar Point on World's record
flight over water, multiwinged plane; by Braun Post Card Co.,
Cleveland, Ohio, c. 1911; divided back................................ 12.00

Locks and dam, Marietta, Ohio; steamboat in lock; by H. P. Fischer's
Studio, Marietta, c. 1907; undivided back............................ 5.00

Locomotive engine No. 28, 1917; engineers standing in front;
divided back... 10.00

New day-line steamer, *Washington Irving*, 1913; by J. Coulson,
Albany, New York; divided back.. 8.00

S. S. *Mauritania*, "The fastest steamer of the world," Theochrome
series No. 192, color; divided back.................................... 7.00

Normandie, "The world's largest ship," with vignette of Commodore
Pugnet; by Manhattan Post Card Publishing Co., c. 1935;
divided back... 4.00

Steam engine in use, main street being paved, postcard shop on
corner, onlookers; divided back... 10.00

Steamer *Favorite* between Tampa, St. Petersburg, and Manatee River
Points; By A. J. Park, "Electric Studio," St. Petersburg, Florida,
1907; undivided back... 8.00

S. S. *Titanic*, sunk April 15, 1912, on her maiden voyage, cancelled
May 9, 1912; by Kraus Mfg. Co., New York; divided back... 17.00

Transporter, opened by Sir John T. Brunner, May 29, 1905, length of
span 1,000 feet (five views); divided back............................ 5.00

Trapper; two photos attached to one card. Old trapper, Mr. William
A. Barchner, has a rifle, hatchet, sack, and an old hat; by
Metropolitan News Co., Boston; undivided back...................... 6.00

Unemployment theme, "Where there is life there is hope"; truck
with sign, "The years of 1917–18 have been forgotten," 1932;
by C. O. Buckingham, Inc.; divided back.............................. 5.00

United States Dreadnaught in Locks, Panama Canal, ships, sailors,
etc.; by Edward H. Mitchell, San Francisco, 1919; divided back.. 3.00

United States Lines; S. S. *America*, 1929; by United Shipping Board;
divided back... 4.00

"Up the mountain to Cloudcroft, New Mexico"; train close-up,
color, 1906; by F. M. Rhomberg of Alamorgordo, New Mexico;
divided back... 6.00

Vickers Naval Airship in Cavendish Dock, Barrow; by Sankey, Photo
Press, Barrow; divided back... 15.00

Vanderbilt Race, Oct. 24, 1908; Robertson stopping while his
assistant straps on a spare tire; divided back....................... 10.00

Welland Ship Canal; twin locks No. 4, under construction; by F. H.
Leslie, Limited of Niagara Falls, printed in Saxony; divided back... 3.00

Studio Portraits

"Der gute Kamerad"; two German soldiers posed as statuary,
painted faces, fake rocks, sepia tone, No. 746/4; by "Amag";
divided back... 16.00

French soldiers posed with two large bombs, mountain backdrop;
photo by G. Gassler, Antermatt; divided back........................ 3.00

Group of four people leaning on a stage set of a Glen Island mock-up
of a boat; divided back.. 3.00

Head of man superimposed over drawing of a fat man, stage prop,
"Taking on Weight in Hot Springs"; divided back..................... 4.00

Hunting dog posed with ducks, shotgun, and cartridge boxes,
"One Day's Duck Shooting in Northern Nebraska," 1908;
divided back... 7.00

Multigraph, five views of same man playing cards, (mirror photo-
graphy); by Wison & Graham, Birmingham, Alabama, c. 1913;
divided back... 10.00

Post-mortem memorial cross with religious card encircled with
netting; by Youtz of Louisville, Ohio; divided back.................. 1.00

Woman holding urn with flowers, No. 1797/5; tinted, c. 1920;
by Furia; divided back... 7.00

Women and children; ten tinted, highly colored photos made in
France, c. 1925.. 35.00

War-Related Views

Buildings, bunk houses, and officers' quarters at Camp Sherman,
Chillicothe, Ohio, (three cards); by the Scholl Printing Comp-
any, Chillicothe, Ohio, 1915; divided backs.......................... 6.00

Cavalry on the march, soldiers, flags; by H. H. Stratton of Chatta-
nooga, Tennessee, c. 1916; color; divided back...................... 3.00

"Greetings from Camp Dix," Wrightstown, New Jersey; soldiers
loading a field gun; photo by Underwood & Underwood,
New York; printed by The Valentine-Souvenir Co., New York;
divided back... 3.00

Man and woman, revolutionists at Juarez, Mexico, equipped with
guns and ammunition; divided back.................................... 8.00

Mischa Elman playing for the soldiers at the K. of C. at the "Sound-
ing Shell," Camp Kearney, California, 1919; divided back.. 3.00

Pup-tent drill, Camp Jackson, Columbia, South Carolina, 1918; by
Army Y. M. C. A.; divided back.. 3.00

Western Views

"A Hold Up," U. S. Mail Coach en route to Bullfrog, Nevada, color;
by Newman Post Card Co., Los Angeles, California; divided back.. 3.00

Alcatraz Island, No. 3191, San Francisco Bay; by Adolph Selige
Publishing Co., St. Louis; undivided back............................. 2.00

An Oregon Fir Tree, nine feet in diameter; man lying in tree cut,
another man standing on saw; color; by E. P. Charlton & Co.
of Portland, Oregon; undivided back................................... 4.00

Birds'-eye views of Dawson, North Dakota; two cards, c. 1908; by
Greenwood, Orr & Co., Fargo, North Dakota; divided back... 7.00

Bird's-eye view of Ely, Nevada, c. 1907; by S. L. Mayer of Salt Lake
City, Utah; divided back... 7.00

Bird's-eye view of St. Anthony, Idaho, No. 5184; by Curran & Co.
Publishers, St. Anthony, Idaho; undivided back...................... 4.00

Bird's-eye view of Victor, Colorado, c. 1909; made in Germany;
divided back... 3.00

Blue Bird and Trilby Mines, Cripple Creek District, Colorado; tinted,
c. 1909; photo by Hileman... 5.00

Chimney Rock, Old Oregon Trail, North Platte Valley, Nebraska;
undivided back.. 2.00

City of Eureka, California; bird's-eye view and description of city
as well as of Humboldt County, "This is the place you have
been looking for," 1906; by J. A. Meiser; divided back.. 7.00

Coaching party, Upper Falls, Yellowstone Park, No. 523; people
standing by coach; Haynes Photo, printed in Germany, sepia-
toned; divided back.. 5.00

Crevice, Royal Gorge, Colorado, No. 12338; color, (from W. H.
Jackson negative); by Detroit Photographic Company; divided
back.. 4.00

"Crow's Nest," Mountain Death Valley, California; showing the
twenty-mule team hauling borax, No. 841, c. 1909; by The
American News Company; undivided back............................. 4.00

"Dandy," the unbroken steer, steer and wagon, South Omaha,
c. 1907; undivided back... 4.00

Digging an irrigation ditch near Greeley, Colorado; writing space on
front, c. 1908; by Tribune Publishing Company, Greeley,
Colorado; divided back... 3.00

Drilling Contest, Labor Day, Goldfield, Nevada, c. 1906; by The
Dennison News Company; divided back................................ 5.00

Falling a 16-foot redwood in Big River Woods, Mendocino County,
California; three men sitting on half-sawed tree; by Cardinell-
Vincent Co.; divided back.. 3.00

First theater in California, 1847, Montery, California, c. 1908; by
Monterey News Co.; divided back...................................... 2.00

Gambler's Row, Reno, Nevada, No. 8485; tinted, 1907; by
M. Reider of Los Angeles; divided back............................... 5.00

Georgetown, Colorado, overview, No. 141; color; undivided back... 3.00

Grazing on cattle range at sunset, No. M225; cowboy in forefront,
color, c. 1910; photo by Chas. E. Morris, Chinook, Montana,
printed in Germany; divided back...................................... 5.00

Main Plaza, San Antonio; writing space on front; by Charles
Opperman, San Antonio, Texas; undivided back...................... 3.00

Main Street, Goldfield, Nevada, c. 1907; color; divided back... 4.00

Main Street, Greeley, Colorado; horses watering, wagons, buildings,
etc., c. 1909; photo by Marsh of Greeley; divided back............. 4.00

Mary McKinney Mine, Cripple Creek District, Colorado; color, 1910;
by The Great Western Post Card and Novelty Co., Denver;

divided back.. 4.00

Mount of the Holy Cross, Colorado, No. 5614, (from W. H. Jackson negative); color "phostint"; Detroit Publishing Company; divided back.. 4.00

Norris Geyser Basin Yellowstone National Park; unsigned; Detroit Photographic Co., second series, color vignette, ornate P. M. C. back; unlisted.. 25.00

North Side Square, York, Nebraska; horse-drawn wagons, c. 1909; by J. Bowers Photographic Co., London-Topeka; divided back.. 3.00

Overview of Kiefer, Oklahoma, c. 1909; photo by C. H. Wehr, Kiefer; divided back.. 4.00

Pack outfit, Big Horn Mountains, c. 1908; sold by Brown's Drug Store, Sheridan, Wyoming; undivided back........................... 5.00

Palace Hotel, San Francisco, California (before destruction); by Adolph Selige Pub. Co., St. Louis; undivided back............... 2.00

Panoramic view of Reno, Nevada, c. 1906; undivided back.......... 3.00

Pioneer dugout in Goldfield, Nevada, 1907; by Allen Photo Company, Goldfield; divided back.. 4.00

Prospector's Outfit, Goldfield, Nevada, No. 322, 1908; wagon filled with supplies, miners; undivided back........................... 6.00

Pulpit Terraces, Yellowstone National Park, No. 115, 1900 copyright; color vignette (W. H. Jackson negative); by Detroit Photographic Co., P. M. C. reverse.. 20.00

Red Top Mine, Goldfield, Nevada; color; by Edward H. Mitchell, San Francisco; undivided back.................................. 5.00

Saltair on the Great Salt Lake; three-part folder, blue print, information and views of swimmers and beach; Saltair Mailing Card, Salt Lake City, Utah, 1915; divided back............................ 4.00

Santa Monica Pier and waterfront, amusement park in distance, 1932; photo by Bertholf; divided back.................................. 2.00

Sheyenne, North Dakota; two cards, c. 1906; by Henry Flaskerud, The Porte Co., Fargo; divided back.............................. 10.00

Tent City looking toward Hotel del Coronado, San Diego, California; color, biplane in sky; by Cardinell-Vincent Co.; divided back.. 3.00

Tetons from Jackson's Lake; color vignette, unsigned; Detroit Photographic Co., ornate "Private Mailing Card" reverse.............. 20.00

U. S. Troopers on a fallen Sequoia in California, c. 1907; color, No. 3284; by M. Rieder of Los Angeles, made in Germany; divided back.. 4.00

Yellowstone stage in front of Post Office at Fairview, Montana; real estate building with sign, "Homesteads Located, Streets Made or Retraced," 1909; divided back................................. 12.00

MISCELLANEOUS VALUES

Assorted Prints	Values
Acrobat in tights; studio backdrop; 3 7/8 by 5½ inch image, 7 by 9 inch mount..	$ 8.00
Boxing team, group; 8 by 10 inch mount............................	20.00
Boy sitting beside desk; iron toy fire engine and stagecoach in forefront; 4 by 5 5/8 inch image, 6 by 8 inch mount..............	7.00
Chester Cathedral; by Francis Bedford, c. 1870; 5 by 8 inch mount.....	20.00
Children in elaborate lace outfits, c. 1900; by Snook of Akron, Ohio; 5 by 7 inch mount..	2.00
Chili Con Carne Festival and Indian Huts, San Antonio, Texas; two 5 by 8 inch mounted views....................................	45.00
Civil War battle scene painting; supplied by Allen & Rowell, photographers, Boston; boudoir view..................................	14.00
Civil War officer holding sword; full-length pose; imperial mount....	20.00
Court House, Garrettsville, Ohio; men on windmill in backyard; C. M. French, photographer; boudoir size..........................	15.00
Court interior; with judge and bailiffs, boudoir size................	14.00
Disaster scene; several burned-out buildings, wreckage; 3¾ by 4¾ inch image, 6 by 7 inch mount..................................	7.00
Family group on front porch; children, dogs, one man holds trumpet, c. 1900; by The Garden City Photo Co., Los Angeles; 7½ by 4½ inch image..	4.00
Farmers with horse-drawn wagons, steam engines, harvesters, and other equipment in the fields; 9½ by 7½ inch image on 14 by 11 inch mount; by H. W. Jones of Atwater, Minnesota..............	15.00
Filipino midgets dancing; information on reverse; 3½ by 5½ inch image; by Gerhard Sisters of St. Louis............................	12.00
Football team; studio group pose, c. 1910; mounted to 8 by 10 inches..	20.00
German soldiers; transposed over photo of town square, 1878, names of regiment No. 27 listed; 9¼ by 12½ inch image............	18.00

General John M. Corse standing on Allatoona; wearing civilian clothes and high hat; mountains, Atlanta, Georgia, c. 1886; by W. Kuhns; mounted to 20 by 16 inches...................... $ 25.00

Girls with lace on heads; bust portrait within oval mask; 6½ by 4¼ inch image mounted to 7½ by 5½ inches............................ 7.00

Girl in draped material; long hair, soft focus, 1902; by Alfred S. Cambell Art Co., Elizabeth, New Jersey; 2½ by 9½ inch image on 2¾ by 10 inch mount.. 10.00

Girl with crown, in fringed costume; tinted, studio pose; imperial-size.. 8.00

Higgins, Charles R., signed photograph; "A Salem Maid," hand-colored; 6½ by 3½ inches mounted............................ 20.00

Horse with saddle, two hunting dogs, shotgun in field; 3¾ by 4¾ inch image, 5¼ by 6¼ inch mount.................................. 3.00

Hunting party; posed with guns and game, tent in background, woods; 8 by 5¾ inch image, 8 by 10 inch mount.................... 9.00

Isambard Kingdom Brunel; standing before the launching chains of the Leviathan (the Great Eastern); albumen print from 1857 negative; 11½ by 9 inch frayed mount............................ 15,225.00

Italy; three mounted prints of a street scene, harbor, panoramic view; 4½ by 5¼ inch images.. 15.00

Japanese woman carrying baby on her back; c. 1880s, hand-colored; 5½ by 3½ inch image.. 15.00

John Brown's grave, North Elba, New York; boudoir view............... 6.00

July 4th, 1911 celebration in Antigo, Wisconsin; old truck, crowd; 5 by 7 inch image.. 18.00

Kneeling man with shotgun, bullet-belt, and upturned hat, in woods; 4¼ by 2½ inch image, 5¾ by 4 inch mount............................ 5.00

Ladies sitting with umbrellas on rocks by a creek, Yellowstone Park; boudoir view.. 12.00

Liquor store interior; men behind counter, bottle displays, gas fixtures; 7 by 5 inch image on 8½ by 6 inch mount............... 7.00

Man posed beside an easel; old electric fixture hanging overhead; 5½ by 4½ inch image, 7½ by 5½ inch mount.......................... 4.00

Man seated on lumber wagon driving a team of two white horses; 5 by 7 inch mounted image.................................... 5.00

Midway entrance, Pan American Exposition at Buffalo, 1901, "Dreamland"; 4¾ by 4 inch image, 6½ by 5½ inch mount.......... 17.00

Miners; group in front of mine shaft and buildings, ore cart on railing, septa-toned; 6½ by 4½ inch image........................ 10.00

Minnehaha Falls; c. 1880, mounted to 6 by 10 inches.................. 6.00

Niagara Falls; two photos of a man and two women, transposed over photos of Falls scenery; 7½ by 8¾ inch mount; stamped Zyback & Co., Niagara Falls.. 10.00

Old sailing ship with full sail, three-masted; mounted to 10 by 12 inches.. 16.00

Panoramic view of harbor with sailing vessels; man and woman in foreground with cart, near San Remo; image 8½ by 9¾ inches... 13.00

Passenger car, Chicago-Milwaukee & St. Paul R. R., banner reads, "Wheelock & Wheelock's Landseekers' excursion to Ryegate, Montana"; 5½ by 3¼ inch image, 7 by 5 inch mount................ 16.00

Photomontage; woman appears as a statue on a pedestal; 3¾ by 7¾ inch image, on 4 by 8¼ inch mount.......................... 10.00

Pike's Peak Railroad Summit, No. 950, "The Old Way and the New"; by W. E. Hook of Colorado Springs, Colorado; imperial size..... 16.00

Picking Tea, Japan; descriptive reverse; by the Philadelphia Museum; 9¼ by 7 inch image, 12 by 9½ inch mount.................... 6.00

Prarie Flower; Indian in costume with rifle; by McCarty of Granville, Pennsylvania; 4 by 8½ inch mount............................ 35.00

Rachel Gurney, portrait, late 1860s—early 1870s; photographed by Julia Margaret Cameron; mounted on card 15 by 12 inches....... 900.00

Railroad workers; large group inside building, c. 1920s; 7 by 5 inches. 6.00

Riverfront scene; trees and rocks, dated 1887; by The Elite Photo and Copying House, Sault St. Marie, Michigan; boudoir view.. 3.00

Rome; three prints of the interior of St. Peter's Basilica, Vatican; Uffizi Gallery, Florence; and Cathedral in Bologna; by Alinari of Rome; 7½ by 9½ inch image on 14 by 17 inch mounts........... 25.00

Royal Arches Cliffs; sepia-toned scenery; 7 by 4½ inch mount; by Fiske.. 35.00

Seascape; single stack steamship in distance; 4 by 5 inch mount.. 8.00

San Remo; two men on dock, with bay, boats, and buildings in the background; 8½ by 10¾ inches mounted.............................. 18.00

Schoolroom; children by desks, Iowa country school; 4¾ by 3¾ inch image, 6½ by 5½ inch mount.................................. 2.00

Single-masted schooner anchored offshore, men on deck, town in background; 7¼ by 9½ inch image, mounted......................... 12.00

Sitting room, circa turn of the century; large Prang lithograph on wall, desk, curtains; 4 by 5 inch image on 5 by 6 inch mount.. 2.00

S. S. City of New York; steamship with three masts, late nineteenth century; mounted to 8 by 10 inches............................ 17.00

Spirit photograph; skeleton in chair smoking a pipe and playing cards at a table with a ghostly figure; 4¾ by 3¾ inch image, 6½ by 5½ inch mount............... $ 35.00

Steamroller in use; man standing in dirt road; 3 3/8 by 5½ inch image on 4¾ by 7 inch mount......... 6.00

Storefronts; Compass Shop and Boot Store; 5 by 8 inch mount......... 22.00

Tibetian woman carrying a child in a basket; tinted; 5 by 9 inch mount............... 5.00

Twenty-third Michigan Infantry landing at Cuba, June, 1898; mounted to 8 by 10 inches............... 10.00

Union soldier; bust pose, Co. C. First Regiment, Mo. Vol.; 4 by 7 inch mount............... 7.00

Victorian Christmas; interior view of child Christmas tree, dolls, and other toys; 5 by 7 inch mount............... 18.00

Weaving in Japan; descriptive reverse; by The Philadelphia Museum; 9½ by 7 inch image, 12 by 9½ inch mount............... 12.00

Western landscapes in The Garden of the Gods; two sepia-toned 4 by 6 inch images on cream mounts............... 15.00

Woman in winter garb; fake snow; imperial portrait by T. Cambell of Mansfield, Ohio............... 3.00

Woman sitting on a wicker chair beside a large picture of a ship, flags draped above; 4¾ by 3¾ inch image, 5¼ by 4¼ inch mount. 5.00

Woman with elaborate floral hat; portrait, 1986; 4 by 5½ inch image, 5¼ by 7¼ inch mount............... 2.00

Woman holding bow; two children posed with feathers and bows with arrows in a studio, supposedly from the Philippines; 5½ by 8¾ inch image on 6 by 10 inch mount............... 10.00

Woman with parasol standing by a fence; retouched by Frank Carey, "Artist and Photographer," Penn Yan, New York; imperial size.. 4.00

Woman with a rose in her hair; bust pose, oval vignette; by J. Lincoln Smith, Zanesville, Ohio; 5 by 9 inch mount............... 4.00

Workers outside of a building; wearing caps, goggles, and overalls, c. 1910; 8 by 10 inch mount............... 6.00

Yosemite Valley; sepia-toned view by Fiske; 7 by 4½ inch mount.. 35.00

Young man in hunting outfit; wearing waders, jacket, and bow tie, holding a shotgun, dog beside him, trees on painted backdrop, c. 1910s; by Pratt of Falconer, New York; 5¼ by 7¼ inch mount............... 10.00

Kodak Prints

Boy holding a rifle standing beside two anchors on board a ship; chocolate mount, 4 1/8 by 5 1/8 inches, image measures 3 7/8 by 3 7/8 inches............... 12.00

Boys sitting on board ship beside rope stacks, wearing straw hats; 3 7/8 by 4 5/8 inch image on 4 1/8 by 5 1/8 inch chocolate mount, Kodak reverse............... 12.00

Front parlor, with chairs, fireplace, and statuary; Kodak No. 2, 3½ inch image on 4¼ by 5¼ inch mount; c. 1896, Albany, New York............... 15.00

Outside family shots; five photographs on Kodak No. 1, 2½ inch diameter images on 4 1/8 by 5 1/8 inch chocolate mounts, Kodak reverses............... 60.00

Woman gazing at a lithopane hanging in a window; 3½ inch diameter image, 4¼ by 5¼ inch white mount............... 15.00

Velox print of a locomotive; showing size and quality of the negative on the No. 1-A Speed Kodak, Eastman Kodak Company, Rochester, New York; 4 1/8 by 2 3/8 inch image on 5¾ by 4 inch mount............... 25.00

Miniatures

Baby in wicker carriage with attached parasol; 1 5/8 by 2 3/8 inch image on 3 by 4 inch mount............... 2.00

Bust photo of a man; mounted on a 5¼ by 3 inch card, sentiment: "With Compliments," c. 1900............... 2.00

Children standing on a sidewalk, store in distance; 3½ inch square cyanotype, 5 inch square mount............... 8.00

Doctor posed beside chest of medicines; 3¼ inch square image on 5 inch square mount............... 12.00

Gem photo of church, horse-drawn wagon passing; gold beveled-edge, 2½ by 1½ inch mount............... 3.00

Gem photo of a woman; by R. W. Knorr of Trenton, New Jersey, "Send you cabinet and get 12 Gems for 25 cents"; 1½ by 2½ inch mount............... 3.00

Photo; visiting cards with oval vignettes; four examples, one has ad: "12 for 50 cts."; Holley Card Works, Meriden, Connecticut, c. 1890s............... 8.00

Photo; visiting card within aluminum case, from the World's Fair, St. Louis, 1904............... 12.00

Reproduction of a pencil sketch by Bonnard; girl wearing a bonnet with the greeting, "A Happy Christmas"; on 2½ by 5 inch mount............... 4.00

Tintype miniature mounted on a carte............... 7.00

Photo-Related Items

Album; floral designs on each page, containing 46 cartes de visite and 8 cabinets, by photographers Brady, Muybridge, Savage, Moro, Sarony, Disderi, and Freres............... 150.00

Album; 11 x 9, leather, with silver horseshoe clasp, containing 24 cabinets and 36 cartes de visite of family pictures; two are of Civil War soldiers............... 50.00

Government postal card; dated 1879, with overall reverse advertisement for a complete photographer's outfit used to duplicate any photograph............... 20.00

Magazine; *The American Amateur Photographer*, of New York City, January 1893............... 10.00

Photocollage; man's photo superimposed over a print of a bear skin; trompe d'oeil retouching............... 18.00

Playing Cards

"Along the C., M. & St. Paul—Lake Michigan to Puget Sound," by Interstate News Co.; Bi-Polar Electric Engine photo on orange backs; oval photo scenes on each card............... 35.00

C. & O. Railway souvenir; 52 cards plus title card, box; each card has oval photo of place along the route, reverse has brown and orange design with ad for the C. & O. Railway............... 25.00

Cuba; souvenir pack, a different view on each card, red and blue reverse with flags of Cuba, c. 1935............... 12.00

Intercolonial Railway and Prince Edward Island Railway; each card has different Canadian view, reverse has ad for the Intercolonial Railway; published by Goodall and Son, London, c. 1900.. 36.00

Montana and Yellowstone Souvenir Playing Cards; published by The Photo Card Co. of Butta, c. 1898; oval photo scenes on each card, backs have a circular scene surrounded by mining views............... 25.00

Pan-American Exposition; oval views of the fair on fronts, backs have map of North and South America joining hands; published by Pan-American Souvenir Playing Card Co., Buffalo, 1901.. 25.00

Rocky Mountain Souvenir Playing Cards by Tom Jones of U. S. P. C., 1899; faces have oval photo views of the area, backs show a Columbine flower............... 25.00

St. Louis World's Fair; photo scenes of fair on each card, backs have the official seal with profiles of Napoleon and Jefferson centered within an eagle; by Samuel Cupples Envelope Co., St. Louis, 1904............... 35.00

Stage Cards; four photos of stage stars of the day on all the aces and court cards, box; published by the U. S. P. C. Company, 1896.. 36.00

Yellowstone Park Souvenir Playing Cards; published by F. Jay Haynes, the official photographer, St. Paul; faces have oval photos of the park, backs have the monogram "YNP" over a floral design, c. 1900............... 30.00

Trade and Insert Cards

Admiral cigarette cards; two examples, featuring theatrical stars Amy Wells and Laura Maxwell, 1 3/8 by 2½ inches............... 4.00

Cigarette cards; featuring stage personalities, the Chapelle Sisters (Duke's Cameo Cigarettes) and Miss Otway (Sweet Caporal Cigarette), 1¼ by 2¾ inches............... 5.00

Colorful trade card, "Photography under a cloud"; cartoon of photographer with a camera, ad for clothiers on reverse............... 4.00

Diecut trade card in shape of a easel, with 1½ by 2 inch photo of Rose Coghlan; ad for Mammoth Dry-Goods, Utica, New York... 5.00

Tobacco card; ballerine on couch, painted backdrop, "Just So" brand, 4 by 2½ inches............... 4.00

Tobacco card; risque woman on couch, high button shoes; G. & A. Navy Long Cut brand, 3¾ by 2¼ inches............... 4.00

Tobacco card; showing ten sample views of actresses, c. 1890s; Lorillard's Climax Plug brand, 5 by 3¼ inches............... 7.00

Tobacco card; woman with can, in theatrical costume; Sweet Lavender brand, 1¼ by 2¾ inches............... 3.00

Trade card; front: photo of the Ruins of the Alliance Opera House crowd in forefront; reverse: ad for Fine Boots and Shoes; Alliance, Ohio, c. 1879s, 5¼ by 3¼ inches............... 10.00

Trade card: oval vignette photo of a building, the Harmony Mill of Cohoes, New York; reverse has an ad for Crane's Dental and Photograph Parlors, 3½ by 2 inches............... 3.00

Bibliography

Bassham Ben L. *The Theatrical Photographs of Napoleon Sarony.* The Kent State University Press, 1978.

Blum, Daniel. *A Pictorial History of the American Theatre, 1860-1976.* 4th edition New York: Crown Publishers, Inc., 1977.

Braive, Michel F. *The Photograph: A Social History.* New York: Mc-Graw Hill Book Company. 1966.

Buckland, Gail. *Reality Recorded, Early Documentary Photography.* Greenwich, Conn.: New York Graphic Society, 1974.

Burdick, J. R. *The American Card Catalog.* New York: Nostalgia Press, Inc., Franklin Square, 1967.

Coe, Brian. *The Birth of Photography.* New York: Taplinger Publishing Company, 1976.

Coe, Brian, Gates and Paul. *The Snapshot Photograph: The Rise of Popular Photography, 1888-1939.* London, England: Ash & Grant, 1977.

Darrah, William C. *Stereo Views: A History of Sterographs in America and Their Collection.* Gettysburg, Pa., Times and News Publishing Company, 1964.

Darrah, William Culp, Russack and Richard. *An Album of Sterographs: Our Country Victorious and Now a Happy Home.* Garden City N.Y.: Doubleday & Company, 1977.

Darrah, William C. *The World of Stereographs.* Gettysburg, Pa., W.C. Darrah, 1977.

Drimmer, Frederick. *Very Special People.* New York: Bantam Books, Amjon Publishers, Inc., 1973.

Duval, William and Valarie Monahan. *Collecting Postcards in Color. 1894-1914.* Poole, Dorset, England: Blanford Press, 1978.

Gassan, Arnold. *A Chronology of Photography.* Athens, Ohio: Handbook Company, 1972.

Gernsheim, Helmut and Alison. *The History of Photography, 1685-1914.* New York: McGraw-Hill Book Company, 1969.

Haas, Robert Barlett. *Muybridge Man in Motion.* Berkley, Los Angeles, London: University of California Press, 1976.

Haller, Margaret. *Collecting Old Photographs.* New York: Arco Publishing Company, Inc., 1978.

Hiley, Michael. *Frank Sutcliffe, Photographer of Whitby.* Boston, Mass.: David R. Godine Publisher, 1974.

Hochman, Gene. *Encyclopedia of American Playing Cards,* Part 1. G. Hochman, U.S.A., 1976.

Howarth-Loomes, B. E. C. *Victorian Photography, an Introduction for Collectors and Connoisseurs.* New York: St. Martin's Press, 1974.

Jensen, Oliver; Paterson Kerr, Joan; and Belsky, Murray. *American Album.* New York: Ballantine Books, 1968.

Jones, William C., and Jones, Elizabeth B. *William Henry Jackson's Colorado.* Boulder, Colo.: Prueit Publishing Company, 1975.

Kaduck, John M. *Mail Memories.* Des Moines, Iowa: Wallace-Homestead Book Company, 1971. *Rare and Expensive Postcards.* Des Moines, Iowa: Wallace-Homestead Book Company, 1974. *Transportation Postcards.* Des Moines, Iowa: Wallace-Homestead Book Company, 1976.

Kahmen, Volker. *Art History of Photography.* New York: The Viking Press, 1974.

Klamkin, Marian. *Picture Postcards.* New York: Dodd, Mead and Company, 1974.

Lowe, James L., Papell, Ben. *Detroit Publishing Company Collector's Guide.* Newtown Square, Pa., Deltiologists of America, 1975.

Lucie-Smith, Edward. *The Invented Eye: Masterpieces of Photography, 1839-1914.* New York: Paddington Press, 1975.

Martin, Paul. *Victorian Snapshots.* London: Country Life Limited. New York: Charles Scribner's Sons, 1939. reprint New York: Arno Press Inc., 1973.

Mathews, Oliver. *Early Photographs and Early Photographers: A Survey in Dictionary Form.* New York, Toronto, London: Pitman Publishing Corp., 1973.

Miller, George and Dorothy. *Picture Postcards in the United States 1893-1918.* New York: Clarkson N. Potter, Inc., 1976.

Morgan, Willard D., ed. *The Encyclopedia of Photography,* Vol. 13. New York: Greystone Press, 1963.

Naef, Weston J. *Era of Exploration; The Rise of Landscape Photography in the American West, 1860-1885.* Boston: Albright-Knox Art Gallery, The Metropolitan Museum of Art, New York Graphic Society, 1975.

Newhall, Beaumont, and Edkins, Diana E. *William H. Jackson.* Fort Worth, Tex.: Morgan and Morgan, Amon Carter Museum, 1974.

Pollack, Peter. *The Picture History of Photography.* New York: Harry N. Abrams, Inc., 1960.

Rodgers, H. J. *Twenty-Three Years Under a Sky-Light, or Life and Experiences of a Photographer.* Hartford, 1872. reprint ed. 1973. Arno Press Inc., from a copy in The George Eastman House Library.

Shafran, Alexander. *Restoration and Photographic Copying.* Philadelphia and New York: Chilton Company Pub., 1967.

Staff, Frank. *The Picture Postcard and Its Origins.* New York and Washington: Frederick A. Praeger, Pub., 1966.

Taft, Robert. *Photography and the American Scene: A Social History 1839-1889.* 1938 reprint. New York: Dover Publications, Inc., 1964.

Tilden, Freeman. *Following the Frontier with F. Jay Haynes, Pioneer Photographer of the Old West.* New York: Alfred A. Knopf, 1964.

Weinstein, Robert A., and Booth, Larry. *Collection, Use and Care of Historical Photographs.* Nashville, Tenn.: American Association for State and Local History, 1977.

Welling, William. *Collector's Guide to Nineteenth-Century Photographs.* London: Collier Books, 1976.

Welsch, Roger, L. *Tall-Tale Postcards: A Pictorial History.* Cranbury, N. J.: A. S. Barnes and Co., Inc., 1976.

Witkin, Lee D., and London, Barbara. *The Photograph Collector's Guide.* Boston, Mass.: Little, Brown and Company, Inc., 1979.

CATALOGS

Acquisitions 1970-1973. Pamphlet published by the International Museum of Photography at George Eastman House, Rochester, N. Y.

Darrah Collection of Stereo Views, Part 1. Hastings Galleries Ltd., May 1 and 2, 1979, New York.

Image of America, Early Photography 1839-1900. Library of Congress, Washington, D. C., 1957, February 8, 1957 exhibit.

Indian Images, Photographs of North American Indians 1847-1928. Smithsonian Institution Press, Washington, D. C., 1970; from an exhibition at the Smithsonian Institution, July-August 1970.

Montgomery Ward & Co., Fall and Winter Catalog for 1894-1895, No. 56. Follett Publishing Company, Chicago and New York, 1970 Reprint ed.

Playing Cards, List 2. Stanley Gibbons Currency Ltd., London, 1978.

PERIODICALS

Andrews, Barbara. "History of Curt Teich & Company." *Deltiology* 117:3.

Bendix, Howard E. "Early Edward Anthony Stereo Views," *Stereo World* 4 (July/August 1977).

Brey, William. "The Langenheims of Pennsylvania," *Stereo World* 6 (March/April 1979).

Guarino, Frank D. "Collecting Unusual Photographs," *Antiques Trader Weekly*, 4 January 1978, p. 58.

Hill, Eric. "Carleton E. Watkins," *Stereo World* 4 (March/April 1977). "London Exhibition, 1851, The Crystal Palace," *Stereo World* 5 (May/June 1978).

Lowe, James L. "Dictionary of Publisher's Initials," *Deltiology* whole numbers 119-27.

————. "Postcard Issues of the Rotograph Company," *Hobbies*, June, 1974.

————. "Tuck: Prince of Postcard Publishers," *Deltiology* 16 (no. 5) whole number 30.

Meinwald, Dan. "A Professional Photographer and His Amateur Counterparts: A Comparative Study," *Image*, June 1979.

Newhall, Beaumont. "How George Eastman Invented the First Kodak Camera," *Image* 59 (March 1958).

"A Note on Early Photomontage Images," *Image* 15 (1972) pp. 19-23.

Print Newsletter, photographic auction prices, June 1979.

Spinning Wheel Magazine (article), May 1974.

Stretch, Bonnie B. "The Golden Age of Landscape Photography," *American Art and Antiques*, March/April 1979, p. 62.

Waldsmith, Thomas. "Charles Weitfle, Colorado Entrepeneur," *Stereo World* 5 (September/October 1978).

Waktins, Warren A. "How Curt Teich Postcards are Produced," *Deltiology* 117:4.

Zebrowski, J. "The Marketplace," *American Art and Antiques*, March/April 1979, p. 14.

Index

-End-